CONTEMPORARY LANDSCAPE PHOTOGRAPHY

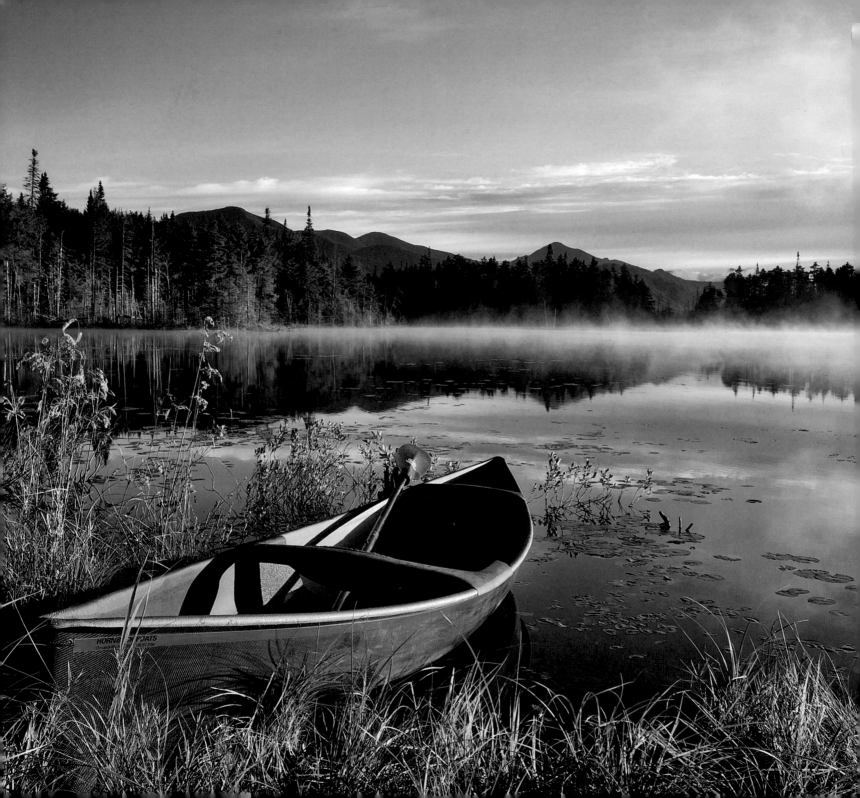

PROFESSIONAL TECHNIQUES FOR CAPTURING SPECTACULAR SETTINGS

CARL E. HEILMAN II
WITH GRETA HEILMAN-CORNELL

CONTEMPORARY LANDSCAPE PHOTOGRAPHY

AMPHOTO BOOKS

an imprint of the Crown Publishing Group
New York

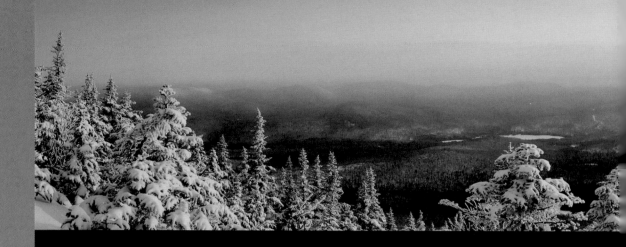

Published in the United States by
Amphoto Books, an imprint of the
Crown Publishing Group, a division of
Random House, Inc., New York
www.crownpublishing.com
www.amphotobooks.com

AMPHOTO BOOKS and the Amphoto Books
logo are trademarks of Random House, Inc.

Originally published in Great Britain as
Advanced Digital Landscape Photography by
Ilex, an imprint of The Ilex Press Limited, Lewes.

This book was conceived, designed,
and produced by The Ilex Press Limited,
210 High Street, Lewes, BN7 2NS, UK

Library of Congress Control Number:
2010920651

ISBN: 978-0-8174-3968-2

Printed in China
Color Origination by Ivy Press Reprographics

First American Edition

10 9 8 7 6 5 4 3 2 1

CONTENTS

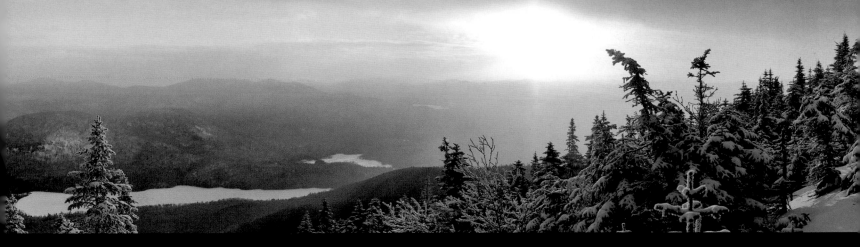

As a child, I enjoyed playing around with a box camera, but didn't have a clue that I would grow up to harbor a deep passion for photography. This passion was born when I moved to the Adirondack Mountains of upstate New York in 1973 and fell in love with the wildness of the remote, snow-covered mountaintops. At that time I made the decision to start taking pictures that would not only capture a sense of the place, but also the feelings of what it was like to be there.

Several months later I bought a used Minolta SRT 101 with a 50 mm lens, and some Kodachrome 64 slide film, and headed off into the mountains to photograph the amazing diversity of nature. I gradually expanded my collection of lenses and filters, bought a tripod, and began my study of landscape photography; learning about the nuances of weather, natural light, and composition. The equipment served me well for several years of exploring in the mountains and provided a great introduction to photography.

I started thinking about moving to digital capture in the early 1990s when the new technology began to appear regularly in photo magazines. Photography was becoming a greater part of my livelihood, but after looking at the options and comparing them to the potential of digital imaging, I decided to wait. Although I was anxious to make the switch to digital, I wasn't satisfied that the relatively early camera files equalled the digital scans I could get from fine-grained 35 mm film. Indeed, it wasn't until the spring of 2007 that I bought my first digital SLR; a Nikon D200. Here, at last, was a camera that gave me more flexibility than a 35 mm SLR and provided me with better image detail than my favorite Velvia 100 film.

The change was revolutionary. Through my years of photography experience, changes in equipment and techniques have produced marked differences in my photography—working with a new lens, learning about hyperfocal settings, and experimenting with different filters all had significant benefits. But the move from film to digital eclipsed everything that had come before. Now, if I can imagine an image, I can create it.

While the switch from analog to digital capture is often a challenge, most of the basic photography techniques and principles are as true today as they were when photographers used glass plates. The physical principles of lenses have not changed, the rules of composition are the same, and landscape photography is still all about light. However, to excel at landscape work, you have to realize that it is not just about being in the right place at the right time. It's also about knowing what makes the right conditions occur, and understanding the mechanics of photography enough to be able to capture the detail and nuances of light at the best possible moment.

Most important, though, is to just go out and play. There is always something that can be photographed, and always a way to make it appear unique and special in whatever light you have. Dewitt Jones' philosophy is "believing is seeing"—you need to believe in yourself, your abilities, and your imagination before you can see the unique imagery that is there. With digital camera technology, if you can believe it is possible, you will see it. And if you can see it, you can capture and create it.

Carl E. Heilman II

1:
EQUIPMENT & TECHNIQUES

Today's high-tech digital cameras have so many features that they can do almost everything except compose an image for you. All of the technological improvements in metering, focusing, and processing make capturing a high-quality image more efficient than it has ever been, but with this sophistication comes complication. Camera manuals now contain staggering amounts of information that can make it hard to understand the built-in features, or, more specifically, the features you actually need. Digital cameras may have the capability to capture images like never before, but if a person doesn't understand the basic principles involved, obtaining a quality photograph will still be hit-or-miss.

However, despite today's digital cameras being so advanced, most of the creative photography techniques found in this book are based solely on working with adjustments in the size of the aperture and the choice of shutter speed. Having complete control of the photographic process depends on understanding the principles involved in these two features, the interplay between them, and how their dynamics change when using different focal length lenses. Being able to apply these principles when using the additional automated features found in today's high-tech cameras will help you create high-quality photographs by choice instead of by chance.

IMAGE FORMATS & CAMERA DESIGNS

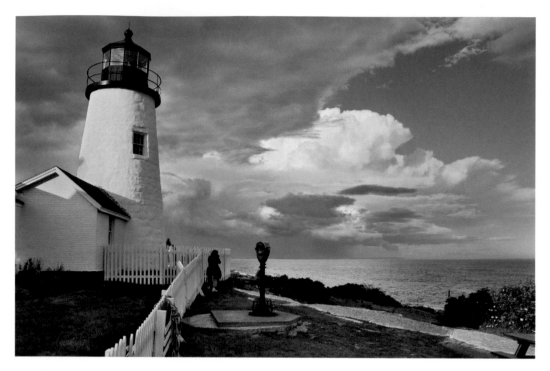

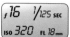

Pemaquid Point Lighthouse,
Bristol, ME

Digital imaging has numerous advantages over film. Total flexibility over the ISO sensitivity, Live View, image enhancement features, instant gratification, a shortened learning curve, and the freedom to experiment without the cost constraints are just a few of the benefits you can enjoy. At the same time, there are plenty of digital camera choices that let photographers approach landscape photography in a way that best suits their own style. Typically, the best quality sensors and greatest variety of technical options are found in the most recent, higher-priced models (especially those that feature full-frame sensors), but technology is always trickling down from top-of-the-line professional cameras to the consumer models and, as you will see, the smaller format sensors are excellent for photographers who are serious about landscapes.

There are several image formats that can be used for digital landscapes, ranging from large format (4 x 5 inch) down to the "designed for digital" Four Thirds standard. While numerous point-and-shoot cameras offer many comparable control options in a small package, they lack one of the more important camera features for landscape photography—interchangeable lenses—and many don't offer really wide-angle focal lengths. Also, the small sensors in point-and-shoot cameras cannot capture the same dynamic range and detail found in images taken on cameras with larger sensors.

The different formats are integrated into three basic digital camera designs: digital SLR (single lens reflex) cameras, rangefinder cameras (where the viewfinder is offset from the lens), and view cameras (traditional bellows-type cameras). The

most popular camera style by far—and the one I will focus on in this book—is the digital SLR. A major advantage of an SLR camera is that the image coming through the lens is reflected onto a mirror and into the pentaprism of the viewfinder so the photographer views the scene as the camera sees it. Digital SLRs also have a wide array of interchangeable lenses, making them a portable, lightweight, and very versatile design.

While they are just as portable as digital SLRs, rangefinder cameras have one significant drawback—the viewfinder is offset from the camera lens. This means it only approximates the same field of view the lens is seeing, and the greatest disadvantage of this rangefinder viewing system for landscape photography is parallax. When focusing at a distance this isn't necessarily a problem, but when you are working with elements that are close to the lens, the parallax effect can be significant, and the viewfinder composition will not always be an exact match to what the lens is seeing.

Finally, there are the view cameras—traditional, bellows-type, large format cameras that were once incredibly popular with landscape photographers looking to achieve the highest quality results on film. As well as working with physically large film that delivers ultra fine-grained results, these cameras feature tilt and shift perspective controls that offer additional creative options when it comes to composing landscape photographs and controlling depth of field. Several manufacturers make digital backs for this type of camera, but the cost is often prohibitively expensive.

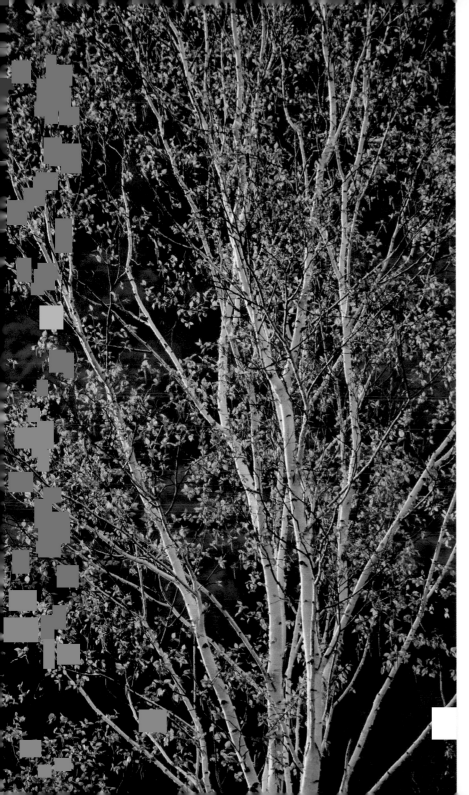

VIEW CAMERA

Large format view cameras were incredibly popular with landscape photographers looking to produce the highest quality images on film.

DIGITAL SLR CAMERA

The digital SLR is now the most popular, and versatile, camera for landscape photography, especially smaller format cameras in a traditional 35 mm SLR style.

f8 1/160 sec ISO 400 FL 400mm

Taken with a 400 mm telephoto lens.
Adirondack Park, NY

IMAGE SENSORS

The heart of a digital SLR is its sensor, and a variety of formats are available. The most popular and affordable cameras use sensors that range in size from full frame, 24 x 36 mm, sensors through APS-sized sensors (based around a 16.7 x 25 mm sensor size), to the Four Thirds standard that has a sensor measuring 21.63 mm across the diagonal. A recent addition to the Four Thirds specification is Micro Four Thirds, which uses the same sensor size, but replaces the pentaprism viewing system of an SLR with an electronic viewfinder and/or Live View LCD screen for viewing the image being photographed. This allows Micro Four Thirds cameras to be made physically smaller, while retaining the image quality of the Four Thirds sensor.

With current sensor and lens technology, some people would argue that a sharp, 12-megapixel digital image shot on a full-frame sensor has the same detail in an enlarged print as traditional medium format film. With this kind of quality available, choosing equipment has more to do with how you like to photograph than it does with the camera you are using.

The number of pixels, however, is not the only consideration. The size of the pixels (or, more accurately, the size of the photosites on the sensor that generates the pixel), also plays an important part in determining image quality. Pixel size, or pixel "pitch," is measured in microns and is determined by two things—the surface area of the sensor and the number of pixels on it. The greater the pixel pitch, the higher the photon capacity of each individual photosite, and higher photon capacity means a broader dynamic range (the range of stops from light to dark that can be recorded), and a higher signal-to-noise ratio (which reduces the amount of non-image-forming noise in the final image).

Before the advent of digital imaging I shot 35 mm Kodachrome and Fuji Velvia for decades, both widely regarded as the highest quality 35 mm films. Now, I work with APS format digital SLR cameras. Although not full-frame, I can still produce large, 24 x 36 inch (60 x 90 cm) prints from 12 megapixel Raw files for exhibitions and print sales—the same print sizes I would make from film. These are printed from 200 ppi (pixels per inch) files, rather than the more common 300 ppi files, but still exhibit excellent sharpness, clarity, and detail, even when viewed only inches away from the print.

SENSOR
The sensor in your camera is the "heart" of a digital SLR. Although resolution is often seen as the measure of quality, the pixel pitch is just as important, perhaps more so.

f20 1/13 sec ISO 400 FL 18mm

Pixels are the basic building blocks of a digital image, and the more pixels you have, the larger you can print or display your images without them appearing "jagged" or pixellated. However, other factors also affect image quality, such as the size of the pixels.
Acadia National Park, ME

KEY CAMERA FEATURES & SHOOTING OPTIONS

Considering all the "bells and whistles" on today's digital cameras, it's easy to get caught up in the technology and forget about the real issue— capturing the wonders of nature. There are so many shooting options on even a basic digital SLR that it's hard to keep pace with all the features and changes, but there are a number of specific camera and shooting features that are especially useful for landscape photography. The more comfortable you become with these settings and shooting options, the easier it will be to let your creativity flow, and the better your images will become.

WEATHERPROOF CONSTRUCTION

Weatherproof construction is a big plus for digital SLRs used for landscape photography. While these camera bodies aren't completely waterproof, weather-resistance definitely helps protect your camera in damp, showery, or rainy conditions. In general, moisture and electronics don't go well together, so it's essential to keep all equipment shielded from the rain. Moisture in a camera can kill the electronics, and moisture in a lens can cause a mold growth that can render a lens useless, so dry them off frequently, and give your kit a chance to dry completely—inside and out— once you are indoors, out of the rain.

ULTRASONIC SENSOR CLEANING

Ultrasonic sensor cleaning has been a great bonus for digital photography and eliminates most of the time you would otherwise spend "dusting" photographs in an image-editing program. I have my camera set to perform a cleaning cycle each time I turn it on. It's still a good idea to thoroughly check your images for dust spots, but checking is often all that needs to be done. The built-in cleaning also cuts down on the number of times the camera's sensor needs to be physically cleaned. This reduces the risk of accidental damage if you attempt to clean it yourself, or reduces the cost involved in having someone clean it for you.

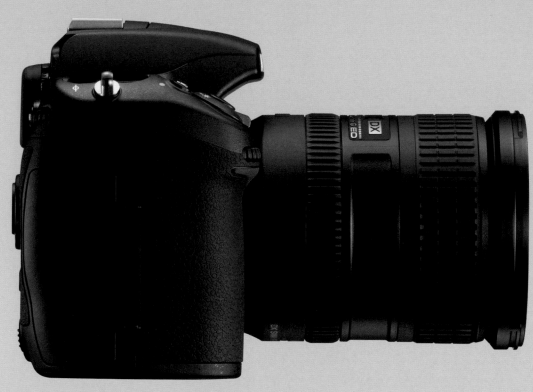

VIEWFINDER

A **viewfinder with 100% coverage** of the image is a big advantage for composition. Being able to see the entire area of a potential photograph helps show up vignetting issues, stray twigs, or leaves at the edge of a photograph, and lets you frame the final image precisely.

DEPTH OF FIELD PREVIEW

I use my **depth of field preview** button for landscape photography pretty regularly. While this darkens the viewfinder image at smaller aperture sizes, if you let your eye get accustomed to the darker image you can physically check the depth of field in the image at the aperture setting that the camera will be shooting at, rather than at the widest aperture setting that is normally seen through the viewfinder. However, the best way to be certain about the depth of field is to take the shot, and then zoom into it on the LCD screen. Check the sharpness of the nearest and farthest detail to see if any adjustment needs to be made to the aperture or hyperfocal focus setting.

REMOTE TERMINAL

It is essential to have a **remote terminal** on the camera body to be able to connect optional camera equipment. Most important is being able to connect a **remote cable release** to trigger the shutter on long exposures without touching the camera, which will help eliminate camera shake.

LCD MONITOR

Larger is definitely better when it comes to the camera's rear **LCD monitor**, as it makes for easier viewing of the image and menu items. An **articulating monitor** that can swing away from the camera back is even better as it opens up more options for composing images from different angles.

LIVE VIEW

Live View is a great feature that lets you compose an image using the camera's rear LCD screen, instead of the viewfinder. Live View offers options for composition that couldn't be done as accurately otherwise, and having an articulating monitor to use in combination with Live View is especially helpful for composition when the camera is placed at an odd angle, such as very close to the ground, over your head, or out over the edge of a cliff. Perhaps the best example of working with Live View was when I placed my camera and tripod on the edge of some thin ice that could hold their weight, but not mine. I adjusted the composition by moving the tripod and watching the Live View on the LCD, before triggering the shot with a remote release.

MIRROR LOCK-UP

Mirror lock-up is an important feature to have when working with macro or telephoto lenses. When using the camera on a tripod, and working with exposure times of about 1/80 sec or longer, there is a good chance there will be some very slight camera shake that will occur from the mirror swinging out of the way just before the shutter opens. Using mirror lock-up eliminates this issue by making each exposure a two step process. Pressing the shutter release once will swing the mirror up and, after a pause of a second or two, you can press the trigger again to open the shutter and make the exposure. The mirror will then drop back into place after the shot is taken.

While video is not a still-photography essential, having an **HD video and sound recording capability** offers another way to expand your creativity and capture the feel of the landscape you are working in. There have been many times I would have loved to shoot some video of what I was seeing, and that possibility— along with stereo sound—is now a reality with some digital SLR models.

SHOOTING MODES

Aperture priority, shutter priority, and *manual* are the only shooting modes I use for landscape photography. While cameras have other, preprogrammed modes, these simply adjust the aperture and shutter settings to optimize depth of field or exposure time and it is much better to take control of this for yourself. The manual mode should also have a "*Bulb*" setting, so you can make exposures longer than the maximum automatic exposure duration (usually 30 seconds) on the camera.

EXPOSURE COMPENSATION

Exposure compensation and *exposure bracketing* are features I use almost all of the time. Exposure compensation is a manual adjustment for over- or underexposing a scene, which can be used to fine-tune a single exposure or manually create a set of bracketed exposures for an HDR sequence.

Automatic exposure bracketing should be used any time there could be issues with how the camera is reading the light, or whenever the histogram shows that the dynamic range of the scene exceeds that of the sensor. With bracketing activated, additional photos of the same scene are shot at overexposed and underexposed settings, creating a sequence of images for HDR work, or simply allowing you to record the best exposure.

CAMERA MENU SET-UP

There are seemingly endless ways to customize and personalize most digital SLR cameras, and while the menus are pretty intuitive, they can vary considerably—even between different camera models from the same manufacturer. While camera manuals typically cover details of all the available features, only a select few of them are pertinent to shooting landscapes specifically. The following options, reached after years of practice in the field, will help you obtain the highest quality files for outdoor photography. While they might not be available on all camera models, they are good features to look for when considering new equipment for landscape photography.

Shooting Menu Options

There are usually several choices for the image *file format*—typically Raw, plus a number of different sizes and quality levels of JPEG. Shooting Raw files is always recommended, as these files contain all the image information that was recorded by the sensor. Raw files can be 12-, 14-, or 16-bit files, depending on the camera, while JPEG files are only ever 8-bit and are compressed at different quality levels.

A bit is a single unit of data, and a camera's bit depth tells how many tonal values there are for each color channel (red, green, and blue). An 8-bit image file has 2^8 "bits" of information per channel, (256 tonal values), whereas a 12-bit file has 2^{12} bits (4096 tonal values). It follows that a 14-bit file (2^{14}) has 16,384 bits per channel, and a 16 bit file (2^{16}) has 65,536. Remember, this is per color channel, and as a color image is produced using three color channels, the actual number of possible colors is multiplied to the power of three, so there are 16.7 million colors in an 8-bit image, and 281 trillion colors in a 16-bit image.

While the math produces some impressive numbers, bit depth takes on real meaning when you are trying to enhance areas of a photograph in an image-editing program. The sky in particular has very subtle transitions between tonal values, and with only 256 tonal values per channel in a JPEG file—and perhaps only several tonal values recorded in the color of the sky—it only needs a minor adjustment in contrast or color to separate these color tones and cause posterization (also referred to as "banding"), which is seen as a distinct tonal jump between color tones. For that single reason, I always recommend shooting Raw so you are starting with the maximum amount of image information. Working in Raw does require post-processing work, but half the fun—and skill—in creating an image is being able to interpret it later in an image-editing program. Not to change it dramatically, but to re-create the full vision you had when taking the photograph.

Choosing a **color space** in the camera only affects JPEG files, as the color space for a Raw image is determined when the file is processed using Raw conversion software. The two color spaces common to almost all digital SLR cameras are Adobe RGB and sRGB. Adobe RGB has a larger color gamut, so is the best choice if you anticipate any image-editing work, while sRGB is the better choice for JPEGs that you don't want to edit as the reduced color gamut is compatible with the web, computer monitors, and printers.

JPEG

JPEG files are processed in-camera, which is ideal if you want to print them straight from your media card. Compared to Raw files, they tend to exhibit greater contrast and sharpness, but as they are 8-bit images, the range of tonal values is limited to 256 levels per color channel, or 16.7 million colors in total.

RAW

Raw files contain the data recorded by the sensor, without in-camera processing. Although they often look noisier, softer, and flatter in terms of contrast when they come out of the camera, their higher bit-depth (commonly 12-bit or 14-bit) means there is a far greater range of tones that can be drawn out and enhanced during post-production.

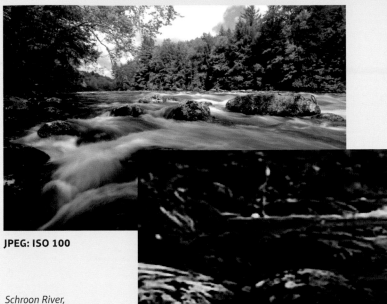

JPEG: ISO 100

*Schroon River,
Adirondack Park, NY*

JPEG: ISO 100 @ 400%

JPEG: ISO 6400

JPEG: ISO 6400 @ 400%

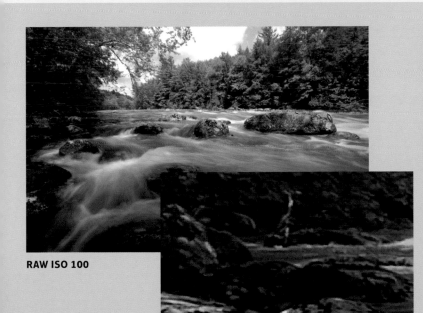

RAW ISO 100

RAW: ISO 100 @ 400%

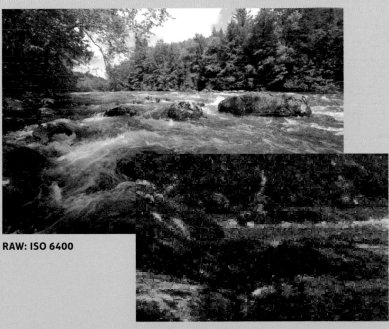

RAW: ISO 6400

RAW: ISO 6400 @ 400%

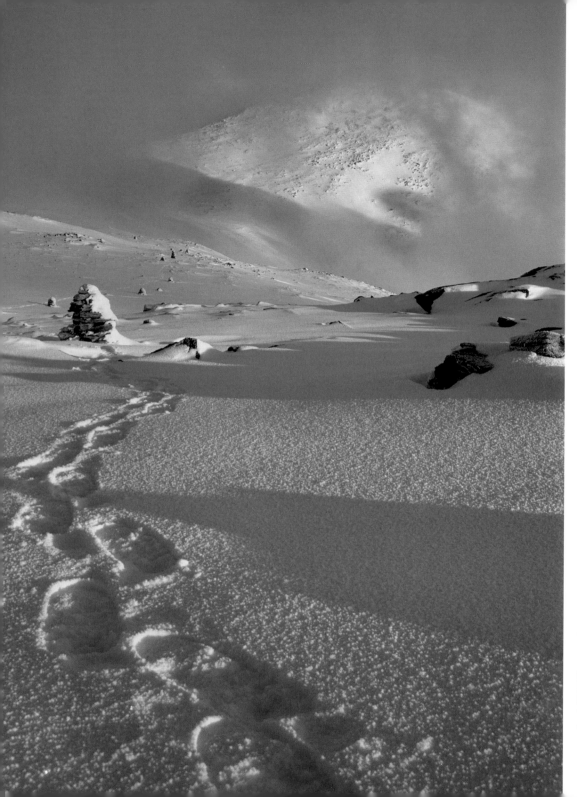

White balance is another setting that does not affect Raw files (it is again determined at the Raw conversion stage), so I tend to keep the white balance set to Auto. With my camera, I have found it offers a reasonably natural rendition of light in conditions ranging from bright sun to nighttime, and from morning fog to dark, ominous storms. White balance bracketing is an option when shooting JPEGs, and if you intend to work with JPEG files that are processed in-camera, then the only real option is to experiment.

Highlights enhancement is a feature found on some digital SLRs (possibly under a different name) that will cause the camera to slightly underexpose an image to hold detail in the highlight areas, and then enhance detail in the shadows to increase the overall dynamic range. Boosting shadows has a tendency to accentuate noise in the shadows and midtones, so this process might be better done in an image-editing program.

I like to turn both **high ISO noise reduction (NR)** and **long exposure NR** on to their highest levels for the cleanest images. While high ISO NR doesn't require any additional processing time, the processing time for long exposure NR will be as long as the actual exposure time with exposures of about 1 second or longer. So, a 30-second long exposure would require an additional 30 seconds for the noise reduction process before another image can be shot. If the battery dies during shooting or processing, the image is lost.

f 16 1/125 sec
ISO 100 FL 24 mm

Shooting in Raw lets you set the white balance at the conversion stage, as well as enabling you to fine-tune exposures taken under challenging conditions. *White Mountain National Forest, NH*

HIGHLIGHTS ALERT 3/4

Highlights
105ND300 _NB14651.NEF ⬆ RAW
09/19/2008 06:56:18 4288x2848

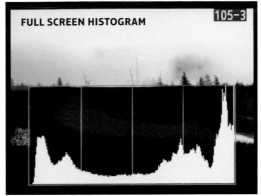

FULL SCREEN HISTOGRAM 105-3

If you have the **continuous shooting** feature on and hold down the shutter release with your camera's exposure bracketing activated, the camera will expose a full set of bracketed images, then stop—perfect for shooting exposure sequences for HDR. This continuous shooting feature can also be turned on for Live View mode and I'll use it much of the time while I'm shooting. I only do single shot bracketing when I am worried about camera shake, or when I need to trigger the shutter at a precise moment. I also like to set the **maximum continuous release** to as high a number as possible so I'm not limited by shooting constraints.

Finally, for **metering, exposure,** and **ISO values** there is an option to use ½-stop or ⅓-stop increments. While settings can be changed more quickly with ½-stop adjustments, it is easier to fine-tune exposures with the ⅓-stop setting, especially when shooting JPEG files. When shooting Raw, there is so much latitude for adjustment at the file conversion stage that the choice becomes a personal preference.

Playback Menu

One of the greatest advantages of working with a digital camera is being able to check the images in the field immediately after taking them. While I remember the anticipation of sending out a roll of film, and the thrill of seeing that I managed to do everything right for a particularly unique shot, I also remember a bit of disappointment at times as well. Being able to view images instantaneously opens up the option of fine tuning exposures, to be sure the camera has captured all of the information needed for that photograph. Rather than thinking of photography as "taking a photo," I now look at it as recording information. The composition matters, of course, but just as important is having all of the information needed to re-create the full dynamic range of tonal values found in a scene.

Image Check

There are three steps that I go through to check most of the images I shoot. The first is to quickly check an image using the **highlights alert.** With this feature turned on, overexposed highlights flash when an image is played back, and at a glance you can tell whether there are any blown-out highlights.

The second check is to take a look at the histogram—and larger is definitely better for the histogram size. A **full-screen histogram** is an available option on some camera models, and this very simple check makes sure you have recorded the full tonal information of the image in one exposure, or a multiple bracketed exposure sequence.

The third check is to use the playback **zoom** feature to check depth of field and sharpness in the picture. I typically zoom in the whole way (which takes me to the pixel level), then zoom out one step. At this magnification level everything will have a slight softness to it, but comparing the detail in an object in the background to detail in the foreground—and then both of them to detail in the mid-focus range—will show the relative sharpness of one plane of focus to another and whether any changes need to be made to the camera or focus settings.

LENSES

Today's computer-designed lenses provide many options for creative landscape photography, but deciding what lens(es) to use depends a lot on your own style, and the type of images that appeal to you most. I especially enjoy working with wide view landscapes, but also like to photograph details, wildlife, and close-ups, as well as adding a human element into my photos on occasion. If I'm heading off for a trek in the mountains I tend to travel lighter, and work with a 10-20 mm zoom and an 18-200 mm zoom, plus maybe a 10.5 mm fisheye or a macro lens. However, if I'm not hiking far, I would take some additional optics along, including fixed focal length wide-angle lenses, a 35-70 mm zoom, 105 mm macro lens, 70-200 mm zoom, plus a 2x teleconverter and some extension tubes. Generally, I use wide-angle lenses for "telling the whole story" when I'm working with a broad scene, while telephoto and macro lenses are all about the detail within the larger picture.

The most basic lens for any camera system is a "standard" lens that has an angle of view of about 45 degrees—an area similar to the main focus area of the human eye. The focal length of a standard lens is based on the diagonal of the image area, so changes for each different sensor size. On a full-frame sensor, for example, the standard focal length is 43 mm (although 50 mm has become the accepted standard), while a focal length of 25 mm is considered the standard on a Four Thirds format camera.

This series of photographs—all taken from the same location—shows how the focal length of your lens can change the image you take, from an ultra-wide 15 mm focal length to a super-telephoto 600 mm. *Brant Lake, Adirondack Park, NY*

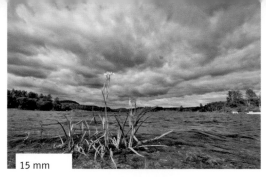

15 mm

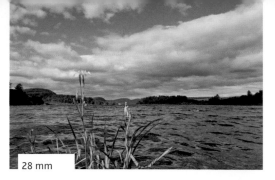

28 mm

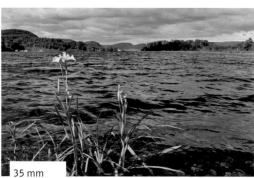

35 mm

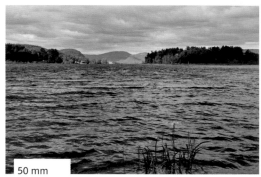

50 mm

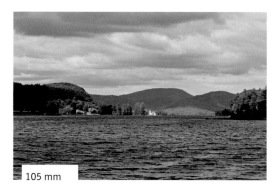

105 mm

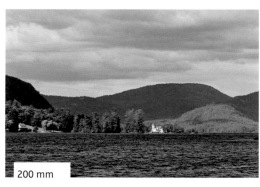

200 mm

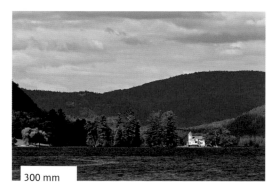

300 mm

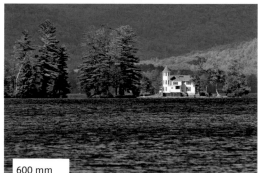

600 mm

Focal Length and Sensor Size

The angle of view of a specific focal length lens is always the same, but the usable field of view is affected by the size of the sensor. As a result, a conversion factor is often used so photographers can compare the focal length of a lens designed for one sensor size with the focal length lens required to provide the same field of view on a full-frame sensor. APS-format sensors have conversion factors of 1.3x to 1.7x depending on the camera model, while the conversion factor for Four Thirds-sized sensors is precisely 2x.

In landscape photography, the most common application of the conversion factor is trying to figure out what lens is needed to get the same result as the wide-angle lenses that were used with film SLRs. For example, with a digital SLR that has an APS-sized sensor (and a conversion factor of 1.5x) I need a 16 mm lens to equal the field of view of my full-frame 24 mm lens (24/1.5), and 13.5 mm to equal a 20 mm lens (20/1.5).

With telephoto focal lengths I benefit from the crop factor as the 1.5x conversion means my 70-200 mm zoom effectively becomes a 105-300 mm zoom.

BELOW Although these images were taken from the same viewpoint, using the same focal length lens, the size of the sensor in the camera means they look very different. *Adirondack Park, NY*

20 mm focal length and Full Frame sensor

20 mm focal length and APS-C sized sensor

20 mm focal length and Four Thirds sensor

Lens Speed

As well as the focal length, the "speed" of a lens also needs to be considered. In this context, speed refers to the amount of light passing through the lens. Each lens contains a mechanical aperture to vary the amount of light traveling through it, and lenses with a maximum aperture opening of f/2.8 or larger (smaller numbers) are considered fast lenses, while slower lenses have a maximum aperture of f/3.5, f/4, or f/5.6. Faster lenses are better for recording images in low-light situations, and for landscapes it's good to have fast, f/2.8 lenses for precisely this reason.

With a maximum aperture of f/1.4, this Canon 24 mm wide-angle lens is ideal for working in low-light situations, or for creating images with a shallow depth of field.

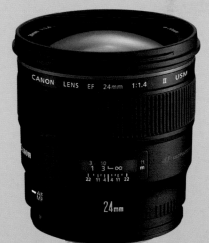

23

Lens Options

After focal length and speed, a further consideration is whether to choose a prime (fixed focal length) lens, or a zoom (variable focal length) lens. There are strong arguments for both. Prime lenses are generally faster than zooms, for example, and it is also easier to optimize the image quality in a single focal length than it is to correct distortions and aberrations across a range of focal lengths in a zoom lens.

However, a single zoom lens can offer up to 15x focal length coverage (an 18-270 mm zoom, for example), which provides incredible flexibility in one lens, not to mention portability. While the quality might be slightly compromised, for many people it will go unnoticed most of the time.

Zooms can be built with an internal or external focus and zoom action—a significant, but often overlooked factor. On lenses with internal focus and/or zoom mechanisms the lens doesn't physically change length as either one of these is adjusted, yet an external zoom can double, or even treble in length as it is zoomed out to its longest focal length. There is also a greater chance for moisture and dust to be drawn into an externally zooming lens, and these designs can also suffer from "lens creep," a phenomenon where the weight of the lens combines with gravity to extend the lens (which changes the focal length) when the lens is pointed toward the ground. However, lenses with an external zoom action are often less expensive to buy.

ZOOM VERSUS PRIME
In the most basic sense, zoom lenses are more versatile than prime lenses. However, the more complex zoom design requires compromises that can affect image quality, and the greater the range of focal lengths covered in a zoom lens, the greater the compromises.

Image Stabilization

Image Stabilization and Vibration Reduction are two of the common names used for a technology that increases lens stability when hand-holding a lens. In general, APS and larger formats typically have the stabilizing features built in to the lens, while Four Thirds cameras rely on sensor-based stabilization that is not lens specific. Stabilization in a lens is claimed to offer a 2–5 stop advantage for shooting, depending on the lens or the stabilization system, which means you can use slower shutter speeds that would usually mean a risk of camera shake. This opens up options for hand-holding photographs that weren't possible before, and while I always recommend using a tripod as much as possible, there are images with wildlife, people, and scenics where you may need to shoot handheld to "catch the moment."

A general recommendation for hand-holding a camera is to shoot with a shutter speed at least as fast as the reciprocal of the focal length being used. For example, when using a 150 mm focal length the shutter speed should be at least 1/150 sec to hand-hold the camera and lens for an acceptably sharp image. Camera and lens stabilization features offer options for shooting hand-held images in lower light situations, but a tripod is still the best way to consistently get sharp images.

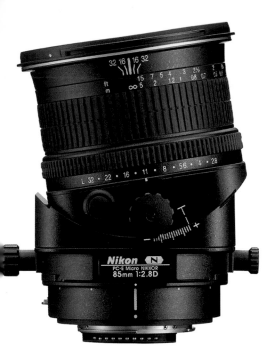

Specialist Lenses

Perspective control—or tilt and shift—lenses allow lens movements that are similar to those used by bellows cameras. The shift movement can be used to reduce wide-angle distortions in landscapes, by straightening the perspective of tall buildings or trees. Alternatively, the tilt movement can be used to maximize (or minimize) depth of field.

A catadioptric (aka reflex or mirror) lens is a type of telephoto lens that uses lenses and curved mirrors for the optics. They are smaller and lighter in weight than comparable refractive focal length lenses, not to mention much cheaper. However, they have a fixed, slow aperture (usually f/8 or f/11), and create lower contrast images.

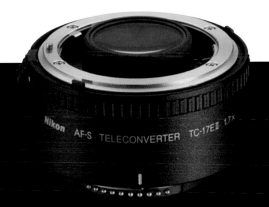

While some stabilization systems are lens-based, others are sensor-based, such as the stabilized sensor in the Olympus E-30 Four Thirds SLR.

Teleconverters

Teleconverters magnify the image coming through the lens, so the lens you are using behaves like a longer focal length. Teleconverters are commonly available offering a 1.4x, 1.7x, or 2x magnification, so a 50 mm standard lens would have an effective focal length of 70 mm with a 1.4x convertor, 85 mm with a 1.7x convertor, or 100 mm with a 2x convertor.

There is a trade-off though, as teleconverters reduce the amount of light reaching the sensor—1 stop of light for a 1.4x convertor, and 2 stops with a 2x convertor. When using a teleconverter, the closest focusing distance of the lens doesn't change, but the depth of field alters according to the working focal length and aperture of the lens with the teleconverter on. For example, a 2x teleconverter on a 50 mm lens at f/5.6 has the depth of field of a 100 mm lens at f/11.

Teleconverters can help keep down both the lens weight and size for landscape photography, and they also cost much less than a new lens. However, it is important to only use a teleconverter with a high quality lens as it will not only magnify the image, but will also magnify any image quality issues of the lens it is used with.

TRIPODS

Tripods are typically considered photo accessories, but for landscape photography a sturdy, versatile tripod is as essential as a good camera and top quality lenses. While a tripod isn't needed for point-and-shoot images on a bright sunny day, it is vital for working with the slower shutter speeds that occur when maximizing depth of field, or working long exposure times. Having your camera on a tripod will slow you down, but don't think of this as a negative—it will encourage you to find the best angle and field of view before shooting.

Tripods come in many different sizes, configurations, and materials, and the most efficient, lightweight models can cost as much as a good lens. The ideal tripod is a balance of features, materials, and weight. The most common (and least expensive) tripods are made from aluminum, but basalt or carbon fiber leg poles are also available, as are magnesium metal fittings, and both will increase the strength of the tripod while reducing the weight. However, this is often at a very high financial cost— aluminum tripods are typically about twice the weight of a similar carbon fiber tripod, but they are also about half the price.

When looking at tripods for landscape photography, choose the lightest one you can afford that will hold your camera and heaviest lens rock solid in a wide variety of positions. Look for one with an articulating center column, independent leg angle movements, and easy-to-use leg locks. The tripod should also adjust easily and efficiently from ground level to above eye level to give the greatest flexibility when it comes to composing an image.

TRIPODS
A tripod is as essential to landscape photography as a good camera and high quality lenses. In general, you get what you pay for, and a well made model can last many years.

Recommended Tripod Features

- A tripod with four leg sections is more compact and easier to attach to a pack, but a tripod with three leg sections will be lighter.

- The tripod legs should be able to spread out parallel to the ground for working at ground level.

- You should be able to move each leg independently of the others, and they should not be attached to the center column.

- Tripod feet should be changeable, so they can be outfitted with rubber feet, spikes, or snow pads.

- Look for moisture- and dust-resistant leg locks.

- It's tough to work between and around the tripod legs, so look for a tripod that goes low to the ground, rather than one with a reversible center column.

- The option to use the center column vertically or horizontally offers more flexibility when it comes to composing shots.

- A built-in bubble level can be useful for leveling the tripod for general shots and panoramic work.

- In windy conditions, a hook on the end of the center column can be used to hang a weighted bag to increase tripod stability.

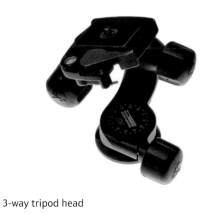

3-way tripod head

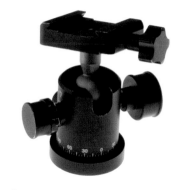

Ballhead

"L" Bracket tripod head

Tripod Heads

Many tripods come without a tripod head, allowing you to choose the one that suits you best. The head should adjust easily, hold the camera securely, and rotate and lock smoothly in both horizontal and vertical positions. While a 3-way panning model has the flexibility needed, a well-designed ballhead is just as flexible, and is easier to adjust and lock. I like using an offset ballhead design that combines movements of both the 3-way and standard ballhead designs.

The mounting plate on a tripod head will be either a manual mount or one of the many quick-release systems. If choosing a quick-release model, select a standard design that will work with a wide variety of equipment. An "L" bracket is a mounting option for the camera that is designed for use with quick release plates. It can be changed quickly from a horizontal to vertical position while keeping the same point of reference for the camera. While an image still generally needs to be adjusted somewhat after changing orientation, this can help speed up the transition.

Recommended Tripod Head Features

- Having the option of a ¼-inch or ⅜-inch threaded bolt on the tripod allows the use of a wider range of tripod heads.

- Well-designed ballheads and offset ballheads offer the best options for landscape photography.

- Choose tripod heads with a larger diameter ball for smoother movements when using heavier cameras and lenses.

- Pistol-grip or joystick style tripod heads add height, and make it harder to work close to the ground.

- A marked 360 degree panning base is useful when shooting a sequence of images for a stitched panoramic photo.

- When the base of a tripod head is level, the camera should be able to tilt better than 90 degrees vertically.

- Standardized quick release plates can make it easier for swapping equipment—and they often have locking features to keep the camera in place on the head.

Tripod Tips

- Extend the lowest tripod legs first to help keep leg locking nuts clean and out of the dirt or sand.

- If used in saltwater, rinse the tripod thoroughly in freshwater after use.

- Remember to turn off the lens and/ or camera stabilization features when the camera is on a tripod.

- For the sharpest images, use the camera's mirror lock-up feature for macro and telephoto work.

FILTERS

Although many filter effects can be reproduced digitally on a computer (and easily masked to affect only specific areas), working with filters in the field offers certain creative options. Filters can be either a screw-on style that fits specific lens diameters, or a filter holder design that uses adaptor rings to fit different diameter lenses. Most filters are available made from either glass or resin, but although they are cheaper I don't recommend resin filters for landscapes as there can be color quality issues, and they scratch more easily than glass.

Skylight, haze, and UV filters all reduce UV rays, but they are most often used as additional protection for the front lens element and kept on the lens all the time; I have a UV filter on the front of all of my lenses as it's cheaper to replace a scratched filter than it is to replace or repair a damaged lens. The only issue that might come from having a UV filter fitted all the time is when you want to add an additional filter onto a wide-angle lens—the extra distance from the lens can mean the additional filter will vignette the corners of the photograph. When you are using a wide-angle lens, remove your UV filter first, or choose thin profile filters specially designed for use with ultra wide-angle lenses.

Graduated neutral density (ND) filters are dark at the top, graduating to transparent at the bottom. The dark, neutral-colored coating at the top reduces the amount of light coming into the camera, to help balance extremes of light in the image. They are most often used to help balance the contrast between a bright sky and a darker foreground. It is important to use graduated ND filters with a filter holder system so the filter can be rotated and adjusted to selectively affect

specific areas of an image. Screw-on ND filters are not appropriate for landscape photography.

Graduated ND filters are available with either a soft or hard gradation, and the strength of the filter can range from 1–5 stops light reduction. The filters can be combined, or used on their own, and I would suggest investing in a 1-stop hard ND filter and a 2-stop soft ND filter to start with.

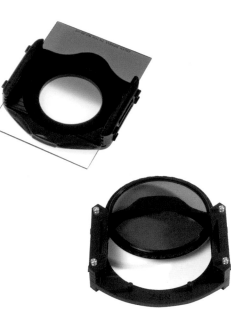

TOP: **GRADUATED ND FILTERS**
Most often used to balance a bright sky with a darker ground, graduated ND filters should be used with a filter holder system.

ABOVE: **POLARIZING FILTER**
It's impossible to recreate all of a polarizing filter's effect digitally, making it an essential filter for landscape photographers.

Polarizing Filters
Polarizing filters are used to reduce reflected light from any surface, including water, vegetation, and glass. A polarizer will also intensify blue skies, which increases the contrast with any clouds, and it cuts down on haze, while enhancing the color tones of vegetation in sunlight or soft light. While many of these polarizing effects can be recreated digitally, it's not possible to reproduce all the effects of the filter in an image-editing program, making it an essential filter for landscape work.

Linear and circular polarizing filters are available, but a circular polarizer must be used for digital cameras so the autofocus and exposure metering features function properly. Polarizers are most effective when used at 90 degrees to the light source, and rotating the filter adjusts the intensity of the polarizing effect on any reflected light in the image. At its most intense, a polarizing filter will reduce the amount of light coming through the lens by 1–2 stops, depending on the filter.

Other Filters
In addition to the landscape essentials are filters for black and white photography and a host of "creative" filters such as starbursts, soft-focus, and fog effects. However, while working with filters can be both fun and helpful, the longer I've been doing digital landscape photography, the fewer filters I use. I now rarely use any filter other than a polarizer. Instead, I look to get as much "pure" information as possible when I capture the image, and then process it in my image-editing software, applying filter effects that portray the mood I felt when I shot the image.

ƒ13 1/80 sec
ISO 250 FL 18mm

TOP: Without polarizer. *Brant Lake, Adirondack Park, NY*

ƒ13 1/320 sec
ISO 250 FL 18mm

BELOW: With polarizer *Brant Lake, Adirondack Park, NY*

ACCESSORIES

Remote Release

In addition to your camera, lens, and tripod, there is a wide range of accessories for your digital SLR that will prove very useful for landscape photography, starting with a remote shutter release. While a camera's self-timer can be used for initiating long exposures when the camera is on a tripod—and it does eliminate the camera shake that comes from pushing the shutter release by hand—a remote release offers spontaneity for shooting at the precise moment desired, and may also have a lock for shooting long, manual exposures. It is best to use the remote release in conjunction with the mirror lock-up feature on a camera, and this is essential for sharp images when doing macro or telephoto work with exposures longer than 1/60 sec.

In terms of what you should look for, the ideal release should have both a trigger and a lock feature. More technical ones may offer a long exposure timer, a multiple exposure feature, an interval timer with an exposure counter, and a self-timer. I often use a remote release with Live View to shoot from angles and locations I couldn't otherwise get to.

Camera Accessories

Additional items that can be handy to have in a camera bag include extension tubes for macro work (when a macro lens is too bulky, or you simply don't own one), a hood loupe to help view the LCD screen in bright conditions, and a right angle viewer that makes it easier to see through the camera's viewfinder when you're working at ground level. I also make sure I pack a good air blower to remove dust from the lens, mirror, or

sensor, a windproof umbrella for weather protection, and / or a camera rain cover for the camera and lens. I might also take portable reflectors that can be used to throw light onto foreground detail, in which case a clamp of some sort is indispensable for holding it at a specific angle. Clamps are also useful for holding an umbrella over your camera when it's raining, and a whole range of other purposes.

Finally, a handheld lightmeter is great for metering specific lighting situations, and a good meter will let you read incident light, reflected light, and also feature a spotmeter. I'll use a handheld lightmeter when I need to assess various points over a large area, such as a wide panorama where I'll be shooting multiple shots to create a stitched panorama.

REMOTE RELEASE
A remote release means you don't have to physically touch your camera when you take a shot, reducing the risk of camera shake.

LIGHTMETER
Although in-camera light meters are very sophisticated, it measures reflected light, whereas a handheld meter also measures the light falling on the subject. This can sometimes be more accurate.

MEMORY CARDS
Although it's tempting to buy one high-capacity card, consider getting several smaller capacity cards instead. That way, if one card fails you won't lose all your images, and can continue using the other cards.

PORTABLE HARD DRIVE
If you're on a once-in-a-lifetime shoot, you want your images to be safe. Even if you've got a laptop with you, consider backing up your files to a portable hard drive as well.

Memory Cards and Hard Drives
As well as the accessories that increase your shooting options out in the field, digital cameras also have demands in terms of file storage. Fortunately, technology keeps finding more efficient ways to put greater amounts of data in smaller spaces, and as hard drives can now hold terabytes of information, and camera media can record tens of gigabytes, it doesn't take much space to hold a lot of image files.

On location, a 16 GB memory card means I can shoot about 1,200–1,300 Raw files, so having just a couple of extra cards along on a trip will cover most all shooting situations. That can eliminate the need for an external hard drive for storage, but it's always good to have a back-up of your files in case a media card fails. When I'm on the road, I use a laptop and portable hard drive, and each evening I'll copy the image files from my media cards, and get my camera batteries charging so they're fresh for the morning. If I have a chance I'll also sort through and cull my images. The basic rule is to make sure you have enough free space on your media cards for the day ahead, and your camera batteries are charged.

LAPTOP
A laptop is ideal for copying your day's photographs off your media cards while you're on the road. You can also check them on a larger screen and edit out any weak shots.

CAMERA PACKS

The choice of camera packs and outdoor gear is directly related to how you plan to photograph and how much equipment needs to be carried. Will a photo excursion require additional hiking gear, or is only camera equipment needed? Will the outing involve canoeing, kayaking, or any activity where equipment could get wet? How accessible does your equipment need to be? All these questions will have an effect on what and how you pack, and it's good to have more than one camera bag so you can adapt to different shooting situations. For example, there are times when it's helpful to bring along everything in your photo shooting arsenal, but, more often than not, you will only need to bring along a custom selection of lenses and equipment to suit the photo conditions you're heading into.

I work with several different styles of camera packs that cover all of the different types of photography I do. The first camera bag I bought was a backpack style designed to hold only my camera gear. Although it works well for storing extra photo equipment at home and for carrying additional gear when I'm traveling, I've never actually used it for a photo trek since there is no room for hiking gear. Instead, the camera pack I use most is a two-section backpack style bag. The top section has space for my hiking gear, and features contoured shoulder straps and a chest strap. This upper rucksack clips onto the bottom section—the camera bag. The camera bag is also contoured, has a mesh covered lumbar padding, a waist belt, and can be used either with the top pack, or independently. An additional strap is included so that when the top section is removed the lower camera section can be used as a shoulder bag, or a belt pack, making it even more versatile.

I typically hand-carry my tripod, but there are straps for securing a tripod onto the camera pack. I have some simple neoprene bags for putting an additional camera body or lens in the top section of the pack if I need to take some extra equipment along. The camera bag also has an all-weather protective cover that can be pulled over the bag for wet weather. I've used this pack all year round for mountain hikes and paddling excursions, and it has held both the camera and hiking gear I've needed for some extreme day-long treks in sub-freezing weather conditions.

Going Ultra-Light

It's not possible to saw the handle off a camera to save weight in the way you can with a toothbrush, so going ultra-light with a camera is a decision in which gear you use.

The smallest format camera I would suggest is a Micro Four Thirds SLR with a pair of lenses—an ultra-wide angle zoom, and a wide-angle to telephoto zoom to cover 18-360 mm focal length equivalents. In addition, pack a remote cable release and a mini carbon fiber tripod.

There are some ultra-light tripods that weigh as little as just over 2 pounds (900g), while a Micro Four Thirds SLR with two zooms will add about 2¼ pounds (1,050g). This gives you a complete camera system that weighs in at less than 4½ pounds (2,050g)—perfect for trekking!

A second pack that I use regularly is a more compact, rectangular shoulder bag. It's large enough for a digital SLR camera body, a couple of zoom lenses, a fisheye lens, a 105 mm macro lens, a handheld panoramic camera, remote releases, filters, and additional small items. It's easy to pick up and carry along when traveling around in a car, and is great for short hikes. I also use a holster style, top-loading shoulder bag for lightweight protection and easy access to a single camera and lens. The most important thing about a camera pack is that it meets your demands.

The pack in this kayak is the two-section bag I use most. All my camera gear fits into the lower section, while my hiking gear sits in the top. *Elk Lake, Adirondack Park, NY*

GETTING TO THE BEST LOCATIONS

Online Research

The internet has become indispensable for my location research, cutting considerable time from the old fashioned methods of phone calls and library research. On my last photography project, for example, I used the web to find tourism guides, travel guides, trail guides, a photography guidebook, maps, park locations and information, general weather conditions, and lodging. I made contacts with local groups to research specific habitats, emailed people to set up photo opportunities, booked tours for specific photos, found ferry schedules and tolls, worked with long range weather forecasts for general timing, and got tide charts—all that without leaving the house! I also made immediate decisions while on the road related to current weather forecasts, satellite views, and Doppler radar loops—again, simply by connecting to the internet.

For location research, Google Earth is a wonderful tool for landscape photographers as you can use the satellite imagery to help visualize potential photo locations anywhere in the world. The on-screen display can be customized in a wide number of ways, but best of all, you can adjust the settings to an angle where you can view a scene as if you were there, looking out to the horizon, and if you turn on the sun mode and adjust the time of day—and year—you can visualize the scene with different shadow effects and determine where the sun rises or sets. In addition to "seeing" your shot before you arrive, the longitude and latitude grid will help pinpoint locations and integrate them with GPS coordinates, while overlays such as the current temperatures, satellite cloud views, and Doppler radar will all help you stay on top of changing weather conditions.

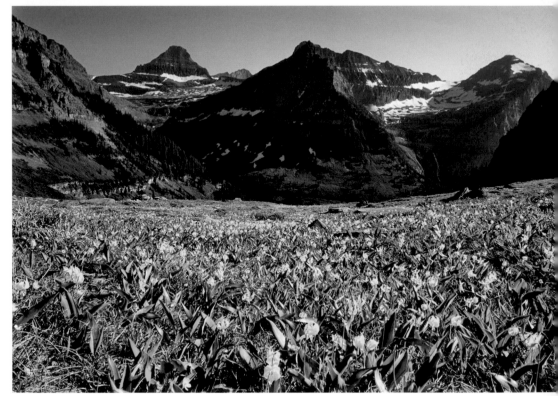

Google Earth makes it easy to scout out a location—and even find a viewpoint—using your computer and the internet. This is the same scene, both "virtually" on Google Earth, and in reality. *Highline Trail, Logan Pass, Glacier National Park, MT*

Metadata is identification and descriptive information that is embedded within a digital file, and it stays with the file through image editing. There are three different metadata file formats—EXIF (Exchangeable Image File), IPTC (International Press Telecommunications Council), and XMP (Extensible Metadata Platform). EXIF data contains shooting information embedded by the camera, such as the camera model, focal length used, shutter speed, aperture, ISO, and so on. EXIF data cannot be edited, unlike IPTC and XMP, which let you add copyright and contact information, rights usage information, keywords and descriptions, and other pertinent details about the image file, such as geotagging data.

GPS Integration and Geotagging

GPS (Global Positioning System) is a satellite-based radio navigation system commonly used by the military, seafarers, drivers, and hikers. It is also a technology that is increasingly being used by photographers—not only to get them to a specific shooting location, but to let them pinpoint where their photos have been taken.

Using in-camera GPS (available on a few camera models) or an optional GPS module such as the one shown below, the precise latitude and longitude where a picture was taken can be added to the EXIF metadata that accompanies the image. This is done either at the time of capture (with in-camera GPS), or when you download your images to your computer. The process, known as "geotagging," means you will always know where an image was taken, even if your library extends to thousands of pictures. This can be very useful for sales through an image library, for example, when someone is looking for a specific location.

Geotagging can also be performed on your computer with specific programs like Microsoft ProPhoto Tools, Maperture for Apple, or even online. Photo-sharing website Flickr lets you drag and drop images onto a map, automatically adding latitude/longitude information, while Picasa lets you add and view your images using Google Earth.

SHUTTER SPEED, APERTURE, ISO & EV

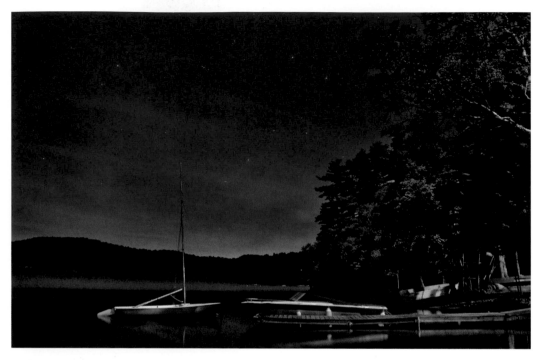

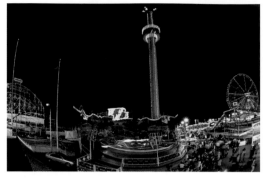

ABOVE: Neon lighting: EV 6. *Astroland, Coney Island, NY*

LEFT: Low moonlight: EV -4. *Fourth Lake Inlet, Adirondack Park, New York*

Landscape photography is all about working with the light to attain the best detail and exposure, and capture the subjective nuances of a scene. Yet most of the photographic variations possible are created using only three basic camera controls—the shutter speed, aperture, and ISO. At its simplest, the shutter speed affects the appearance of objects in motion, the aperture controls the depth of field, and ISO makes the sensor more or less sensitive to light.

Light intensities for photography are measured in Exposure Values, or "EV," and are based on an ISO of 100. An EV of 0 corresponds to the intensity of light needed to properly expose a neutral, 18% gray card using a 1 second exposure and an aperture setting of f/1.0. The intensity of light doubles for each full EV increase.

However, light that is regulated by the camera shutter and lens aperture is measured in stops (or f-stops if referring only to the aperture). Used together, the shutter speed and aperture allow different combinations of exposure times and aperture openings to create a balanced exposure at the same EV. For example, a hazy, sunny day with soft shadows has an EV value of 14. With an ISO speed of 100, a camera's Program mode would probably set a shutter speed of 1/250 sec and an aperture of f/8.

The creative element of exposure is overriding these settings to adjust for subject motion or depth of field. To continue the example, reducing the amount of light coming through the aperture by 3 f-stops (to f/22), while increasing the length of the exposure by 3 stops (to 1/30 sec), would

still properly expose the EV 14 scene, but the depth of field would be maximized due to the f/22 aperture. Alternatively, opening up the aperture by 3 stops (to f/2.8), and decreasing the length of the exsure by 3 stops (to 1/2000 sec) would freeze almost any moving object, but the overall exposure level will be the same.

ISO offers the opportunity to adjust the digital sensor's sensitivity to light, so you can work in a wide variety of lighting situations. Adjusting the ISO from 100 to 3200, for example, increases the sensitivity by 5 stops, which allows adjustments to be made to the shutter speed and aperture of 5 stops, while still maintaining the same exposure overall. There is a trade-off though: digital noise increases with the ISO setting, and can produce a soft, grainy appearance that can offset the benefit.

EV CHART EXPOSURE VALUES AT 100 ISO

The following grid lists a range of common landscape situations, and their corresponding Exposure Value. In conjunction with the accompanying Exposure Value Chart you can determine the correct exposure for any subject, without relying on your camera's exposure meter.

EV	Typical subject	EV	Typical subject
-6	Starlit night sky	+6–7	Lights in fairs and amusement parks
-5	Crescent moonlight, faint aurora	+7–8	Bright street scenes, dawn and twilight
-4	Quarter phase moonlight, medium intensity aurora	+9–11	Just before sunrise or just after sunset
-3	Full moonlight, bright aurora	+12	Heavily overcast, or open shade with sunlight
-2	Full moon light on a snowscape	+13	Cloudy, bright with no shadows
-1–+1	Night-time city skylines (varying intensity of light)	+14	Hazy sunlight with soft shadows, or bright sun low in sky
+2	Distant lit buildings (at night)	+15	Bright sunlight overhead with sharp shadows
+3–5	Floodlights on buildings and street lights	+16	Bright sunlight on snow or light sand
		+17–20	Specular sunlight reflections, intense manmade lighting

EXPOSURE VALUE CHART ISO RELATED TO LIGHT INTENSITY (EV), APERTURE, AND SHUTTER SPEED

ISO							Aperture										
50	100	200	400	800	1600	3200	f/1.0	f/1.4	f/2.0	f/2.8	f/4	f/5.6	f/8	f/11	f/16	f/22	f/32
			20	19	18	17										8000	4000
		20	19	18	17	16									8000	4000	2000
	20	19	18	17	16	15								8000	4000	2000	1000
20	19	18	17	16	15	14							8000	4000	2000	1000	500
19	18	17	16	15	14	13						8000	4000	2000	1000	500	250
18	17	16	15	14	13	12					8000	4000	2000	1000	500	250	125
17	16	15	14	13	12	11				8000	4000	2000	1000	500	250	125	60
16	15	14	13	12	11	10			8000	4000	2000	1000	500	250	125	60	30
15	14	13	12	11	10	9		8000	4000	2000	1000	500	250	125	60	30	15
14	13	12	11	10	9	8	8000	4000	2000	1000	500	250	125	60	30	15	8
13	12	11	10	9	8	7	4000	2000	1000	500	250	125	60	30	15	8	4
12	11	10	9	8	7	6	2000	1000	500	250	125	60	30	15	8	4	2
11	10	9	8	7	6	5	1000	500	250	125	60	30	15	8	4	2	1"
10	9	8	7	6	5	4	500	250	125	60	30	15	8	4	2	1"	2"
9	8	7	6	5	4	3	250	125	60	30	15	8	4	2	1"	2"	4"
8	7	6	5	4	3	2	125	60	30	15	8	4	2	1"	2"	4"	8"
7	6	5	4	3	2	1	60	30	15	8	4	2	1"	2"	4"	8"	15"
6	5	4	3	2	1	0	30	15	8	4	2	1"	2"	4"	8"	15"	30"
5	4	3	2	1	0	-1	15	8	4	2	1"	2"	4"	8"	15"	30"	1'
4	3	2	1	0	-1	-2	8	4	2	1"	2"	4"	8"	15"	30"	1'	2'
3	2	1	0	-1	-2	-3	4	2	1"	2"	4"	8"	15"	30"	1'	2'	4'
2	1	0	-1	-2	-3	-4	2	1"	2"	4"	8"	15"	30"	1'	2'	4'	8'
1	0	-1	-2	-3	-4	-5	1"	2"	4"	8"	15"	30"	1'	2'	4'	8'	16'
0	-1	-2	-3	-4	-5	-6	2"	4"	8"	15"	30"	1'	2'	4'	8'	16'	32'
-1	-2	-3	-4	-5	-6		4"	8"	15"	30"	1'	2'	4'	8'	16'	32'	64'
-2	-3	-4	-5	-6			8"	15"	30"	1'	2'	4'	8'	16'	32'	64'	128'
-3	-4	-5	-6				15"	30"	1'	2'	4'	8'	16'	32'	64'	128'	
-4	-5	-6					30"	1'	2'	4'	8'	16'	32'	64'	128'		
-5	-6						1'	2'	4'	8'	16'	32'	64'	128'			

EV (Exposure Values) · Shutter Speed (fractions of a second, seconds, minutes)

To use the EV chart, select the ISO you want to use from the left (gray) side of the grid, and move down to the EV of the scene you are photographing.

Move across the row to the right (blue) side of the grid and choose the shutter speed and aperture.

You can then switch your camera to Manual and set the ISO, shutter speed, and aperture before taking the photograph.

EXPOSURE METERING

Although it is possible to take successful photographs using an exposure value chart to guide you to the correct shutter speed, aperture, and ISO settings, most photographers will use a lightmeter of some kind, whether it's the metering system built into their camera or a handheld lightmeter. But, even using a sophisticated electronic meter, there are two principles of exposure to consider: First, lightmeters are calibrated to average the dynamic range of a scene to an exposure with an 18% gray tonal value. Second, a single exposure might not be enough to record all of the tonal values you see with your eye. However, the wonderful thing about digital photography is there are easy checks you can make to be sure you nailed the exposure perfectly, or took enough bracketed shots to encompass the full contrast range (dynamic range) of the scene.

Metering Modes

Most digital cameras offer three metering patterns; a cover-all composite metering mode commonly known as matrix or evaluative metering, centerweighted metering, and a partial or spotmetering mode.

Composite metering evaluates a number of readings from different sections in the image (the actual number of sections varies between camera makes and models), and compares those tonal values to images in a database to determine the ideal exposure. As efficient as this sounds, I have not used a camera that will compensate for the tonal balance in every situation, and while cameras have come a long way from the match-needle lightmeter in my first 35 mm SLR, they still have a long way to go before they will assess a scene better than the exposure compensation method I would recommend.

Of the other two metering modes, centerweighted metering compares information in the central circle of the viewfinder with readings from the outside. Priority is given to the area within the circle, based on the assumption that this is where the main subject lies, but is balanced with readings from the rest of the view.

However, the most precise way to read an isolated area in an image comes from spotmetering (or partial metering). This pattern determines the exposure from a specific area in the center of the frame, making it a great way to determine the exposure for wildlife with light or dark fur, a neutral object in a daytime scene that includes the sun, or perhaps a brightly lit section in a night landscape, for example.

Metering in Practice

While each of these metering patterns has its specific uses, for landscapes I generally use the camera's composite metering pattern and the exposure compensation feature as needed. Let's start by exploring exposure and metering by working with the "Sunny 16." This is a good reference rule to remember, and despite being a pre-digital idea the principle still applies.

Essentially, "Sunny 16" is based on the fact that the exposure required on a bright, sunny day (where there are well-defined shadows) is 1/125 sec at f/16, using ISO 100 film (or a sensitivity setting of ISO 100 on a digital camera). With a landscape, a lightmeter will read the tonal values of a blue sky, sunlit trees, and grass, and the tonal density of each of these elements is roughly an 18% gray. Tonal values of the shadows, lighter areas at the horizon, and small puffy white clouds, will balance each other out so the whole scene averages to 18% gray for a dead-on exposure.

However, if you take the same sunny day, but cover the landscape with fresh, white snow, the camera's lightmeter will still consider that both the blue sky and the snow are 18% gray, and will determine an exposure accordingly. The result will be an underexposed image with muddy tonal values in the snow, and a very dense blue sky. To prevent this, you need to overexpose the snow scene—about 1 stop will render the snow with white tones, and the sky a bright blue.

If you changed the composition so it was all snow detail with a few soft shadows and no sky, the camera would still consider the scene as 18% gray, which would mean it would come out even darker. It would need about 2 full stops of overexposure for the snow to render as white.

Conversely, if a scene has a relatively high proportion of shadows or darker tones, it will need varying amounts of underexposure to render it properly. Adjusting the exposure can be done easily with the exposure compensation feature on the camera, remembering two basic principles; overexpose bright scenes, and underexpose dark ones.

To expand on this, I go through three steps for every critical photograph I take. First, while composing the image I scan the tonal values and consider how closely the camera's lightmeter will average them to an 18% gray. Then I adjust the camera's exposure compensation setting accordingly, increasing the exposure for lighter scenes, and decreasing it for darker ones.

OPPOSITE: This shot was exposed for the predominance of snow by increasing the exposure by 1 ½ stops over the metered reading. *Hudson River, Adirondack Park, NY*

METERING MODES

EVALUATIVE

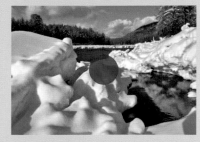

CENTERWEIGHTED

PARTIAL

SPOT

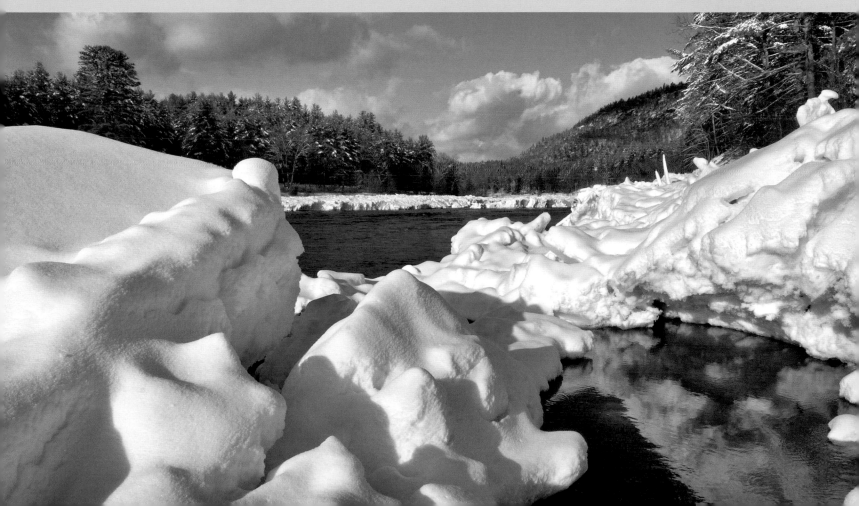

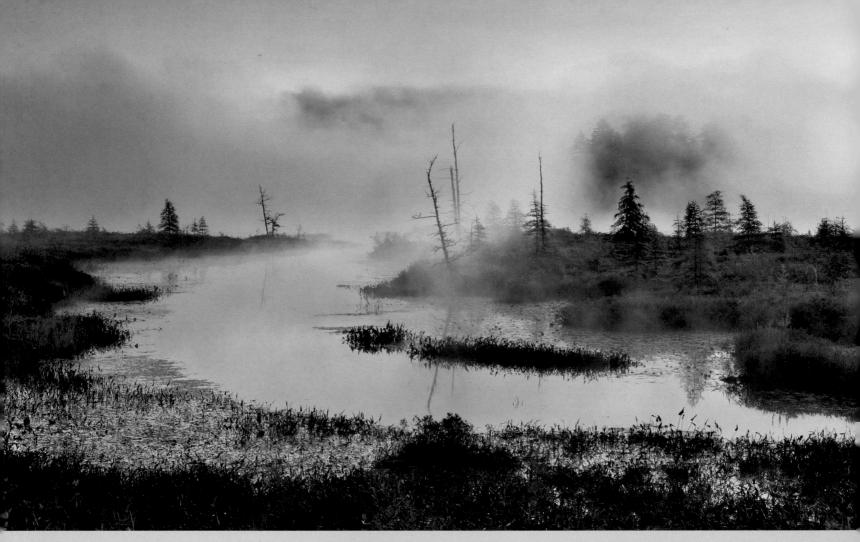

ABOVE: The contrast range in this scene required two exposures to create an HDR composite. *Adirondack Park, NY*

f 13 1/40 SEC
ISO 250 FL 44mm

Both the highlight warning (the black area in the sky) and the histogram on my camera tell me this image has lost highlight detail.

Reducing the exposure shifts the histogram to the left and the highlight warning confirms all the light detail has been recorded. However, there are now some missing shadow tones.

Having made the exposure, the next step is to check the histogram. A histogram shows the amount of, and placement of, all the tonal values in a photograph, with black areas represented on the left, and white on the right. If an image has a lot of lighter tones, like a snow image, the histogram's bell curve will be higher on the right side of the histogram. There might be several "bells" on the graph, but most important are the extreme black and white tone readings. When the curve on the histogram stops short of either the black or white point it shows there is no pure white or black, and there is image information in all of the shadow/highlight areas. This is ideal, as you can fine-tune this on your computer.

However, any height to the histogram at either end of the scale indicates overexposed highlights (at the white/right end), and/or underexposed shadows (at the black/left end). This means the dynamic range of the scene exceeds the sensor's ability to record it, so the brightest areas will be pure white, with no detail, and/or the darkest sections will be completely black.

If a single image does not capture the entire dynamic range of the scene, the answer is to bracket the image by at least one full stop—or more—to create a set of images that can be composited later with HDR work. When shooting for HDR, I generally set the initial exposure for the midpoint, and then bracket either side of that. Bracketing three full stops (one lighter, and one darker exposure, plus the "correct" exposure) is generally enough, but there are times when I have shot up to nine images, covering a nine-stop bracket range. The object is to take as many bracketed exposures as needed so there is tonal detail in every part of the image, from the deepest shadow to brightest highlight. Shoot

bracketed HDR exposures on a tripod whenever possible so the images are perfectly aligned.

The third and final step in assessing an image is to fully zoom into the image and check detail and sharpness. I pan from the middle focal area to the foreground and background, looking for any blurriness caused by movement—of the camera or objects in the scene—and checking for sharpness. As long as there is an opportunity to review an image, and shoot again if necessary, you should be able to record every bit of image information needed to render all the tonal values of a scene. Just remember, the shutter speed affects the appearance of motion, while the aperture setting controls the depth of field.

Perfect Images Every Time

- Check the view for a comparison to an 18% gray tonal balance. Scenes with a predominance of lighter tones need overexposure, and a predominance of darker areas need underexposure.

- Shoot the image and check the histogram for detail in the highlights and shadows. Then adjust the exposure, or prepare to shoot a sequence of bracketed exposures if necessary.

- Zoom into the final image—and every image needed for a bracketed sequence—to check sharpness and depth of field. Again, if anything isn't as you want it, adjust the shutter speed and/or aperture and focal point and shoot again.

EXPOSURE MODES

Just as there are three primary metering modes, all digital SLRs feature four key exposure, or shooting modes; Programed Automatic Exposure (abbreviated to Program AE, or simply Program), Aperture Priority, Shutter Priority, and Manual, often referred to as a whole as PASM. Your camera may also feature a wide range of automatic modes such as Full Auto, Landscape, Portrait, Sunset, Macro, and so on, but these can be ignored totally as they don't provide the control you need over the shutter speed or aperture.

Of the PASM modes, the first three are automatic or semi-automatic shooting modes that let the photographer concentrate more on the picture, and less on the mechanics. However, working with these modes still requires an understanding of the principles involved in order to use them effectively. For at least 95% of the landscape images I shoot I will use either Aperture Priority or Shutter Priority, while the remaining percentage is shot in Manual mode. The only time I will consider using Program is for snapshots at birthday parties and family get-togethers, and even then I often use a more specific shooting mode.

Aperture Priority is used when depth of field is most important, simply because it allows you to choose the aperture for the depth of field you want (and the ISO for image quality), while the camera determines the shutter speed. To control the motion within a scene, and work with a specific shutter speed for action, wildlife, or creative techniques, Shutter Priority is a better option—you choose the shutter speed and ISO, and the camera sets the aperture. Manual mode is really only necessary when you want to use specific aperture and shutter speed settings, or if you're working with extra long exposures using the Bulb setting. Manual is especially useful for

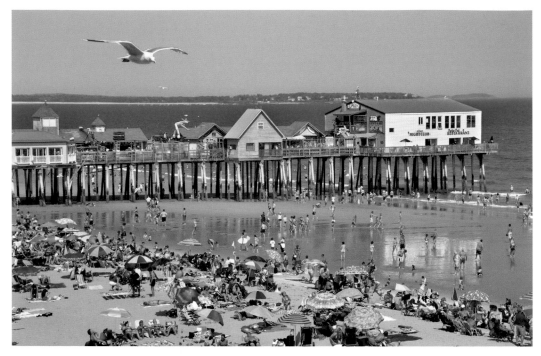

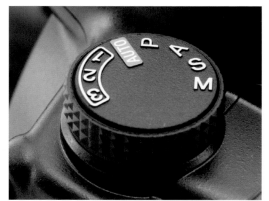

shooting images that will be stitched for panoramas. You can set the exposure for the scene as a whole and the camera will not change anything as you shoot. This guarantees the tonal densities match from one image to the next.

ABOVE: Setting a fast shutter speed in Shutter Priority mode meant I could keep the passing seagull sharp. *Old Orchard Beach, ME*

OPPOSITE: Setting the camera to its manual Bulb setting let me make a 40 minute exposure for this night-time shot. *Fourth Lake, Adirondack Park, NY*

EXPOSURE MODES

LEFT: There might be a lot of exposure modes on your camera's control dial, but the only four you need to concern yourself with are Program, Aperture Priority, Shutter Priority, and Manual—PASM for short.

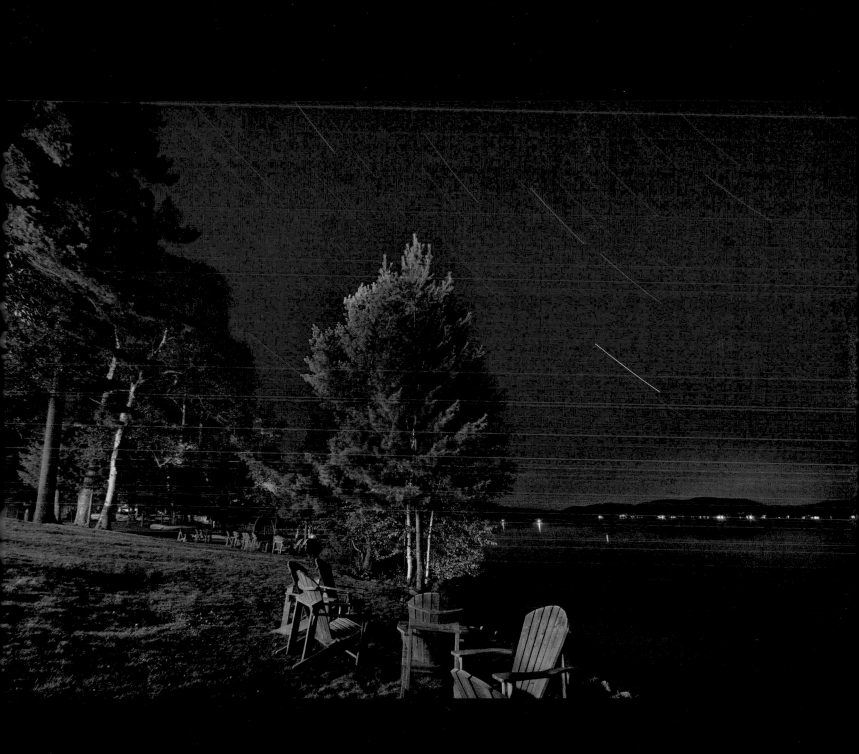

DEPTH OF FIELD

A key element in creative landscape photography is understanding the concept and principles of depth of field. "Depth of field" (DoF) refers to the amount of an image that is in apparent focus both in front of, and behind, the actual point of focus. All lenses focus most sharply at a given point, but the image softens progressively on either side of that point of focus. The section with a softness that is imperceptible to the human eye—the sharp area—becomes the depth of field.

The amount of depth of field is directly related to three things: the size of the aperture opening, the focusing distance, and the focal length of the lens. The largest aperture opening provides the least depth of field, while the smallest aperture opening provides the greatest depth of field. There is also less depth of field when focusing on subjects that are closer to the lens, and more DoF when focusing farther away. Shorter focal length lenses (wide-angle lenses) offer a greater depth of field than longer, telephoto focal lengths.

Many landscape photographs have subjects in both the foreground and background, and keeping both areas sharply focused requires the greater depth of field that comes from working with aperture settings of f/16 and smaller. To help you visualize this, most SLRs have a depth of field preview feature that lets you to see through the lens with the aperture set to the f-stop you will take the picture at. If your camera doesn't have a depth of field preview, the alternative is to shoot the picture and then preview the image. Zoom in on the foreground and background detail to be sure all necessary elements of the image are sharp, then readjust the settings and shoot again if necessary.

Depth of Field Tips

- Use the depth of field preview button to check sharpness in the composition.

- Shoot an image and zoom into the preview to check sharpness.

- Use a tripod for the sharpest results when a small aperture results in a slow shutter speed.

- Move farther away from your subject for greater depth of field in the image.

- Wide-angle lenses and small apertures provide the greatest depth of field.

- Longer focal length lenses are best for isolating details and have least depth of field.

- Experiment with various focal lengths to better understand the principle of depth of field.

This sequence of shots shows the depth of field reducing, from top to bottom, as the aperture widens. A shallow depth of field makes the foreground stand out.
Adirondack Park, NY

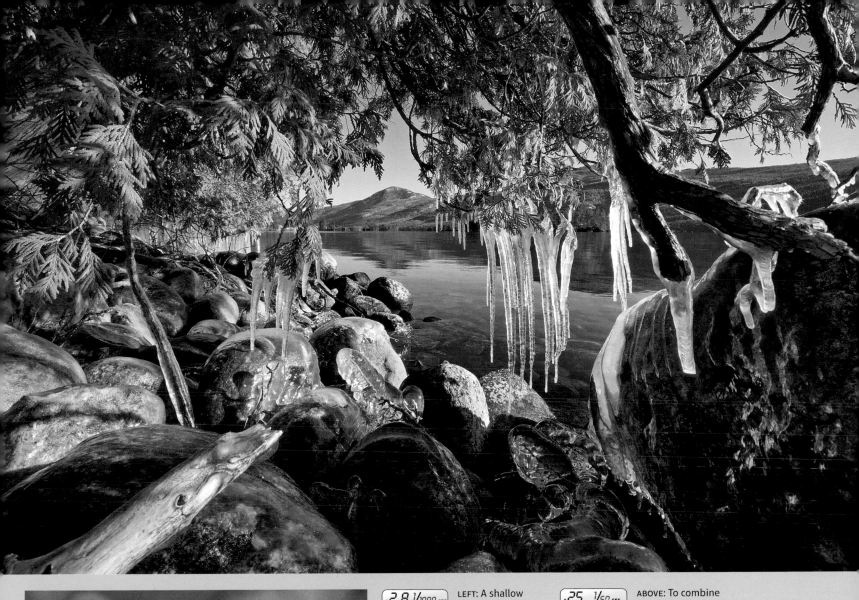

| f 2.8 1/1000 SEC |
| ISO 100 FL 200 mm |

LEFT: A shallow depth of field can successfully emphasize your chosen detail while hinting at a landscape or environment that is softly blurred behind. *Adirondack Park, NY*

| f 25 1/60 SEC |
| ISO 100 FL 12 mm |

ABOVE: To combine foreground elements with background landscape you need to use a long depth of field, like this view of Black Mountain, NY, which was captured at f/25. *Lake George, Adirondack Park, NY*

HYPERFOCAL SETTINGS

One of the biggest shifts for my landscape photography composition came when I learned—many years ago—how to use the hyperfocal settings on a lens to maximize depth of field. These settings provide specific numbers to work with for setting up the depth of field, and understanding this concept and how it works is a way of maximizing the capabilities of each lens. Today, I often focus my images using only the hyperfocal settings on the lens, since I know the numbers will provide the focus range needed, rather than relying on the camera's autofocus. Yet while hyperfocal settings are still printed on prime lenses, they aren't shown on most zoom lenses, and some newer lenses don't even have a window to show the focusing distance.

The setting for the hyperfocal point of focus is midway between the setting for the nearest point that is in focus and the setting for the farthest point in focus. To find the hyperfocal point you need to have a distance scale on your lens. Start by focusing on the nearest point in the scene that you want to be in focus, and check the distance on the lens. Then focus on the farthest point you want to be in focus, and note that distance setting as well. Midway between the near and far distance settings is the hyperfocal point—the distance you actually set as the point of focus on the lens.

This system works as long as the hyperfocal settings for the depth of field are within the physical capability of the lens and aperture. However, if there isn't a focusing distance scale on your lens (something omitted from some modern lenses) it is much harder, if not impossible, to implement. In that case, the best you can do is use a hyperfocal distance chart, such as the one on the opposite page.

The limitation of using a chart like this is most assume infinity to be the farthest focus point. Also, there will be a certain amount of guesswork involved when it comes to focusing at the hyperfocal distance—the best you can do is pick a point that you think is roughly the right distance away, and focus manually on it. But the great thing about digital capture is you can immediately check the photograph on the camera's screen, to determine the accuracy of the focus settings. Simply zoom into the picture to check all specific points of focus, and make adjustments to the aperture and shoot again if necessary.

Depth of Field on Small Sensors

Cameras with APS or Four Thirds sensors require shorter focal length lenses to provide the same field of view as a camera with a full-frame sensor. For example, with its 2x conversion factor, a Four Thirds-format 10 mm lens will provide the same field of view as a 20 mm lens on a digital SLR with a full-frame sensor. The advantage is that shorter focal lengths produce a greater depth of field—at f/22, a 10 mm lens has a depth of field extending from 3 inches (7.5 cm) to infinity, while a 20 mm lens covers 12 inches (30 cm) to infinity.

This applies to all focal length lenses in relation to different sensor sizes, as it is only the field of view that changes depending on sensor size, not the actual focal length. A 10 mm lens is always a 10 mm lens, even if it offers a comparable view to a 20 mm lens on a smaller sensor.

 ABOVE: Using an 18 mm wide-angle focal length and an aperture of f/22, the hyperfocal distance is 1' 8" (50 cm). This means the depth of field extends from 10-inches (26 cm) to infinity or, in this case, from the weathered tree in the foreground to the distant mountains. *Bryce Canyon National Park, UT*

ABOVE: The hyperfocal scale on a Nikon 24 mm f/2.8 lens. Many modern lenses no longer feature this useful scale that shows the minimum and maximum distances that will appear in focus at any given aperture.

HYPERFOCAL DISTANCE CHART

The grid below assumes a depth of field that extends from the nearest possible point of focus to infinity.

NF is the near focal point (the nearest point that will appear in focus).

HF is the hyperfocal distance—the actual distance you need to focus at to achieve a depth of field that covers the near point of focus all the way to infinity at the specific aperture setting.

		f/1.4		f/2		f/2.8		f/4		f/5.6		f/8		f/11		f/16		f/22		f/32	
		Ft & In	Meters	Ft & In	Meters	Ft & In	Meters	Ft & In	Meters	Ft & In	Meters	Ft & In	Meters	Ft & In	Meters	Ft & In	Meters	Ft & In	Meters	Ft & In	Meters
10 mm	HF	8'3"	2.53	5'10"	1.79	4'2"	1.26	2'11"	0.89	2'1"	0.63	1'6"	0.45	1'0"	0.32	0'9"	0.22	0'6"	0.16	0'4"	0.11
	NF	4'2"	1.26	2'11"	0.89	2'1"	0.63	1'6"	0.45	1'0"	0.32	0'9"	0.22	0'6"	0.16	0'4"	0.11	0'3"	0.08	0'2"	0.06
12 mm	HF	11'11"	3.64	8'5"	2.57	6'0"	1.82	4'3"	1.29	3'0"	0.91	2'1"	0.64	1'6"	0.45	1'1"	0.32	0'9"	0.23	0'6"	0.16
	NF	6'0"	1.82	4'3"	1.29	3'0"	0.91	2'1"	0.64	1'6"	0.45	1'1"	0.32	0'9"	0.23	0'6"	0.16	0'4"	0.11	0'3"	0.08
14 mm	HF	16'3"	4.95	11'6"	3.50	8'1"	2.48	5'9"	1.75	4'1"	1.24	2'10"	0.88	2'0"	0.62	1'5"	0.44	1'0"	0.31	0'9"	0.22
	NF	8'1"	2.48	5'9"	1.75	4'1	1.24	2'10"	0.88	2'0"	0.62	1'5"	0.44	1'0"	0.31	0'9"	0.22	0'6"	0.15	0'4"	0.11
16 mm	HF	21'3"	6.47	15'0"	4.57	10'7"	3.23	7'6"	2.29	5'4"	1.62	3'9"	1.14	2'8"	0.81	1'10"	0.57	1'4"	0.40	0'11"	0.29
	NF	10'7"	3.23	7'6"	2.29	5'4"	1.62	3'9"	1.14	2'8"	0.81	1'10"	0.57	1'4"	0.40	0'11"	0.29	0'8"	0.20	0'6"	0.14
18 mm	HF	26'10"	8.18	19'0"	5.79	13'5"	4.09	9'6"	2.89	6'9"	2.05	4'9"	1.45	3'4"	1.02	2'4"	0.72	1'8"	0.51	1'2"	0.36
	NF	13'5"	4.09	9'6"	2.89	6'9"	2.05	4'9"	1.45	3'4"	1.02	2'4"	0.72	1'8"	0.51	1'2"	0.36	0'10"	0.26	0'7"	0.18
20 mm	HF	33'2"	10.1	23'5"	7.14	16'7"	5.05	11'9"	3.57	8'3"	2.53	5'10"	1.79	4'2"	1.26	2'11"	0.89	2'1"	0.63	1'6"	0.45
	NF	16'7"	5.05	11'9"	3.57	8'3"	2.53	5'10"	1.79	4'2"	1.26	2'11"	0.89	2'1"	0.63	1'6"	0.45	1'0"	0.32	0'9"	0.22
24 mm	HF	47'9"	14.6	33'9"	10.3	23'10"	7.27	16'10"	5.14	11'11"	3.64	8'5"	2.57	6'0"	1.82	4'3"	1.29	3'0"	0.91	2'1"	0.64
	NF	23'10"	7.27	16'10"	5.14	11'11"	3.64	8'5"	2.57	6'0"	1.82	4'3"	1.29	3'0"	0.91	2'1"	0.64	1'6"	0.45	1'1"	0.32
28 mm	HF	65'0"	19.8	45'11"	14.0	32'6"	9.90	23'0"	7.00	16'3"	4.95	11'6"	3.50	8'1"	2.47	5'9"	1.75	4'1"	1.24	2'10"	0.88
	NF	32'6"	9.90	23'0"	7.00	16'3"	4.95	11'6"	3.50	8'1"	2.47	5'9"	1.75	4'1"	1.24	2'10"	0.88	2'0"	0.62	1'5"	0.44
35 mm	HF	101'	30.9	71'9"	21.9	50'9"	15.5	35'11"	10.9	25'4"	7.73	17'11"	5.47	12'8"	3.87	9'0"	2.73	6'4"	1.93	4'6"	1.37
	NF	50'9"	15.5	35'11"	10.9	25'5"	7.74	17'11"	5.47	12'8"	3.87	9'0"	2.73	6'4"	1.93	4'6"	1.37	3'2"	0.97	2'3"	0.68
50 mm	HF	207'	63.1	146'	44.6	103'	31.6	73'3"	22.3	51'9"	15.8	36'7"	11.2	25'11"	7.89	18'4"	5.58	12'11"	3.95	9'2"	2.79
	NF	103'	31.6	73'3"	22.3	51'9"	15.8	36'7"	11.2	25'11"	7.89	18'4"	5.58	12'11"	3.95	9'2"	2.79	6'6"	1.97	4'7"	1.40
72 mm	HF	429'	131	303'	92.6	214'	65.5	151'	46.3	107'	32.7	75'11"	23.1	53'8"	16.4	38'0"	11.6	26'10"	8.18	19'0"	5.79
	NF	214'	65.5	151'	46.3	107'	32.7	75'11"	23.1	53'8"	16.4	38'0"	11.6	26'10"	8.18	19'0"	5.79	13'5"	4.09	9'6"	2.89
105 mm	HF	913'	278	645'	197	456'	139	322'	98.4	228'	69.6	161'	49.2	114'	34.8	80'9"	24.6	57'1"	17.4	40'4"	12.3
	NF	456'	139	322'	98.4	228'	69.6	161'	49.2	114'	34.8	80'9"	24.6	57'1"	17.4	40'4"	12.3	28'7"	8.70	20'2"	6.15
150 mm	HF	1864'	568	1318'	402	932'	284	659'	201	466'	142	329'	100	233'	71.0	164'	50.2	116'	35.5	82'5"	25.1
	NF	932'	284	659'	201	466'	142	329'	100	233'	71.0	164'	50.2	116'	35.5	82'5"	25.1	58'3"	17.8	41'2"	12.6
200 mm	HF	3314'	1,010	2343'	714	1657'	505	1171'	357	828'	253	585'	179	414'	126	292'	89.3	207'	63.1	146'	44.6
	NF	1657'	505	1171'	357	828'	253	585'	179	414'	126	292'	89.3	207'	63.1	146'	44.6	103'	31.6	73'3"	22.3

Hyperfocal Rules of Thumb

- Depth of field is directly related to the focal length of the lens.

- Short focal length, wide-angle lenses have greater depth of field and long focal length, telephoto lenses have a much shallower depth of field.

- The smaller the aperture, the greater the depth of field.

- The hyperfocal point on a lens is midway between the near point of focus and the far point of focus.

- Since a shorter focal length lens is required with a smaller sensor to provide the same field of view as that of a larger sensor, there is greater depth of field for the same field of view with the smaller sensor.

Hyperfocal Setting Steps

- Focus on the nearest subject and note the position on the lens barrel.

- Check the settings on the chart to see if that falls into range for the depth of field for the lens and aperture setting.

- Focus on the farthest point of focus and note that position on the lens barrel.

- Set the focus point of the lens midway between the near and far points to take the picture.

STOP ACTION, BLUR, MOTION & PANNING

Motion can be used creatively in many ways in landscape photography, and while we most often try to make a landscape image as sharp as possible, the motion of blowing grasses or leaves, falling snow, or other moving elements can add a wonderful contrast and energy to an otherwise static scene. While stopping action or allowing motion blur are rather basic concepts, these two principles are the basis for many of the creative actions that can be done with a camera. While adjusting the aperture determines the range of focus in an image, it is the shutter speed that determines whether an object will appear still and sharp, or blurred through motion.

Stopping the action of a subject depends on the shutter speed used, the focal length of the lens, the speed of the subject, and whether the subject is moving in line with the axis of the camera and lens, or at an angle to it. Subjects that are moving from side to side across the focal plane show the highest rate of movement and are most prone to motion blur. Also, longer telephoto lenses are more likely to show motion blur since it takes a shorter period of time for a subject to cross the field of view than with a wide angle lens. As a result, longer lenses require proportionately faster shutter speeds to completely stop the action of a moving subject.

Placing the camera on a tripod and using a slow shutter speed to take a picture of moving water is one of the most common uses of blur. With a relatively slow shutter speed the technique can add a silky look to the water, or, with an extra long exposure of 20 seconds or more, the water's motion will become so soft that it creates a fog-like effect. The landscape around the water will be tack sharp, and only the water—and anything else that moved—will appear blurred.

Panning the camera is most often a handheld technique that can be used to create any number of effects. The most basic application is to track a moving subject with the camera, taking the exposure as you carefully follow the motion with the camera. This is most often used for sports and wildlife photography, but it can also be applied to any subject that has motion, or even used to photograph a still subject, when the panning action will create an abstract motion effect. Stabilized lenses are great for panning techniques as a combination of stabilization and focus tracking helps the camera pan in tighter integration with a subject for a sharper image. When tracking a moving subject, use the continuous autofocus mode.

f8 1/6 sec
ISO 100 FL 48mm

Windblown woodland sunflowers become an energetic blur of green and yellow thanks to a slow shutter speed. *Adirondack Park, NY*

Tips

- Try shutter speeds of 1/8 sec or longer to blur water.

- Shorter focal length lenses need longer exposure times than longer lenses to blur motion.

- When panning the camera, track the subject continuously—before, during, and after taking the shot.

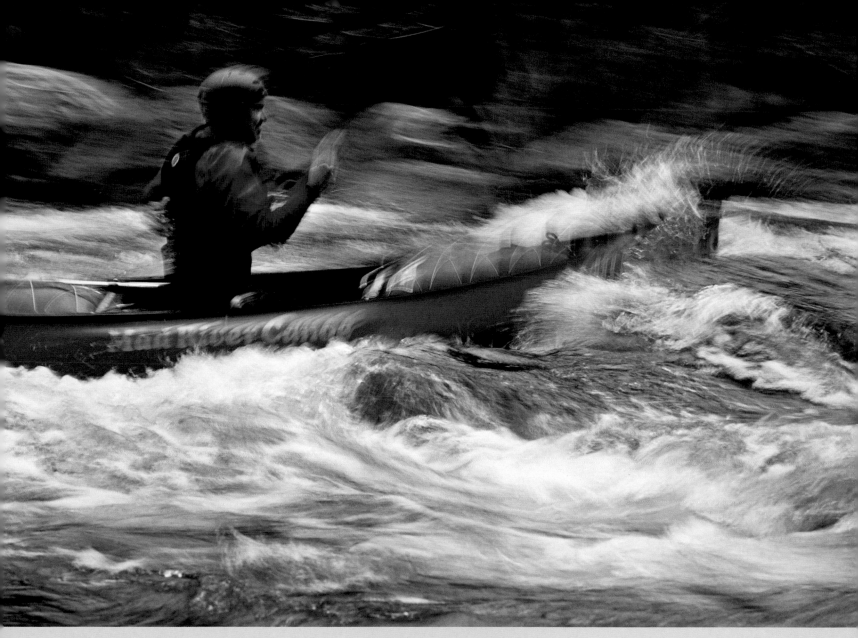

 f8 1/10 sec ISO 100 FL 60mm Stabilized lenses are helpful for panning any subject. This was one of several 1/10 sec exposures I took while tracking the action of the canoeist.
Schroon River, Adirondack Park, NY

FLASH & ARTIFICIAL LIGHT

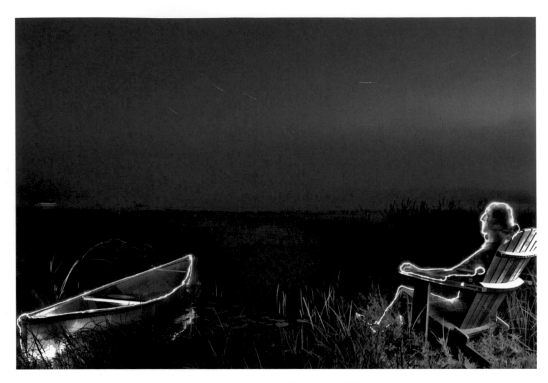

,5.6 19 MINS ISO 200 FL 18mm After the sun goes down there are additional options for artificial lighting. LED flashlights, headlamps, portable spotlights, and flash units can all be used for "painting with light." With a long exposure set (see Nocturnal Images, page 118), fine point lights can be used to add outlines to a subject, while more diffused lights or spotlights can be used to highlight wider areas—the possibilities are endless! *Brant Lake, Adirondack Park, NY*

Landscape photography may be all about the light, but it can also be about the lighting. For years I was a natural light purist, and wouldn't consider using a flash or other light source to take a photograph of the natural world. However, I began to change my opinion when I realized some of the creative options it opened up, and the fun I was missing out on. There are times when a carefully orchestrated flash can dramatically enhance a landscape photograph and, if you enjoy experimenting, playing around with artificial light at night can help you create some unique imagery.

At its most basic, a flash can be used to enhance a foreground subject, fill in shadow detail, or balance the ambient light for a more pleasing

photo in backlit and side-lit situations. Modern flash technology uses the camera's through-the-lens metering systems for trouble-free exposures, and most cameras feature flash exposure compensation and flash bracketing for even greater control.

A flash unit or a built-in flash can be used for most landscape photography situations. While a built-in flash might not have the power of a separate flash unit (or the swiveling and tilting head, or variable focal length adjustments), it should still be sufficient in providing a controlled amount of fill light as most fill flash situations are closer to the camera. However, when working with a built-in flash and wide-angle lenses, be sure to remove the lens hood so it won't vignette the flash

and create a shadow on the image. Larger diameter wide-angle lenses could vignette the flash as well, so it's good to make a test shot and check it over thoroughly to see if there are any issues. Don't forget to take a set of shots without the flash as well, so you have the additional image choice.

The key to using your flash is not to be afraid of it—just experiment! Many fill flash situations work best with the flash set to a ½ to one full stop less than the ambient exposure, so set the flash exposure compensation to -0.5EV or -1EV (underexposure). If the subject is farther away and it's not getting enough light from the flash, try setting it to overexposure. If you have an off-camera cord for your flash, or it works wirelessly, it can be used to add light from different angles including underneath, the side, or reflected from an umbrella. Try using a portable softbox to diffuse the light of the flash (they are made for built-in flashes and hotshoe-mounted flash units), and use exposure bracketing as well as flash bracketing, or adding a filter for the sky and/or colored gels for the flash.

f 18 1/50 sec
ISO 320 FL 14mm

BELOW: Adding a burst of flash to a landscape image is not something everyone will like, but you don't know what the result will be unless you try it. Here the difference is quite extreme—with flash, the balance of the shot changes, and the foreground plant becomes the dominant subject. *Lake George, Adirondack Park, NY*

LANDSCAPE PHOTOGRAPHY ETHICS

Although we've talked about equipment and technical issues so far, landscape photography is also about respect. It's about respect for those around you while you are photographing; respect for the environment you are photographing and traveling through; and respect for all the living creatures in the surrounding habitats. There is no photograph that is worth harming wildlife or part of the environment, or doing something that could cause harm or anguish for people around you. Perhaps the simplest statement is the well used hiker's rule: "Take only memories (in this case photographs), leave only footprints."

When working in a wild, natural environment, it is important to minimize your impact. Research and learn about the habitat you will be photographing in, as this will help you better understand the natural cycles and habits of wildlife, as well as any potential issues in endangered habitats you might be traveling through. This research also provides a better understanding of when and where to photograph.

Stay on existing trails and rock as much as possible to lessen your impact and potential erosion issues, and use longer lenses when necessary to stay at a distance and help avoid stress to wildlife. Always be aware of the impact of your footsteps and presence, and if you see any inappropriate behavior, offer suggestions for improvement and, if need be, inform local authorities about the problem.

The photo I've included here is rather extreme, but it definitely makes a point. I don't photograph environmental degradation often, but this one said so much about the "carry in and don't carry out" crowd. It wasn't in a protected park, but it was in the middle of one of the few remaining dwarf pine barrens in the world. At the end of a long, single lane, dirt road were several piles of assorted debris, and it was the mannequin's head that caught my eye, peppered with shotgun pellets, and discarded among the beer cans, soda cans, and shotgun shells. For me it summed up the complete lack of respect some people have for the environment and the world around them.

Scan from film. *Dwarf Pine Barrens, Long Island, NY*

2:
CREATING YOUR VISION

Creating a fine landscape photograph is a lot like composing a symphony, where each instrument creates its own space and mood. In a landscape photograph you are working with the "instruments" of light, contrast, detail, texture, lines, and shadows, and when these elements come together harmoniously the image can touch us on a deep level, becoming an almost spiritual experience.

Placing the key details is all about a flow of energy, so think of each element in the image as a source of energy. Because the eye is attracted to objects of similar energy and content it is often easier to see the details that do work, rather than the ones that don't. It is important to scan every detail through the viewfinder, and then visualize the image in its entirety.

I like to have one element that catches the eye. When your eye goes there it sees another element, and another, and another, until the eye scans the entire image, eventually coming full circle to the first element again. It's all about the harmony of detail, texture, tone, and contrast, which create a balance of energy throughout the photograph.

COMPOSITION BASICS

There are various guidelines for composition, but no set rules—each photographic composition is a very personal thing. Composition guidelines, such as the rule of thirds, the Golden Ratio, or the Golden Triangle offer thoughts on placement of the main subject, and while these rules are a great way to interpret and discuss balance when sitting in a classroom, I don't necessarily think about them at great length when composing images in the field. Instead, when I am shooting, I work with tonal balance and energy flow. I try not to place very light or dark areas near the edge of an image, or center the main subject. If any subject really dominates, it often naturally ends up near an intersection of the thirds.

I try to create an even, balanced flow of energy from light to dark, flowers to trees, and from lines to other shapes that draws a person around, through, and deeper into the details of an image. Any element that is proportionately too heavy can draw the eye and interrupt the smooth flow of energy—sometimes just a small bright or dark spot in a corner is enough to break the flow.

Yet at the same time I have many photos that break my own guidelines. For example, the Zion photo (opposite, top) goes completely against my typical suggestions, but all of the wrong things actually create a nice balance in the photograph. From the main focal point of the snow-covered cliffs, the eye is drawn to the cliff silhouette on the left. The moon helps pull the eye away from the cliffs, to the tree detail on the right, and then back to the snow on the cliffs. The moon is in the center of the image, the cliff silhouette fills the left side, and the horizon is skewed. Everything appears to be wrong, and yet when you apply the Golden Triangle—not something I had in mind at the time—it suddenly works as a whole.

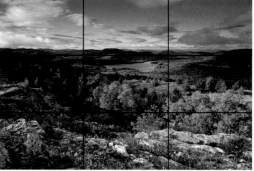

RULE OF THIRDS
The rule of thirds is based on the idea of splitting the frame in three, vertically and horizontally, and placing key elements of the image on the "thirds lines," or the points where they intersect. *Treadway Mountain, Adirondack Park, NY*

GOLDEN TRIANGLE

The Golden Triangle may appear to be just triangles within triangles, within triangles, but perhaps it explains why the unconventional framing of this image works? *Zion National Park, UT*

GOLDEN RATIO

Essentially a math formula in a visual form, the Golden Ratio is an esthetically pleasing shape that can be traced back to the Ancient Greeks. Here (far right) I digitally moved one of the balloons so it sat better on the Golden Spiral. Does it improve the composition? *Queensbury, NY*

LEARNING FROM THE MASTERS

Every landscape photographer started at the very beginning. They developed an appreciation for their subject, learned about and mastered their craft, and created their own vision for portraying the world around them. In studying the work of well known landscape photographers, I was particularly captivated by the classic black-and-white work of Ansel Adams. Through his skills as a black and white photographer and print maker he was able to capture the energy of the wild landscape and communicate the essence of his experience and passion for the landscape.

But photography is not simply about imitating the masters—it is about learning from them. A landscape master thoroughly understands the mechanics of his craft so that each step in the photographic process becomes second nature. As he is composing an image, he knows what he expects to see in the final print and has the ability

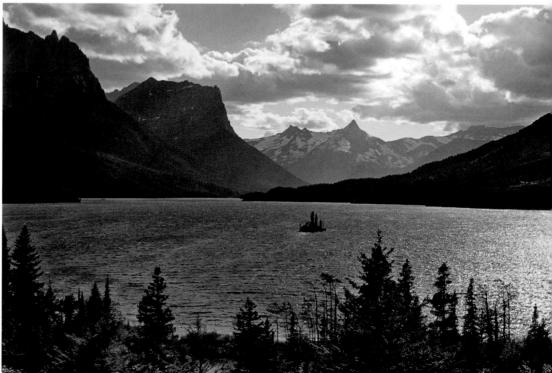

ABOVE: The National Parks in the U.S. were all photographed by the masters, so it's always a challenge to photograph these iconic scenes in a new light. *Grand Canyon National Park, AZ*

LEFT: With digital imaging it's possible to shoot everything in color, and then convert specific choices to black and white in an image-editing program, perhaps to emulate a landscape master. *Glacier National Park, MT*

to make that happen. He often knows where he wants to photograph, when he wants to be there, the lighting he would like to have, how the current weather might affect the photograph, and can adapt to any changing conditions.

Studying the work of photographers such as Ansel Adams and Edward Weston offers perspectives on composition, lighting, and ways of creating energy in a photograph that transcend the limitations of a two-dimensional medium. Their use of light, contrast, texture, and tonal values helps give us a solid background to work from, and finding what appeals to you in other photographs will help create ideas for your own compositions.

Of course, each photographer ultimately creates their own approach, and becoming a master of the craft is a process. I have been inspired by the work of many contemporary outdoor photography

masters as well as work I've seen from participants in my photography workshops. Each person has their own unique viewpoint and is attracted to different features in the landscape. They build on the work that they themselves have seen, and create images based on their individual backgrounds.

In order to evoke emotions with landscape photography it is good to have a knowledge of— and be emotionally connected to—the subject being photographed. Making a landscape image visually stimulating to others has more to do with what excites you in a photograph than simply recording what is in front of you. It is about shadows and highlights, subtle details and bold textures, mountain ranges and open waters, forested hillsides and hidden waterfalls, and wildflowers and wildlife. It is also about appreciating the balance of nature, the changing of the seasons, and portraying the many moods of atmosphere and light.

PASSION & FINDING YOUR OWN STYLE

Nothing has the potential to help convey the emotion of the moment in a photograph more than being passionate about what you are photographing. This applies to any photography subject, whether it's a person or a landscape, or colors, details, and textures. Passion can be triggered by an emotional connection to the subject, or it could be related to specific lighting situations or composition. It can also be related to the act of photography itself, and how it allows you to communicate your vision and interpret the world around you.

To help understand where a passion for photography comes from, begin by asking yourself some basic questions: Why do I photograph? What is it I want to communicate? Why am I attracted to this subject? Having a better understanding of the emotions and subjects that are triggering your passion is key to creative, evocative compositions.

My passion for the landscape is about the beauty, freedom, simplicity, and spiritual energy I connect to when I'm in a wild landscape. The more wild and primeval the landscape, the better I can tune in. When I first started photographing, I was so passionate about the wilderness that I would not take a photograph if there was a house or other manmade object in the scene. Eventually, my passion for the wilderness evolved into a passion for working with the camera anywhere, and I applied the same rules to everything I was photographing, tuning in to the energy of the subject and finding a way to capture that through lighting, composition, and timing. As a result, I discovered I could recreate the energy of the moment in urban settings as well as in the wilderness.

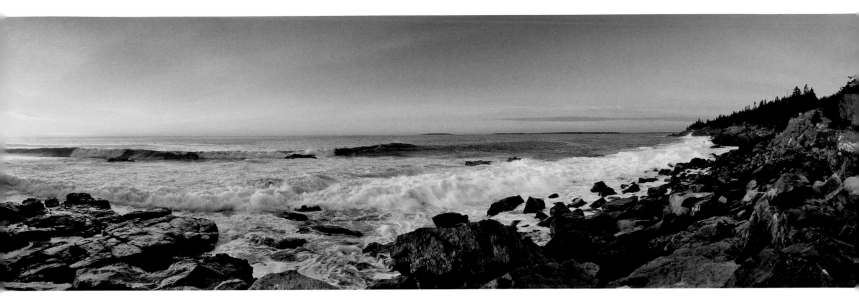

However, whereas passion comes from within, "style" is something that finds you. Once the basic principles of apertures and shutter speeds, and the mechanics of the camera become second nature, it is easier to concentrate on the subject matter and composition without the technicalities getting in the way. At that point, you are free to explore your passions through photography, and photograph what you are passionate about. What landscapes really turn you on? Are you drawn to the energy of a city, with cars zipping down the street, people hurrying to work, lights on everywhere, and the sharp, glittering, angular facades? Or, perhaps the restive qualities of a peaceful sunset over a wild lake have a greater emotional impact for you? Are you more attracted to broad, vast, landscapes, or to the subtle details within the view? Photograph whatever excites you at the moment, from your own point of view, and work with your passions. Your "style" will naturally develop—it's not what you see, but how you see it.

ABOVE: Sunrises, sunsets, and waves crashing onto a shoreline are emotional triggers for most people. *Western Head, Acadia National Park, ME*

OPPOSITE LEFT, & OPPOSITE RIGHT: Snow, clouds, and mountains are favorite subjects of mine— especially those in the Adirondacks of upstate New York. *Mount Marcy, Adirondack Park, NY*

LEFT: Lighting adds a different energy when photographing in the city. There's only about a magic half hour when both city lights and atmospheric lighting coincide. *Chrysler building, New York City*

VISUALIZING & COMPOSING

Visualize, compose, and shoot: I go through the same three-step process with almost every photograph I take. The first step—visualization—is all about becoming aware of the photograph. Stop, close one eye to see the view in just two dimensions (as a camera does), then scout for the interesting details. Look at the view from different heights, and try to visualize what it might look like from another angle, at a different vantage point. Use your hands to create an approximate image frame, or work with a card or plastic 35 mm slide frame at different distances from your eye to approximate the framing of various focal lengths. In addition, think about how adding filters, bracketing, HDR imaging, or additional color work can affect the final photograph.

Visualizing an image is a who, what, when, where, why, and how process, with "what if?" being the most important element of creative photography. What if I were to look at this scene from a higher or lower angle? What if I used a long shutter speed? What if I tried a different lens or filter? What if I used a shallow depth of field? What if I adjusted the ISO setting? What if I tried panning the camera? What if I waited for different light or weather conditions? What if I returned at another time of year, when the sun is at a different angle? These are all questions you need to ask yourself.

Once those questions have been answered, the second step is to get the camera out, put a lens on, and physically work the scene with different focal lengths. The key to composition is to condense the larger view down to the main supporting details within a scene. Our tendency is to step into a grand landscape and visualize the whole scene, but creating an evocative photograph comes from composing the image around eye-catching details.

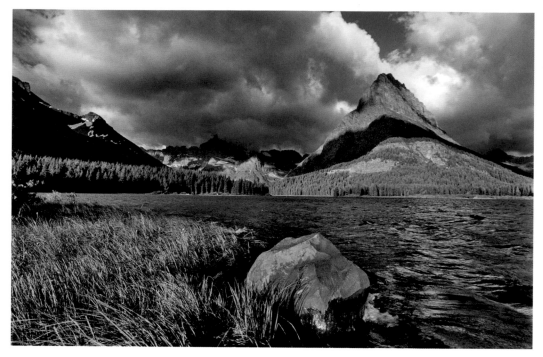

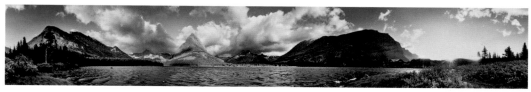

Some people work from the details out, others from the wide view in. Since my thought pattern tends to work from the widest view to the details, I typically look for the broadest view that will work for a composition first. I'll start by looking at whether I can do a 360 degree panorama, then work my way in to a narrower panorama, a wide-angle landscape, telephoto details, and finally think about macro imagery. Oftentimes, there are many smaller detailed views within a larger view.

When I visit a scene, I tend to start with the broadest view and work down to the details. Here, I started with a panorama (above), then looked at how I could make more images by focusing in on specific sections of the same scene (top). *Swiftcurrent Lake, Glacier National Park, MT*

Visualize, Compose, and Shoot

- Recognize the value of a familiar subject, but perceive the essence of what you are looking at.

- The best photographs come from not only seeing the view, but experiencing it as well.

- Learn how to express your feelings for the subject through the mood of the photograph.

- Having one quality image is far better than having a quantity of less inspiring images.

- Learn to sense anachronisms in the composition. It is often easier to see what does fit, than what doesn't.

f22 1/60 SEC ISO 100 FL 18mm This fiery ornamental tree had wonderful detail in the branches, but I also wanted to give it a sense of place within the Japanese garden setting. This composition would still work if a branch covered over the doorway, but the door calls you deeper into the image and adds a sense of mystery. *Hammond Museum Japanese Stroll Garden, North Salem, NY*

TONAL BALANCE & LIGHTING

Varying intensities of light, combined with an endless array of color values, are the landscape photographer's palette. Since color tones themselves can be so captivating, color photography is about balancing color intensities, as well as highlight and shadow detail. Many landscape images work with a full range of tonal values, from a black point in the shadows to a white point in the sky or highlight. However, images that are mostly about textures often rely on a softness of the tonal values and the use of different colors and subtle lines to create eye-catching images.

Light can be direct, reflected, filtered, or diffused. An object in direct light reflects both the intensity and color tone of the light falling in it, while reflected and filtered light takes on the hue of the source it is coming from. Yet at the same time, light is constantly changing. Even on a clear, sunny day, the angle of the sun changes by the minute, with occasional passing clouds softening the light and subtly changing the hue, or white cloud tops bouncing light around and helping fill in harsh shadows. When the sun is closer to the horizon, the light is filtered through a greater proportion of the atmosphere and becomes softer and warmer. This "magic hour" light is wonderful for landscape photography.

The angle of the light also helps create or diminish contrast, and there is no right or wrong angle—each angle of light enhances the landscape in a different way. The low elevation side-lighting of morning and evening is very effective at creating depth in a landscape. Each object has its own shadow and contrast that helps it stand out from other elements, helping draw the eye into an image. Front-lit subjects, with the sun behind you, typically have a flatter feel with few shadows, and

lighting will be more similar throughout the image. Finally, backlighting can be used to create silhouettes, where the subject appears quite dark against a lighter background. A fill-flash, or bracketed images and HDR techniques can help add some detail to a silhouette if desired.

While it is generally suggested to avoid working in the midday sun, good photographs can still be created that have a different energy to low angle, low-light shots. Midday can be a good time to photograph activities, or scenes where the composition relies more on details in the image than on the lighting. A few clouds in the midday sky can make a big shift in the lighting as well as offer more shooting options.

f8　1/8 sec　ISO 400　FL 120mm

ABOVE: Expose for the color in the sky to create a twilight silhouette. Tilt the camera up, meter off the sky above the cliffs, hold that exposure, and recompose the shot. *Zion National Park, UT*

f22　1/2 sec　ISO 100　FL 18mm

OPPOSITE: A variety of color tones, contrasts, and shadow lines draw the eye from the foreground rocks, across the fall colors, to the snow-capped mountains in the background. The contrasts in the clear, "magic hour" light required a bracket range of about 5 stops and careful blending. *The High Peaks, Adirondack Park, NY*

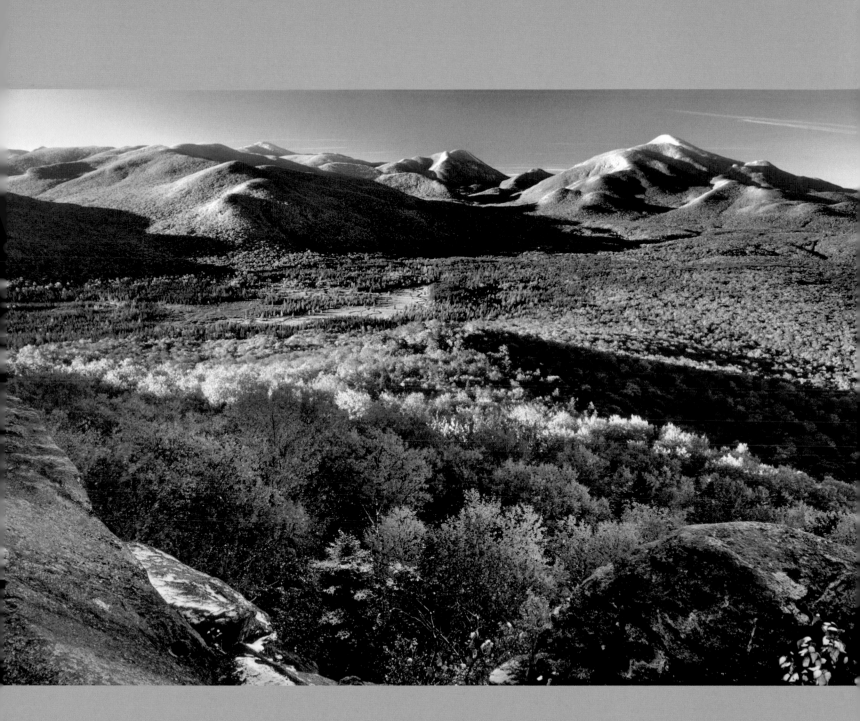

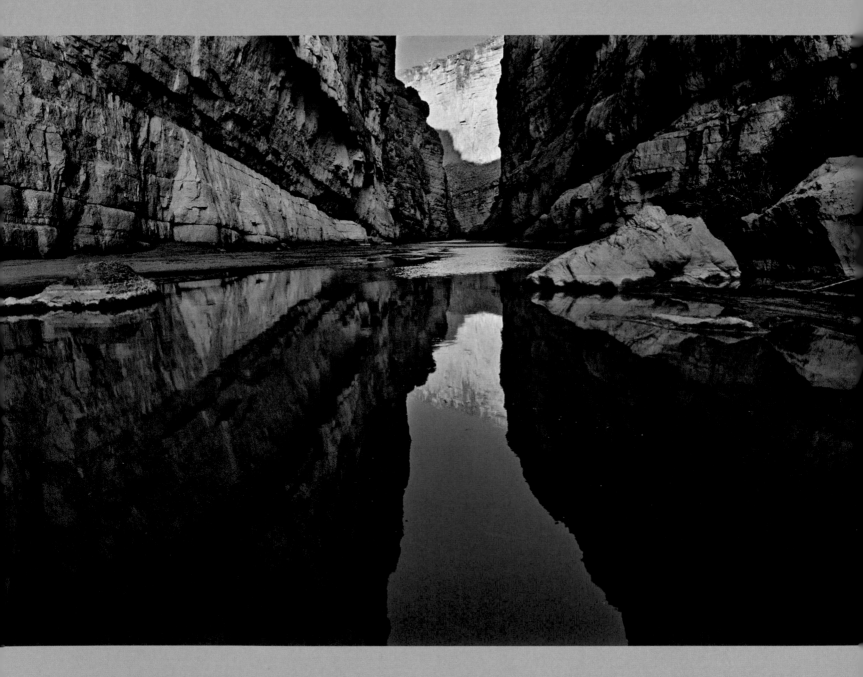

 LEFT: A balance of tones that draw the eye from the reflections of the sky in the water, to the sunlit cliff, help give a sense of the magnificence of this canyon. *Big Bend National Park, TX*

 RIGHT: The morning sun shining through the breaking fog was just right for picking out detail in the pickerel weed and flowers, and for the highlights in the fog. There is a balance of tones from the upper left to the lower right, and a balance of contrasting tones from the lower left to the upper right. *Lake Lila, Adirondack Park, NY*

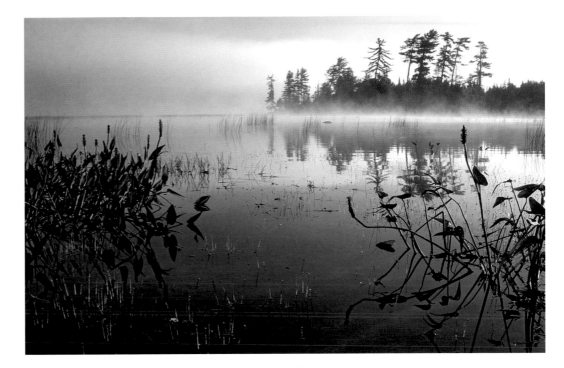

One of the best ways to judge the intensity of the light is by looking at the shadows. Are they soft and blending in, or are they sharp-edged and contrasty? Can you easily see detail in both shadow and highlight areas, or is there an intense contrast between them? In bright, contrasty light, consider working out in the open, photographing broad landscapes where dark shadows won't impact the scene as much. The softer, diffuse light of overcast days is great for photographing in woods, along the edge of streams and cascades, or for taking moody shots of harbors or cities.

Understanding the intensity of the contrast is also important for determining whether, and how much to bracket. Check the dynamic range of a scene by taking a close look at the histogram. If the dynamic range of the image comes close to both the black and white points, bracket by a stop either way, just so you're sure you have detail to work with using HDR imaging if it's necessary. You can also check the dynamic range of a scene by taking a spotmeter reading from the highlights and the shadows. To make an exposure, split the difference on the two readings and overexpose by 2 stops to produce an even exposure for both highlights and shadows. For example, if the spot reading on the darkest shadow is f/1.8 at a given ISO and shutter speed, and a reading on the brightest highlight is f/32, this is a range of 8 stops. The midpoint between the two would be f/8. Since highlights need to be overexposed by 2 stops from the 18% gray meter reading to yield white, making the exposure at f/4 would overexpose the mid value by 2 stops. This will also mean the shadows are underexposed by 2 stops, making them near-black instead of neutral gray.

The longer I've photographed, the more conscious I've become of both the intensity and the hue of the light wherever I am, and I always try to take into account the built-in "auto white balance" of human vision. Our brain automatically compensates for changes in the hue of the light, allowing us to perceive normal color tones in conditions where there has actually been a considerable color shift. While film is formulated to best match certain lighting conditions, a digital camera can be adjusted to use an automatic or manual white color balance setting, or one of several programed settings for specific lighting conditions. I generally use the "Auto" setting for outdoor landscapes, since it is so easy to do final color balance touch-ups in Photoshop, especially when you shoot Raw files.

MAKING WEATHER WORK FOR YOU

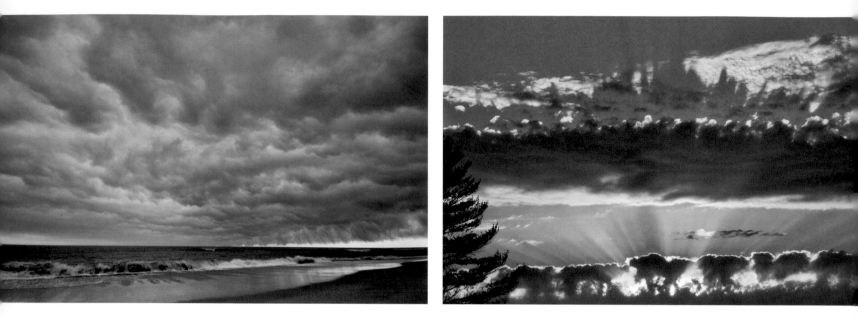

One of the most variable aspects of landscape photography is the weather. You can understand the principles of the camera, composition, and lighting, but getting the shot is still dependant on the weather. However, by having an understanding of why different conditions occur, the weather becomes something you expect. For example, why are some sunrise or sunset clouds so spectacular while others have no color at all? When can you expect fog in the morning? Why do some mornings have a lot of frost or dew, while others are relatively dry? Is it going to rain or snow? Why didn't I pay more attention to Earth and Space Science in school?

Essentially, there are two basic weather systems: high-pressure systems that have a clockwise circulation of relatively cool, drier air, and low-pressure systems with a counter-clockwise circulation of warmer, moister air. These weather systems move in a general west-to-east direction. The warmer, lower pressure air at the leading edge of a low, rises up over the more dense air of a high to form clouds, while the leading edge of a high, pushes in under the edge of a departing low.

The age old saying "Red sky at night sailor's delight. Red sky in the morning sailor's take warning," reflects the basic principles of these two weather systems. As the sun rises in the clear air of a High in the east, the warm, red rays of the sun light up the over-running clouds of the Low. The result is a beautiful sunrise, but only because of the clouds that are running ahead of the coming storm system. When a Low is passing by late in the day, and the clear air of a High is pushing in behind it, the clouds will begin to break and, as the sun sets, the light shining up on the clearing clouds will create a nice, dramatic sunset.

If you have plans to photograph, check long-range forecast maps daily on the internet. Make final

OPPOSITE LEFT: Approaching, or retreating, storm clouds can add drama to a landscape photograph, or even become the subject. *Outer Banks, Nags Head, NC*

OPPOSITE RIGHT: Crepuscular rays (God's rays) from the setting sun. *Adirondack Park, NY*

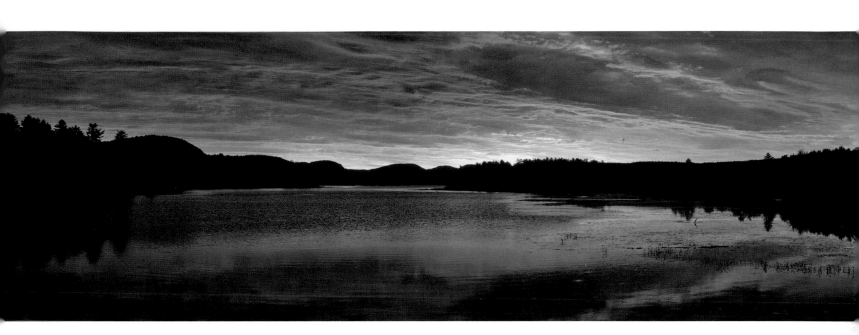

decisions on where to go—and when—by keeping a close eye on short range predictions, and then check the actual cloud movement with satellite imagery right before you head out.

Fog, frost, and dew are all related to the relative humidity of the air at night. Warmer air can hold more moisture than cooler air, and while the air cools overnight the moisture content doesn't change, only the ability of the air to hold that quantity of moisture. When the air cools down to a point where it can no longer hold all of the moisture, dew or frost—and possibly fog—will form, especially in valleys and near bodies of water. A general rule of thumb is that there is rarely mist or dew when the drier air of a High first moves in, but as it passes over, and the moisture from a Low mixes with the air, there is a much greater chance for fog, dew, or frost. At the ocean, a warm, moist, southerly breeze blowing over cooler waters can form a fog lasting as long as the weather conditions causing it.

TOP: Understanding basic weather systems will help you prepare for your shoot. For this shot, the over-running clouds of a low front were moving in overnight and the sun was rising in the moist, clear air of a departing high—the perfect conditions for a potentially stunning sunrise. *Brant Lake, Adirondack Park, NY*

RIGHT: A fisheye lens, used close to the subject, makes for a more abstract image. *Brant Lake, Adirondack Park, NY*

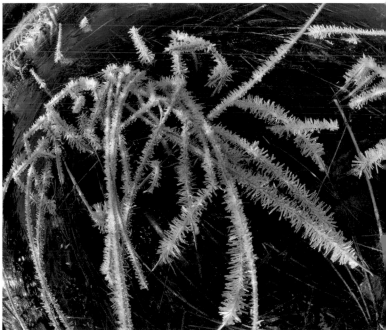

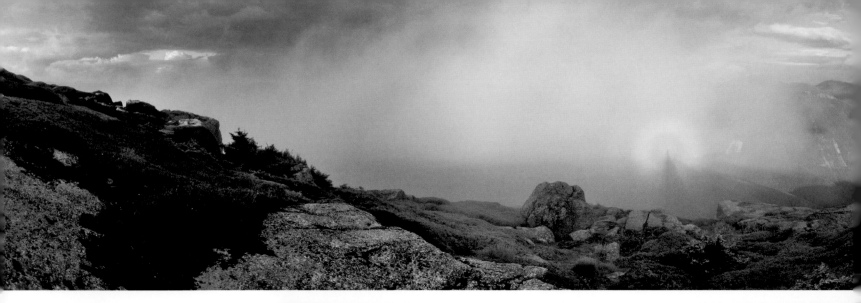

 ƒ22 **1/30 sec** **ISO 100** **FL 42mm** ABOVE: This 360 degree view revealed my shadow, the Specter of the Brocken, and surrounding "glory" in the misty clouds opposite the sun. *Algonquin Peak, Adirondack Park, NY*

ƒ11 **1/30 sec** **ISO 200** **FL 50mm** RIGHT: I saw the showers in the distance and knew I might see a rainbow over the ocean. I drove some 30 miles trying to get to the shoreline before sunset. *Fire Island National Seashore, NY*

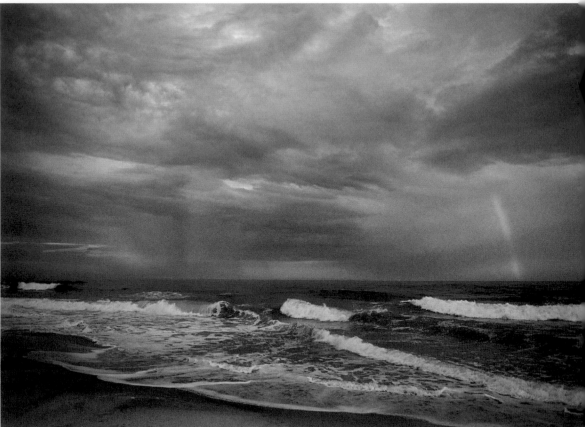

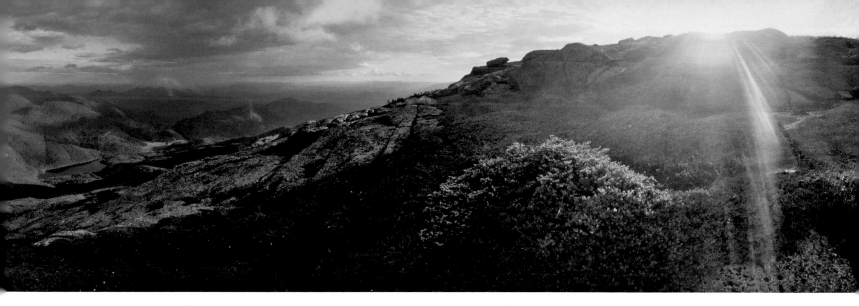

However, there are many variables in determining weather conditions, so you need to think ahead, always be prepared, and keep checking behind you—landscape photography is not about being in the right place at the right time, it's about putting yourself in the right place at the right time! It's about watching cloud movement and its interaction with the light and the landscape. It's about understanding local weather patterns and making your own predictions regarding photography conditions at specific times of the day. It's also about understanding the local ecology, blooming times, and the habits and habitats of local wildlife. But most of all, it's asking yourself that one simple question: What if?

Whenever I am photographing I am always thinking ahead to "what I might see." It's relatively easy to spot what's in front of you (or behind you) in the moment, but thinking about what is possible in the near future can be the difference between getting a spectacular and unique shot, or packing up and heading home. Some really great photographs do happen by accident, but being able to consistently capture "unexpected" photographs comes from keen observation and having an educated awareness.

Local weather can play a major part, especially when photographing in and around a mountainous area. Since both air pressure and temperature decrease with altitude, taller mountains create their own weather patterns, and this opens up many possibilities for special cloud and weather related photos, especially during changes in weather systems. The "Specter of the Brocken," for example, is a misty apparition of your shadow falling deep into the softness of clouds wafting around a mountain ridge. It is often accompanied by a "glory," which appears as a circular rainbow-glow emanating from around the head of the observer. It requires bright sunlight on one side, and a nice misty cloud on the other. These phenomena are most often seen from an airplane as it passes over clouds, but it is most dramatic when observed from just a few feet away on a wild mountaintop.

Facing toward the sun, light can also refract into individual, rainbow-colored points of light in snow, dew covered grasses, and spider webs. Rings around the sun or moon are formed from light refracting in the ice particles of high altitude cirrus clouds—the same phenomena that creates sun dogs, the bright rainbow-colored pillars of light seen usually when a low sun is shining through high cirrus and stratus clouds. The rings and sun dogs often foretell weather moving in.

There are also the clouds themselves—puffy cumulus clouds and billowing storm clouds, and lenticular, mackerel, and stratus clouds. Lenticular clouds form as wind pushes layers of warmer, moist air up into the cooler temperatures above tall mountains. They can stack up over the peaks in layers that can be thousands of feet high, and are especially dramatic when highlighted with the colors of sunrise and sunset light. There are also crepuscular rays, anticrepuscular rays, sun pillars, and, of course, rainbows! One of the best ways to become familiar with some of the weather related possibilities, is to research different weather-related books, or visit weather-related websites such as www.cloudappreciationsociety.org.

CREATING THE THIRD DIMENSION

Taking a photograph that you can "walk into" is a fun challenge, especially as the most important principle to remember is that a camera records a landscape on media that has only two dimensions. Our binocular vision gives us three-dimensional vision, but a camera sees with only one eye, and there is no sense of depth in a photograph unless we create it using lighting, composition, or both.

The main thing to remember is this is simply an illusion created by the placement and the perspective of objects and details within the image. It's about creating a composition that places subjects in relation to one another in a way that will trigger the brain to react as if it were taking in the actual view. Place your hand over one of your eyes and look around you—this is how the camera "sees" things. Much of what you look at with one eye will completely lose it's three-dimensional sensation, although certain combinations of objects might still be perceived as having depth. Look closely at the parts of the view where you get a sense of depth to see what makes these specific elements different to the rest. The composition may be simple or complicated, but is most likely based on just a couple of basic features.

Lighting, Lines, and Lenses

Low angle side lighting—when the sun is less than about 30 degrees in elevation above the horizon—creates shadow lines and contrast on the landscape that help give a sense of depth. The difference in light and dark areas draws the eye from one area of contrast to the next, pulling you deeper into an image. In soft light, tonal shifts in the objects themselves can create a similar effect, as gently contrasting tones and colors pull the eye from one object to the next.

Each subject in the view also has its own energy, based on its shape, relative size, and the intensity of contrast with its background and similar nearby objects. Colors, details, textures, and flowing or straight lines also have an energy that can pull the eye farther into the "distance" of an image. The eye also reacts to the size difference of similar objects, and we understand that those in the foreground will be larger than those in the background, especially when they are placed so that one leads to the next.

Wide-angle lenses are the most effective for creating compositions that offer a three-dimensional effect. The wider field of view makes it easier to work with a larger number of eye-catching subjects, while the greater depth of field makes it possible to work with subjects up close. This offers increased perspective between near and far, and with an ultra-wide-angle lens a tiny flower can be quite large in the foreground, becoming a main focal point that draws you into the rest of the view.

ABOVE: All it takes is the simplest of lines, tones, and perspective in sizes to create a sense of three dimensions. The sun draws the eye from the foreground footprint to the background. *Natural Bridge, Arikok National Park, Aruba*

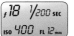

OPPOSITE: Perspective lines, shadow lines, and the relative size of objects, help provide a sense of three dimensions. *The Abbott School, Castine, ME*

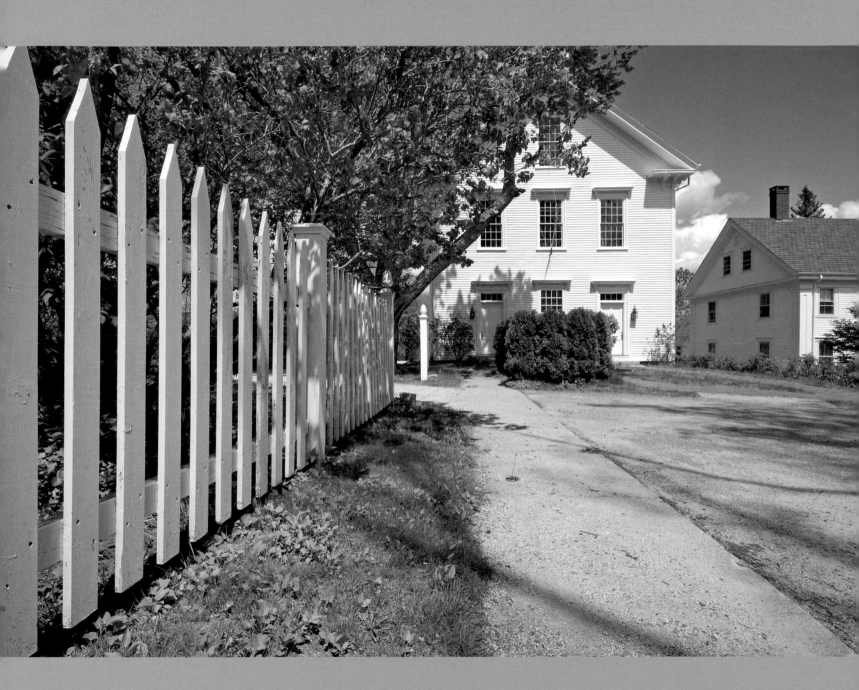

A SENSE OF PLACE

From the time I first started taking pictures with an SLR, my personal goal was to re-create the feelings of place—to portray how special and unique a place is, and to evoke the sensation of being there at the time the photograph was created. Capturing an image that conveys a sense of place comes from understanding all the techniques used for creating a photograph, including rules of composition, tonal balance, depth of field, and lighting. When it all comes together effectively there's a dimension to the image that adds atmosphere, depth, and life.

The composition can be simple or complex—a wide panorama or a sparse telephoto composition with only a few elements. It has as much to do with the timing of the photograph as it does with the actual place. The key is that the photograph encompasses the mood of being there, with a quality that evokes the energy of the location.

Knowing the subject and any features that help make that location unique is the key. For example, locations I return to regularly include the various mountain summits in the Adirondack High Peaks region. By visiting a location a few times you can develop a personal feel for its essence—what separates it from other places. Afterward you can figure out what light and weather conditions would work best to highlight the scene. The clarity of a winter sunset can make a rocky outcrop appear sharp and exciting, for example, though later in the year, when all the trees have filled out with a "spring green" color, there is a timeless sense of natural life. It is all about light and shadows, mountains and valleys, puddles and reflections, and the blue sky and approaching clouds highlighted by the light of a low sun.

It's not always possible to wait months, however. Many of the images here were more spontaneous,

or even affected by serendipity. For example, with the sunrise image of Lake George (opposite), I had been photographing the dawn light for almost an hour and was at first frustrated that a boat was ruining the stillness of the lake. I then realized this was the shot, and took the photo when the boat moved into position to give compositional balance to the image. This added "dimension" to the lake, giving perspective to the spaciousness of the view, and helping draw the viewer into the image.

The Death Valley sand dunes (below left) have many elements that keep the eye moving around the image. The textures and shadows of the foreground dune contrast with the vegetation and smoothness of the farther dunes. The footsteps on the middle left dune catch your eye, as do the shadows, lines, and curves of the farthest dunes. The fissured foothills in the background add depth and contrast and enhance the sense of place.

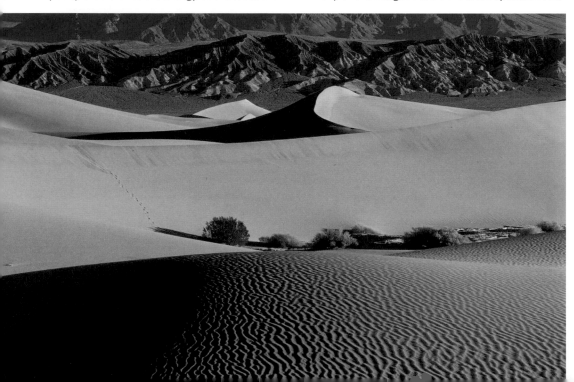

ƒ 16 1/30 sec
ISO 100 FL 28 mm

LEFT: Here, a number of details—footsteps, rippled sand, and rugged plant life—combine to give a feeling of the desert. *Death Valley National Park, CA*

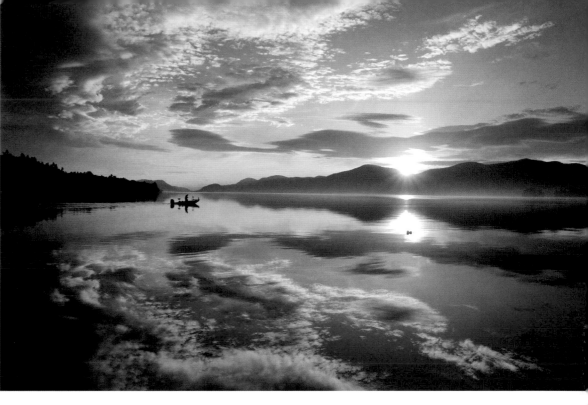

 RIGHT: The arrival of the boat on this still lake provides a key focal point that emphasizes the scale of the surroundings. *Lake George, Adirondack Park, NY*

 BOTTOM RIGHT: Framing this composition through the abandoned building helps tell a story about the location; that people have been and gone. *Red Rock Lakes National Wildlife Refuge, MT*

Creating a Sense of Place

- Lift your head from the viewfinder and allow yourself to feel the wider scene.

- Work with objects in the foreground that lead to other elements in the background to help create the illusion of three dimensions.

- Proportion the elements so the eye keeps moving from one to another in the image.

- Simplify to only the elements needed to convey the feelings of that moment.

- Note how varying weather and lighting conditions could affect the composition and mood.

- Anticipate what might happen, to be ready for the unexpected.

- Pre-visualize what you would like to happen so you can be ready when it does.

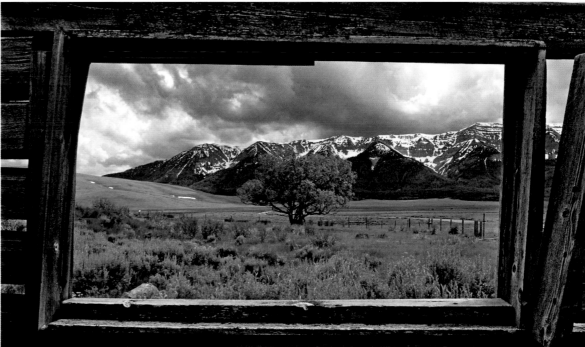

EVOKING EMOTION

A photograph that has the power to evoke an emotional response has the greatest impact on the viewer. There are many different aspects of composition that help stir a person's emotions. Each has its own unique energy and mood depending on the subject matter and tonal quality. Color, light, tonal contrast, texture, detail, perspective, lines, atmosphere, clouds, motion, potential and kinetic energy, subject matter, people, wildlife, animals, and expressions are among the many elements that can contribute to evoking emotion in a photograph.

There are several basic emotions—love, joy, surprise, sadness, anger, and fear. Combinations of these, along with additional stimuli, help create all of the subtle nuances we feel. We all have many different emotional responses to various stimuli that result in us simply being either happy, or unhappy, and it's the same with a photograph. When looking through the photos in this book there might be similar content in some of them, yet the unique combinations of elements in each one evokes a different emotional response. Each color creates its own mood; some are relaxing, others are more stimulating. A soft, warm-toned sunrise stimulates a different emotion to one with intensely lit clouds. Each new texture adds a different mood, while images that feature wildlife or people pull at us in yet another way.

One of the most important factors in evoking emotion in a photograph is being in touch with those emotions yourself. Don't try to work a scene too quickly. If you find you aren't feeling the emotions, take a few minutes to slow down and become absorbed by the scene. Treat it as a meditation. Close your eyes, feel the warmth of the sun, and tune in to the sounds around you.

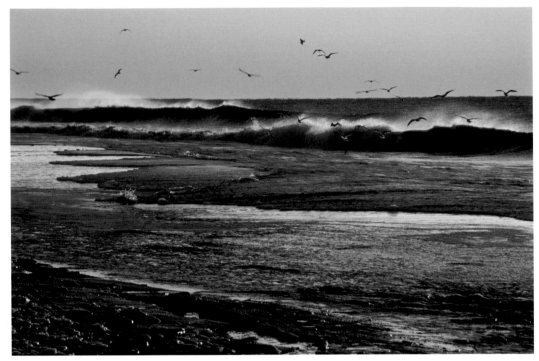

This is a process that can be practiced wherever you are, whether or not you have a camera in your hand. Take notice of whatever it is that attracts your eye and triggers an emotion. Perhaps it's a flower, or a color in the sky, or an action by a person or animal? Notice what type of emotion you are sensing. Is it happy or sad? Go further and feel where it affects your body, and how. Then notice whether there are any other features in the view that affect the composition and that mood. Maybe there's a whole flower bed involved, or there's a particular way the landscape is related to the sky, or there's another element that is a part of the action.

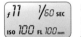

f 11 · 1/60 SEC · ISO 100 · FL 100 mm

ABOVE: The color of sunrise is a common emotive trigger, as is wildlife. *Jones Beach State Park, NY*

f 8 · 1/60 SEC · ISO 100 · FL 110 mm

OPPOSITE: Color, light, texture, and detail create a bold, yet dreamy mountainscape in the Great Smoky Mountains National Park. *Great Smoky Mountains National Park, NC*

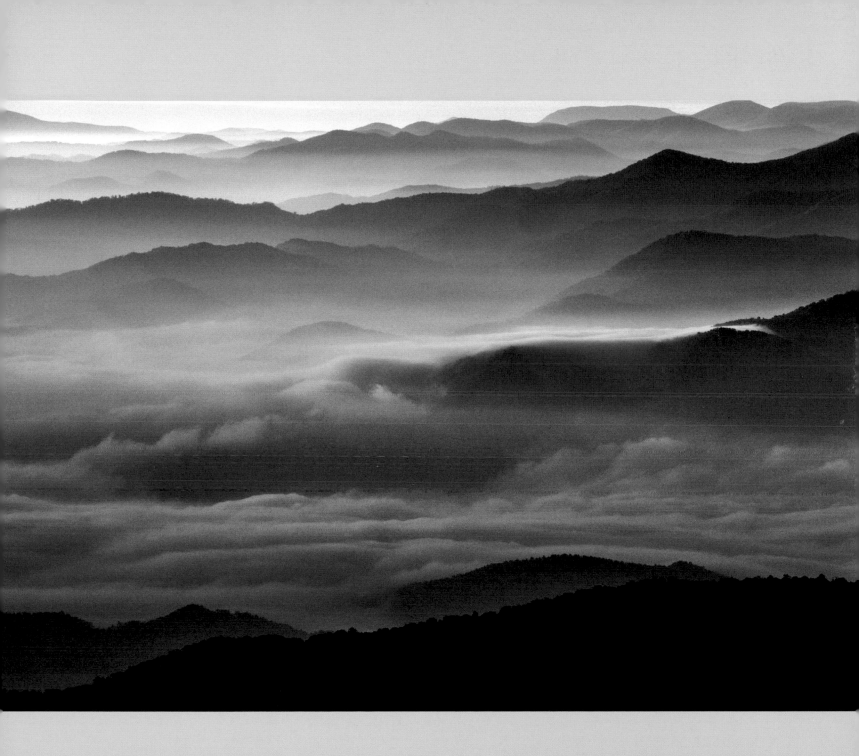

CREATIVE EFFECTS

Experimenting with creative effects takes us back to that main question: What if? What if I tried something completely different? What if I were to play with depth of field? What if I moved the camera while taking the shot? What if I played with the zoom during a long exposure? What if I panned the camera? What if I combined similar exposures? What if I combined two different images? What if I underexposed this image? What if I took a really long exposure, or combined a number of shorter ones? "What if" opens up endless possibilities, and it's all about imagination—and aperture and shutter speed.

All of the creative possibilities are related to the two basic camera principles that control depth of field and image motion. Beyond that it is completely up to your imagination. There is a photograph waiting to happen everywhere, but it is up to us to imagine it and create it. Bold, vibrant imagery jumps out at us and screams for us to take a photo, but creative images take thought and ingenuity, as well as experience, persistence, and a bit of luck. It takes a good working knowledge of how the aperture and shutter work together, a creative feel for how well your experiments are heading toward your vision, persistence to keep honing the image until it meets your goal, and sometimes a bit of luck as to how the components all come together.

Once you are comfortable with the basics, it's really about playing with the camera; getting an idea in your head that might work for the subject matter and just "playing" to see what happens. Playing with the amount of depth of field, and the focus point. Playing with the shutter speed to get a sense of motion, or lack of, and then checking the histogram, and thoroughly checking the image on screen after each shot.

The digital process offers the opportunity to experiment with creative techniques like never before. Being able to immediately scrutinize an image, and then immediately refine the technique for another image, is very helpful for the creative process. It allows you to fully fine-tune the entire shoot and photograph exactly what it is you are visualizing. There are no worries about burning through rolls of film just to get one good shot, only to be disappointed after waiting days or weeks to see the results, so let your creativity run riot. Take the shot any way you think, regardless of whether someone's told you it's the right or wrong way. If it doesn't work out, what have you lost? Nothing but a moment of time. But if it is successful, you'll have gained a whole lot more.

I was traveling across the Adirondacks on a drizzly, early spring day, and thought I'd stop to photograph a small rocky gorge along the Sacandaga River. While the light mist and high waters of spring provided a nice mood, it wasn't quite what I had hoped for, so I decided it was time to play and see what I could come up with.

After taking a "normal" photo (1), the first thing I did was to breathe on the UV filter on the lens, and let it evaporate a little to add a dreamy, misty effect (2).

Next, I put on a telephoto zoom and worked with the detail in the moving water (3 & 4), before liberating the camera from the tripod and panning the camera across the landscape (5).

The panning got me thinking about playing with different zoom effects, so I tried rotating the camera while I held the zoom barrel. I did that first on the broader scene, and then zoomed in to see what effects I might get on the foaming rapid. The tight shot with the whirlpool effect was one of my favorites from the shoot (6).

1	2	3
4	6	
5		

East Branch Sacandaga River, Adirondack Park, NY

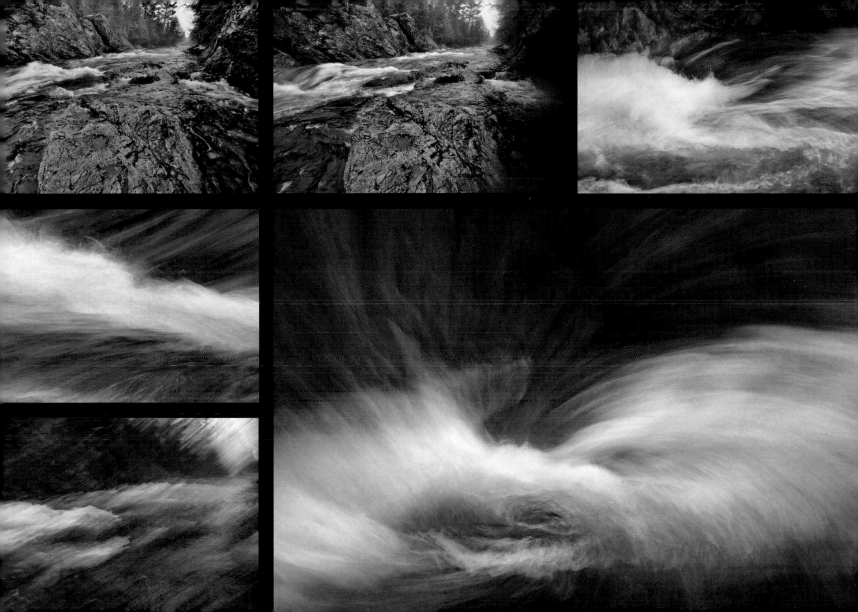

SELECTIVE FOCUS & SOFT FOCUS

 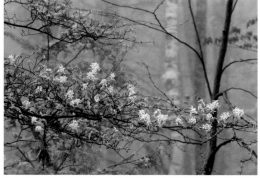 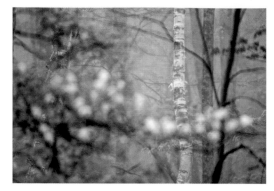

The amount of an image that appears to be in focus is determined by the aperture, as well as the focal length of the lens. While I use wide-angle lenses and a small diameter aperture to maximize the depth of field for many of my landscape photos, telephoto lenses with wider aperture settings work best when I want to emphasize a particular detail and isolate it against a soft and fuzzy background. The basic principles were covered in the first chapter.

When photographing details with a wide aperture and a telephoto lens, it's also possible to photograph "through" leaves, flowers, and other soft detail, where the colors of the leaves or flowers around or over the selected focus point add a soft focus effect. Experiment with different aperture settings and focal lengths, and check each image using the depth of field preview button, or shoot sample images and view them closely on the LCD screen.

When it comes to creating an overall soft focus effect, there are several options. Dedicated soft focus lenses are often used for wedding and portrait photography, but due to their occasional use and high price they generally don't make their way into a landscape photographer's equipment

bag. There are also soft focus filters that you can attach to the front of a regular lens, although some people simply smear Vaseline on a skylight or UV filter to create a soft effect. But what I tend to play around with more in the field is much easier, and far more cost-effective—I just breathe on the UV filter on the front of the lens. It tends to evaporate from the center, outward, which offers all kinds of options for the intensity and location of the effect. Simply breathe more heavily in the areas where you'd like more of a misty effect, keep watching through the viewfinder, and click the shutter when your breath has evaporated to the desired amount. It's not very scientific, but this is all about creativity!

The final option is to apply a soft focus effect in your image-editing program, but while many different effects can easily be created in Photoshop, there is nothing that can recreate a properly composed selective focus image. There is also software that will work in the opposite direction—enhancing the depth of field by compositing images focused at different points in a scene. This can be helpful at times, but again, it is better to understand how to create these types of images with the camera and lens.

ABOVE: Selective focus works well when you use a long, telephoto lens and a wide aperture setting. The choice of focus point is also important. All the shots in the sequence above were taken with a 200 mm focal length. The first was shot with an aperture of f/22 and everything is sharply focused. Opening up to f/9 gives more choice—focusing on the leaves closest to the camera in the first shot, and the trees in the background in the second image. *Adirondack Park, NY*

TOP: Breathing on my UV filter added a misty effect, putting an emphasis on the needles in the foreground, and adding mood and mystery to the background. *Adirondack Park, NY*

BOTTOM: This photo was more about the phlox, but as I was setting up I noticed the crab spider as well. Note the soft edges of the leaves, which frame the image and concentrate the focus on the flowers and spider. *Adirondack Park, NY*

MOTION BLUR & CAMERA BLUR

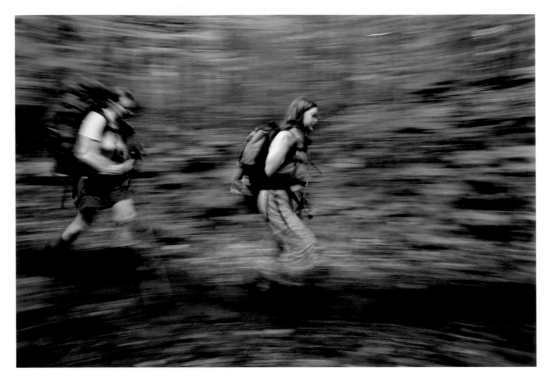

camera with any moving subject—flowing and falling water, flying birds, running animals, falling snow—anything that is moving! Or try panning the camera on still subjects—panning vertically on grass reeds, or tree trunks at the water's edge, for example—or experiment with holding still on the subject briefly, then panning in the same exposure. The possibilities are endless!

A third idea is to adjust the focal length of a zoom lens during an exposure. Adjusting the focal length while the camera is on a tripod gives a flare effect to highlights in an image, which emanate from a central point. Handholding the camera while zooming opens up many more possibilities. Try zooming while panning on a subject, or, instead of zooming the lens, try holding the lens barrel and rotating the camera (with a rotating zoom lens) to get a whole different creative effect. Just imagine, play, and keep checking to see what's working out (and what isn't), before practicing more with the techniques that work best.

There are two basic ways to create blur from motion in a photograph—motion blur and camera blur. Motion blur generally comes from keeping the camera still and controlling the shutter speed, while camera blur is created by panning the camera to follow the a subject, or moving the camera and/or lens to create a blur effect in a static image. Both use longer than normal exposure times to create the effect.

Adjusting the shutter speed to affect the amount of blur in a subject opens up all kinds of creative options. Since the amount of blur is dependent on both the focal length being used and the speed of the object being tracked, there is no definitive answer on the specific exposure time required to create a certain amount of blur. The effect is really more of a personal, creative thing, so it's best to experiment to see what works best in any given situation. The shooting specs listed with the images shown here will help give a starting point for settings, but every situation is unique and needs to go through its own trial and error session.

Moving the camera during an exposure opens up different options. Stabilized lenses, with continuous autofocus turned on, are great for panning on a subject, as the stabilization helps hold the lens steady while tracking a subject. Shoot several exposures while tracking the subject's motion as it can be tough to know exactly what the background will be when you actually take the shot. Plus, it usually takes several attempts to get one shot that comes out just right. You can pan the

TOP: Panning on a moving subject is a fun way to portray action. This was a 1/4 sec exposure with a 35 mm (full frame) lens with a pair of hikers walking along at a good pace. *High Peaks Trail, Adirondack Park, NY*

OPPOSITE: It was snowing with plenty of nice big flakes, and I got thinking about trying something different. I asked myself "What if I tried panning on the snow as it's falling?" *Brant Lake, Adirondack Park, NY*

MULTIPLE EXPOSURES & IN-CAMERA COMPOSITES

LEFT: Multiple exposure composites can be done in-camera or in an image-editing program. It's fun to experiment in the field, but Photoshop offers more control for placement and tones, as in this composite of a floodlit night landscape and the moon. *Fourth Lake, Adirondack Park, NY*

OPPOSITE: I focused on the nearest tulips and took the first shot, then focused slightly farther into the flowers and made a second exposure. Two more exposures, each focused slightly farther from the camera resulted in this dreamlike multiple exposure. *Highland Park, Rochester, NY*

Multiple exposure photos are composited images that contain a multiple of short exposures—or longer exposures—in a single frame. They can combine different exposures of the same image, or sandwich two or more different photos to create a unique sense of action.

Sandwiching different images is best when the dark areas of one image blend with the light areas of another. An "Orton"—named after Michael Orton, who experimented with sandwiching two slightly overexposed slides together and re-photographing them—is a sandwich of two exposures of the same image, where one of them is in focus, and the other one is not. This adds a wonderful, dreamy effect to a photo and is best created using a larger aperture for a reduced depth of field in each exposure. By changing

the focal length of a zoom lens it's possible to adjust the field of view of the focused image to more closely match that of the out of focus one, and taking this process a step further, I've played around with creating multiple exposures that use multiple focus points. For example, the photo of the tulip beds is a composite of four different exposures, all shot on a tripod, but each with a different focus point. One was shot with a near focus point, another with the farthest point in focus, and two with different focus points in between.

Multiple exposures can have all kinds of combinations. Try overlaying a still image with a zoomed image, or a panned image. Experiment and adjust the effect by underexposing one image and overexposing the other. For even greater control, play around with the image overlay

feature found on some cameras that composite two different images. You can composite different exposures of the same image shot on a steady tripod, or you can sandwich completely different images. This feature will create an additional image file, which can then be composited with even more images.

With digital technology it's also possible to use the multiple exposure feature to mimic a very long exposure effect. Instead of using a neutral density filter to create a longer exposure, create a multiple exposure of several different original exposures shot on a sturdy tripod. This will create a similar result to adding a neutral density filter over the lens to cut down on the amount of light and lengthen the exposure.

All of these thoughts can be applied to multiple exposures shot using the interval timer as well—all options that keep bringing us back to the fundamental question: "What if?" It's all up to your imagination and your understanding of the shutter speed and aperture.

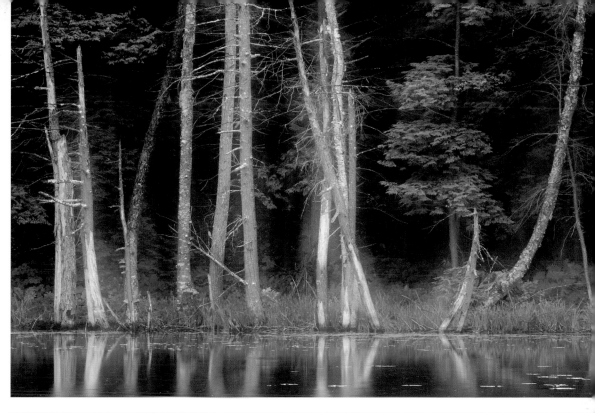

OPPOSITE: To create a feeling of motion in this shot I composited ten separate exposures. **"The Gates,"** *Central Park, New York City*

ABOVE RIGHT: A sharply focused image combined with an out of focus one to create an "Orton." *North Pond, Adirondack Park, NY*

RIGHT: This image is made up of about 30 fast exposures—each shot as I panned up and down over a number of dead trees standing at the edge of a wetland. *Osewego County Nature Park, Lake Lorraine, NY*

PATTERNS & FINE ART

LEFT: The woods were beautiful on this day, but it was the detail of this silhouetted branch that really caught my eye. *Adirondack Park, NY*

What is it that makes us consider a photograph to be "fine art?" What makes one image a fine art print, and another not? As he was critiquing some of my images, one gallery owner I met suggested that many of my photographs were "location photography," while some were "fine art." While the photos that defined a location and had a "sense of place" were well done, they weren't considered by him to be "fine art." That conversation stimulated a considerable amount of thought and I've been mulling over the definition of "fine art photography" right up to this final moment of truth.

According to a number of online definitions, fine art photography refers to photographs that are created to fulfill the creative vision of the artist—a definition that is vague enough so each photographer can decide what is "fine art" and what is not. In picking my own images for this section, I was drawn to the ones that have a complete energy of their own, and would be tough to caption as being from any particular place. They don't compel the mind to add labels, but rather ask us to be absorbed into the flow of their energy. Their composition is about the depth of simplicity and a feeling of timelessness.

So perhaps less is more when it comes to fine art? These "fine art" photographs have all been refined down to their essential ingredients and composed so there is a subtle flow and interplay between all of the elements. The images ask as many questions as they give answers, and beckon you to look deeper to find a hidden meaning. It's almost as if each image has its own soul, yet you find a part of yourself within the image.

Each photograph has it's own mystery. While the images are about the details, there is a unique interplay of the lines, contours, textures, and colors or tonal contrasts. They are not about the whole story that was going on at the time, but they each have a complete story of their own. They offer a picture of the greater perspective by giving away only a few details.

Could it be that fine art landscapes are therefore about the subtleties of nature—the finer details, the softness of light, and nuances of the varied tones and patterns of nature? Images that are about symmetry, or chaos, but have a way of making complete sense of both?

LEFT: I had walked past this tree many times, eventually photographing it when the nearby shoreline was enveloped in fog, which helped highlight and fill in the detail on all sides of its weathered trunk. *Ocean walk, Acadia National Park, ME*

TOP: The lines on these leaves are striking. The patterns and symmetry pull you deeper into the shadows. *False Hellebore, Adirondack Park, NY*

ABOVE: A long exposure of surf in misty light, as the ocean foams over the cobblestones. *Cobble beach, Acadia National Park, ME*

LINES & ABSTRACTS

Image composition is really all about the lines. Tonal balance and contrast is important, but much of what catches my eye in a landscape has to do with lines. Horizon lines, lines of mountains, waves on the water, shadow lines, curving and straight lines, single lines, repeating lines, and the wonderful flowing lines found in different patterns and textures as well. Sometimes the interest is in the lines themselves, while other times the lines are an integral part of what draws me into the rest of the landscape.

The lines may stand out in some way by themselves, as a silhouette, or may be a very integral part of a subject in the photograph. Some lines are completely chaotic and create more of an abstract, while others create a pleasing pattern. Other lines need to be imagined, and don't appear until after an exposure is taken. Flowing water has many lines in the current that show up in a long exposure, but aren't readily seen when glancing at the surface of the water. Long exposures of any moving subject will create lines that only show up in a photograph, so need to be imagined during composition.

There are lines everywhere we look—in the desert, the forests, the mountains, and oceans, as well as in fields, farms, and cities. The lines that become most interesting are those that contrast within the image: Concave next to convex, straight next to curved, vertical or horizontal, lines that are perpendicular, triangles compared to squares. All add a different interest and texture to a photograph.

There are also outlines of shapes and textures. Borders of details often become outlines in an image, and shadows and other edges of contrast can create a system of lines throughout a picture. While we look at a scene as a whole, the eye is keying in on the lines that create textures, with the most pleasing having the best balance.

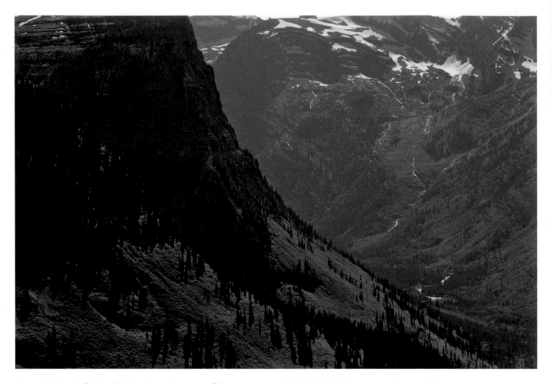

It can be helpful to think about some of the general rules of composition when looking at the lines that form the image. The Golden Spiral or Golden Triangle, for example, can help provide guidelines for the placement and proportions of lines within an image.

There are times when intensifying and isolating lines against a softer background works best, while other times they are better when they blend right in. Since lines in nature often tend to be chaotic, an effective composition comes from finding or creating a balance in the chaos that is pleasing to the eye. Ultimately, lines add an energy to a photograph and help direct us through and around the image. They can take us in a direction, or can be a defined stopping point.

ABOVE: Most striking here are the edge lines of the mountains that help define distance. But it is the vertical lines of the trees and shadows, and the soft lines in the valley that add greater interest. *Glacier National Park, MT*

OPPOSITE: Photographed from a mountain ridge about 1,600 feet (500 meters) above the water, this is a very abstract pattern of lines and details. The sailboat helps offer a point of reference. *Lake George, Adirondack Park, NY*

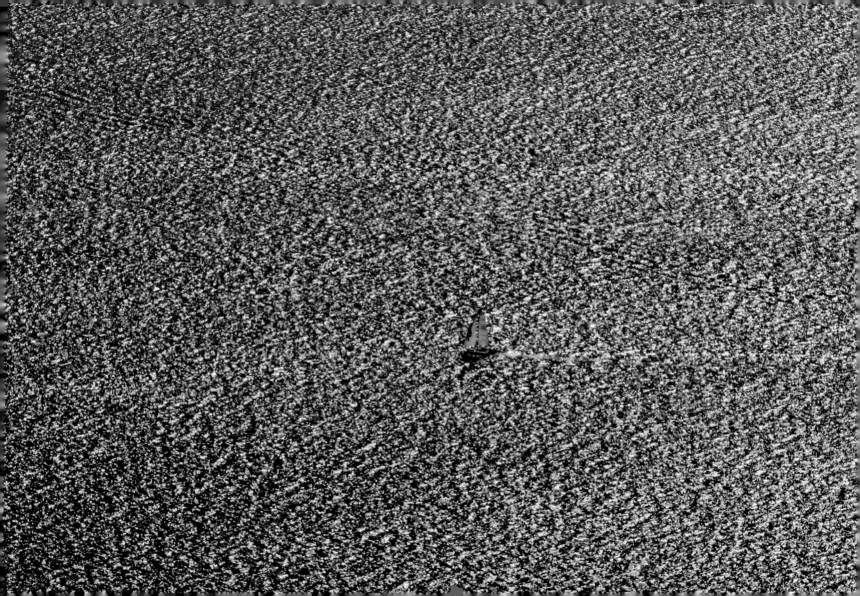

INFRARED LANDSCAPES

LEFT: Although some digital SLRs are capable of recording infrared images not all of them are. Most can be professionally converted to shoot infrared pictures, but once they have been converted they may not be able to take a "normal" photograph. *Castine, ME*

OPPOSITE: A traditional infrared image, shot on film. Blue skies with white, fluffy clouds, and foliage are most noticeably affected when you shoot infrared landscapes. *Near Lyons Falls, NY*

Infrared (IR) photography has had a mystical allure ever since the film became commercially available in the 1930s, and the addition of false-color infrared film in the 1960s added an extra dimension. Shooting infrared with film requires the use of specific orange, red, or visually opaque infrared filters that block out varying amounts of the blue wavelengths of visible light. The film reacts to the near-infrared wavelengths, so subjects that reflect higher amounts of infrared wavelengths appear brighter in the photograph.

Infrared images are typically black and white, with the whitest areas coming from healthy, green vegetation that reflects a high percentage of infrared light and gives a sort of "snowstorm" effect to a spring or summer photograph. Clouds also reflect infrared wavelengths and appear bright, while a bright blue sky contains very little infrared light, creating a dramatic intensity as brilliant white clouds contrast with a near-black sky. There is also a slightly soft, dreamy effect with infrared images, from the scattering of the infrared light waves as they reflect from the details in each subject.

Shooting infrared the traditional way—with a digital camera and IR enhancing filters—can

range from being interesting and fun, to near-impossible. Although digital sensors are reactive to infrared wavelengths, most digital cameras use an IR blocking filter over the sensor. As a result, adding an IR *enhancing* filter to the lens will simply cut down the amount of light that is recorded by the sensor (the filter over the sensor will effectively negate the effect of the filter over the lens), so exposure times become extremely long, without creating an infrared image. Therefore, if you're considering using a camera that you already own for infrared photography, it's best to do a bit of research before investing in an expensive filter, to be sure you can actually capture infrared images with your camera.

If your camera isn't capable of infrared capture, there are a number of options. For example, if you definitely want to shoot infrared, some digital cameras are made specifically for infrared photography, while others let you change or remove the internal filter so the camera records infrared light. Failing that, almost all digital SLR cameras can be converted to shoot infrared, although the conversion process is expensive, will invalidate any manufacturer's warranty, and potentially limits the camera to only recording infrared images, so is perhaps best only considered if you have a "spare" camera body.

Alternatively, there are a couple of post-processing techniques covered in the last chapter that mimic the infrared effect. They actually offer many more options when it comes to making adjustments and creative effects. Plus, in addition to having the processed infrared image, you also have an original color file as well.

LANDSCAPES, SCENICS & CLOSE-UPS

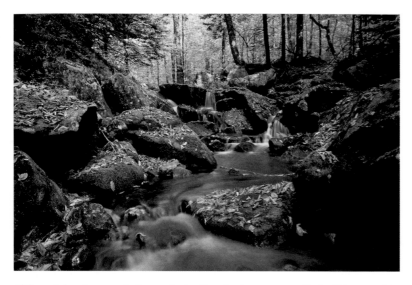

Although landscape photography is often broken down into seascapes, mountainscapes, cityscapes, and so on, they all still fit under the main heading of landscape, and the phrase "landscape photography" encompasses a diversity of subjects and compositions. This means there are options for shooting landscape and scenic images almost everywhere we look. Subjects can include lakes, mountains, fields, farms, parks, gardens, cities, towns, buildings, wilderness, harbors, oceans, and skies, plus all of the details contained in between—anything other than that would be limiting and attempting to place a portion of the landscape within a box. People and wildlife are also as much a part of the landscape as the mountains and lakes, and can be portrayed as such.

As a general rule, though, landscape photographs are typically scenic images or close-up detail shots. Different focal lengths offer an infinite number of ways to portray the landscape—from fisheye lenses and zooms, to macro and super telephoto lenses. While telephoto and macro lenses are used mostly for "close-up" type detail, and wide angle lenses are generally used for the grand scenic images, some of the more unique imagery comes from overlapping uses of the different lenses.

Landscape photography can be simple documentation, but it can also be creative imagery that draws a person into the whole through the essence of the details. Both styles require composition and technical skills, and a connection to place. While good documentary photography provides a sense of place, artistic interpretations help draw people into the spiritual qualities of the subject through the soul of the photographer. To help with this, the landscape around us is always evolving and adapting; the weather is always changing and each person sees the landscape with a fresh perspective and photographs it in a unique way. Even if we were to look at the same landscape all of the time, it's in a constant state of flux, so there would always be a new way to portray it.

LEFT: Working in the woods has its own set of challenges—and rewards. *Spuytenduivel Creek, Adirondack Park, NY*

ABOVE: The horses add a great sense of place to this frosty, farm scene. *Adirondack Park, NY*

OPPOSITE: While I rarely use a "standard" lens, this detail was photographed with a 35 mm focal length (52 mm equivalent). *Wiscasset, ME*

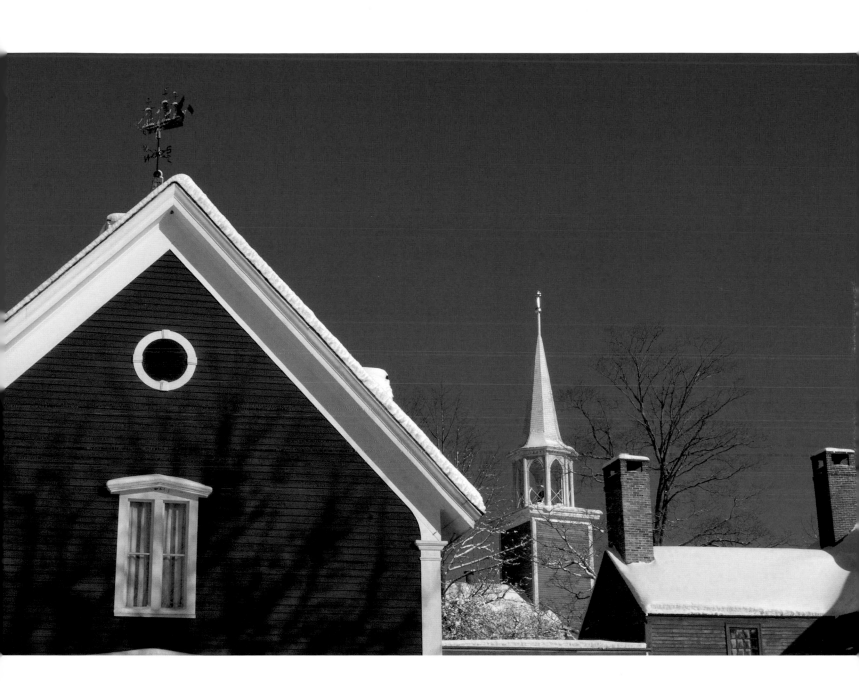

WIDE-ANGLE STORIES

I rarely shoot with a "normal" focal length lens, and mostly use either wide-angle focal lengths or telephoto. It seems I'm either looking at the really wide picture, or the details within. Wide-angle lenses offer many different options for landscape photography composition, but above all they are excellent at capturing the feel of wide open spaces. By including so many different details within an image, photos shot with a wide-angle lens really help define a location. For example, you can play with a composition over such a wide area—as much as 84 degrees wide with a 24 mm full-frame lens, and 114 degrees wide with a 14 mm full-frame lens. Even more compositional fun comes from having the extra depth of field to work with. This adds so many different shooting options, and is one of the main reasons why I expect to continue shooting with the APS-C format for most of my landscape work.

As I discussed earlier in the book, the smaller APS sensor requires a wider angle lens to get the same field of view of a full frame or 35 mm SLR. So, while the 10-20 mm zoom I use on my APS-C sized sensor provides focal lengths equivalent to a 15-30 mm lens on a full frame camera, it has the increased depth of field that comes from a 10-20 mm focal length. The depth of field difference offers a lot of composition options when you consider that at f/22, a 20 mm lens has a hyperfocal depth of field from 1 foot (30 cm) to infinity, while a 30 mm lens has a hyperfocal maximum of just over 2 feet (60 cm) to infinity. It may only be a 12-inch difference, but being able to have an object in focus that is a foot closer to the lens can open up a host of additional composition perspectives.

The easiest way to play with depth of field is to set the lens to it's minimum aperture, set the hyperfocal focus point settings on the lens, and then set up the camera so it is within range of the nearest focusing point of the closest subject in the composition. Then check through the viewfinder to adjust the final balance of the image composition. Be sure to check out other angles with your wide-angle lenses, too. We most often think of broad mountain, lake, or skyline shots with a wide-angle lens, but you can use them to offer more detailed perspectives as well. Think high and low. Tilt the camera up, down, sideways, vertically, and horizontally. Look at flower beds close-up, or look down from up above. If a subject happens to have an unusual angle or curve, take a closer look—with a wide-angle lens—and see what kind of less conventional perspectives you can come up with. Some will work, others won't, but by exploring different angles you are potentially creating unique images.

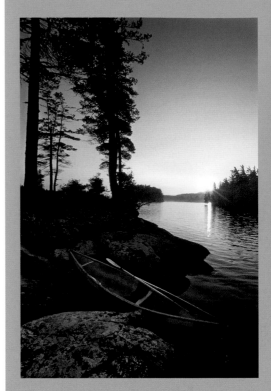

 ABOVE: I shot this image from a standing height to give more perspective to the water, which is a major part of the image. *Saranac Lake, Adirondack Park, NY*

 RIGHT: This is a wide angle view of the mountain/fog layers image on the following page, showing just how important it is to look at a view from many different perspectives. *View from St.Regis Mountain, Adirondack Park, NY*

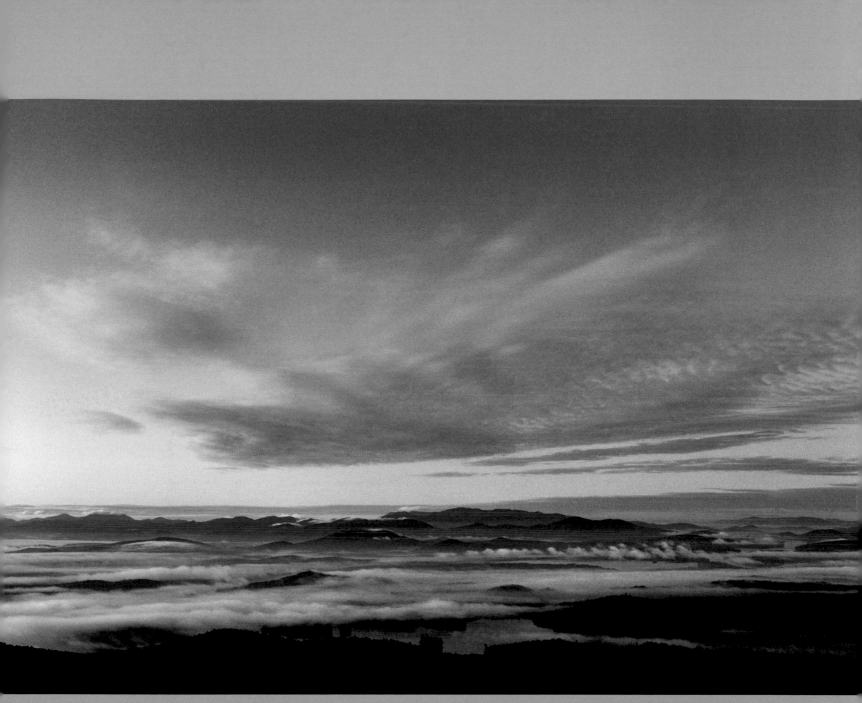

TELEPHOTO DETAIL

Working with a telephoto lens is like photographing the landscape through a spyglass, as longer focal lengths hone in on the eye-catching details found within a wide-angle view. While wide angle images are often composed of a number of different, loosely related subjects, the details in telephoto images are tightly integrated, isolating and enhancing the individual details that make each landscape story unique. Landscape composition with a telephoto lens is most often about the lines, textures, and tones in the image. Since a telephoto lens tends to compress the foreground into the background (and has minimal depth of field capability), there is really no way to create a sense of depth and dimension in a photo. But don't think of this as a limitation, work with it to your advantage to create more abstract images that work precisely because of their almost two-dimensional appearance.

When working to isolate a single detail against a background, choose a wide aperture so the background appears soft and without any detail at all. That's the easy way to work with a telephoto lens. It's tougher when you want to have a specific amount of the image in sharp focus, while still having some blur to the background. This becomes a balance of how close the camera needs to be to the subject in relation to the focal length needed to get the framing and depth of field desired, plus how soft you want the background to appear.

As telephoto focal lengths have less depth of field to work with, you need to pay more attention to the hyperfocal settings to control the effect in the image. Working closer to the subject with a shorter focal length lens offers greater depth of field and a more detailed background, while working with a longer length lens from farther away decreases the depth of field options. Check

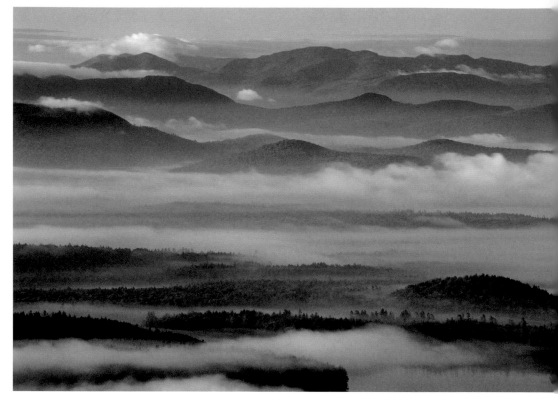

the composition in the camera with the depth of field preview button, and then carefully check the final image on the screen for sharpness, softness, and any signs of undesired motion.

Movement is the biggest concern when working with longer telephoto focal lengths. When the lens is tripod-mounted, be sure to turn off any stabilization to avoid blur as the lens attempts to lock in a photo. Also, some of the best telephoto landscape images are taken in low or soft lighting conditions that often require the use of slower shutter speeds, so use the mirror lock-up feature with shutter speeds less than 1/100 sec.

ABOVE: While the wide-angle view on the previous page gave a feel for the whole view and sky, the telephoto detail photo enhances the wonder of the moment. *View from St. Regis Mountain, Adirondack Park, NY*

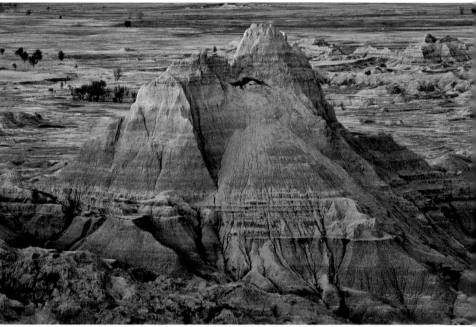

 ABOVE: Telephoto lenses compress depth, emphasizing details and creating more abstract images. *Adirondack Park, NY*

 TOP RIGHT: A 200 mm lens compressed this dawn landscape into a mix of lines and textures. *Badlands National Park, SD*

RIGHT: Long lenses are not just for distant shots—these ripples and reflections were taken from about 10 feet (3 m) away. *Schroon River, Adirondack Park, NY*

PANORAMIC VISTAS

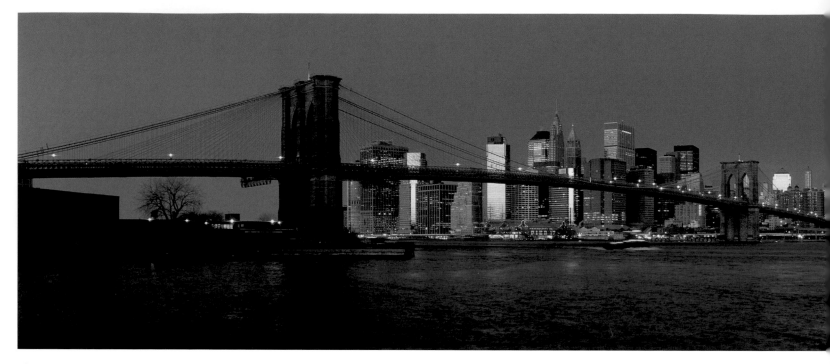

Almost any image that is cropped to a 2:1 aspect ratio or wider is considered "panoramic," but a true panoramic image is one that has a wider degree of view than that of human vision, which is about 160 degrees. This is a wider field of view than can be shot with any wide-angle lens, except for a fisheye lens, so true panoramic images need to be created with specialized rotating lens or body cameras, or by using a sequence of individual digital images and stitching software.

While panoramic images can be created in all types of landscapes, there are many more elements that need to be considered for an effective panorama. For a start, all of the general rules for subject placement and tonal variations apply to panoramic compositions, with the only real difference relating to the interpretation of horizontal lines. In standard format photography most lenses are rectilinear. There might be some length distortion with wide-angle lenses, but straight lines are straight and curved lines are curved. This is not so when working with panoramas.

To demonstrate this, stand back from the center of the edge of a table. Extend your arm so it points at the center edge and slowly turn your body, keeping your arm at the same height. As you turn left or right you will notice that the table edge appears to "rise" above the level of your hand. The effect is more pronounced if you are looking at a convex curve, where the ends of the curve are going away from you, and less obvious with a concave curve. The same applies to panoramas that are shot from one central location: straight lines will become curved, convex curves will become even more curved, and concave lines will straighten out. So, set the camera up on the inside of a curve to straighten it, and the outside of a curve to exaggerate it.

We'll cover the mechanics of stitching panoramas in the final chapter, but when you shoot a panoramic sequence you should aim to rotate the camera around the nodal point of the lens, with an overlap of 20–35% between frames to allow your stitching software to work efficiently. Shooting a sequence of images using a vertical orientation will increase the number of pixels in the height of a panorama, and the resolution and field of view can be increased further by shooting multiple rows of images. When it comes to processing, stitch each row individually, and then stitch these together.

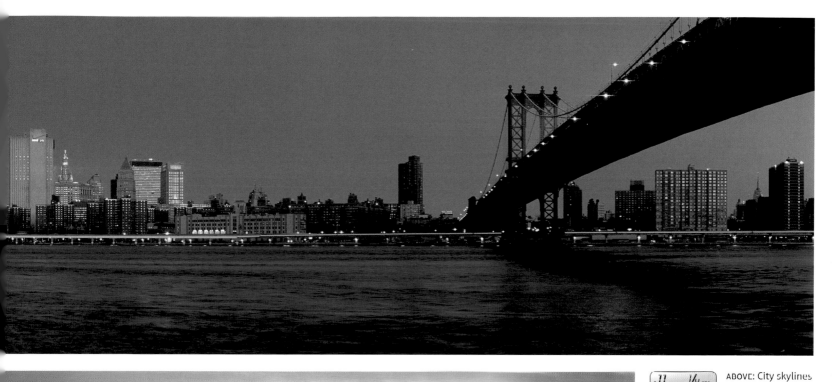

ABOVE: City skylines make effective panoramas, especially at dusk or dawn. *New York City*

CENTER LEFT: A predawn hike was needed to catch this sunrise over fresh snowfall. *Blue Mountain View, Adirondack Park, NY*

BOTTOM LEFT: Setting your exposure manually is essential if you are shooting an extremely wide view that will contain a range of lighting conditions. *Boca Prins, Arikok National Park, Aruba*

MACRO LANDSCAPES

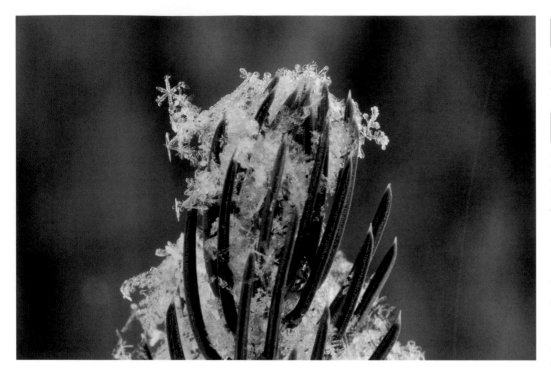

f22 5 SECS
ISO 400 FL 150mm
LEFT: A 70-200 mm zoom lens with an extension tube revealed the delicate snowflake detail on this spruce tip. *Adirondack Park, NY*

f22 1/15 SEC
ISO 200 FL 20mm
OPPOSITE: Using an 8 mm extension tube on a 20 mm lens let me work with the lens almost touching the flower, while still offering a sense of the landscape in the background. *Lake George, Adirondack Park, NY*

Although each aspect of landscape photography presents its own challenges, working with macro equipment is one of the more demanding facets. Effectively viewing the landscape through a magnifying glass can provide us with a whole new way of looking at the world, and it can be much more than just photographing a specific subject.

There are several equipment choices for taking a closer look at the landscape, which range from macro-capable lenses, to extension tubes, bellows, and close-up lenses (often referred to as close-up filters). A true macro lens will offer a 1:1 ratio, where the subject size on the image is the same as the size of the subject being photographed. A 1:2 lens images subjects at ½ of life size, while 2:1 will provide 2x magnification, and so on.

Extension tubes offer an inexpensive way to turn 20 mm and longer focal length lenses into macro equipment. At their most basic they are simply a hollow tube that moves the lens farther away from the camera body. Different sized extension tubes have different effects, but one of the fun things I enjoy playing around with is using a very thin (8 mm) extension tube on a 20 or 24 mm focal length lens. Using a small aperture to maximize the depth of field lets you position the lens almost up against the subject, so the main emphasis is on the foreground subject, with enough detail in the background to provide a sense of place.

Close-up lenses screw to the front of a lens like a filter (which is why they're often called close-up filters, despite not filtering the light in any way) and come with different magnification strengths, ranging from +1 to +4 diopters. Adding a close-up lens to a conventional lens will allow you to focus closer, but they don't offer as many options as extension tubes. However, these filters shouldn't be disregarded. They can be stacked to increase their effect, used to add additional levels of magnification to a macro lens, or attached to a lens fitted to an extension tube.

Macro photography is really about the details within the details, and the best way to see this for yourself is to set up the camera and just experiment. Lie down in some dew or frost-covered grass and see what colors and textures appear in the viewfinder. Don't think about specific subjects, like flowers, webs, or insects—just see what creations evolve. Put an extension tube on a zoom or try adding a close-up lens so leaves and flowers become a wash of colored shapes, and details are reduced to simple lines and textures.

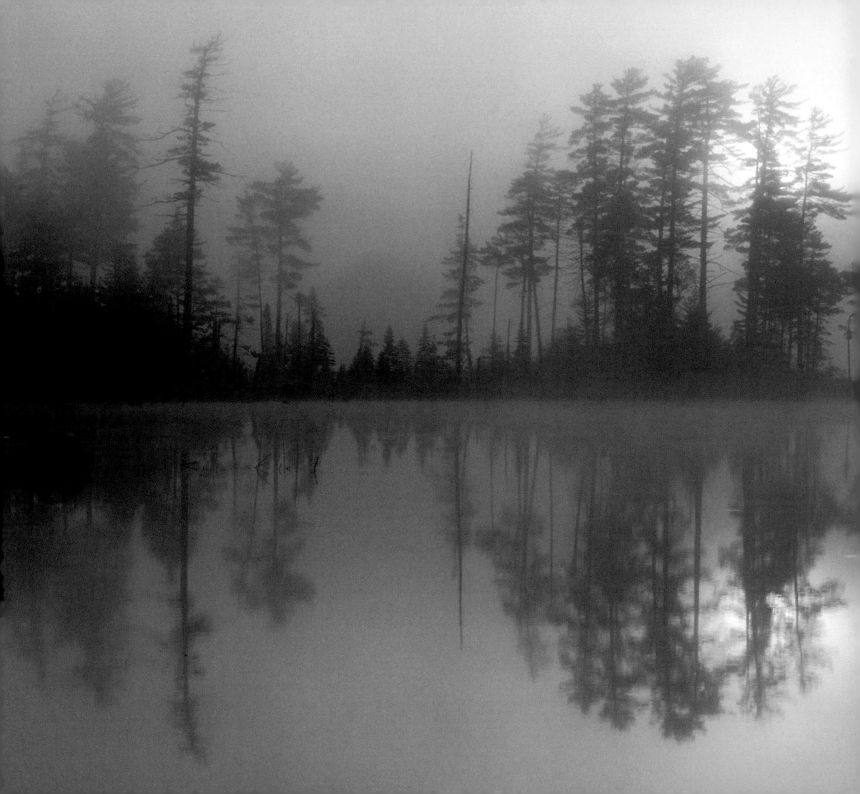

3:
ON LOCATION

The best landscape photographs come from putting yourself in great locations when the lighting is just right. Although wonderful "accidents" can occur, knowing how to be in the right location at the right time means you will have choices instead of chances. Making the right decisions comes from being able to scout and visualize new locations, as well as understanding how both the present and future weather conditions and lighting could affect the quality and mood of a photograph.

Understanding location and lighting answers the first questions for a landscape photographer—where to photograph and when. It also provides insights into how and why. A very general rule I use for where to be and when, is to photograph open landscapes when it's sunny, and work in the woods or with textures and more detail-oriented subjects when the light is softer and more subdued. Beyond that, it's down to the subject being photographed and the mood you are trying to create.

MAKING THE MOST OF LIGHT & LOCATION

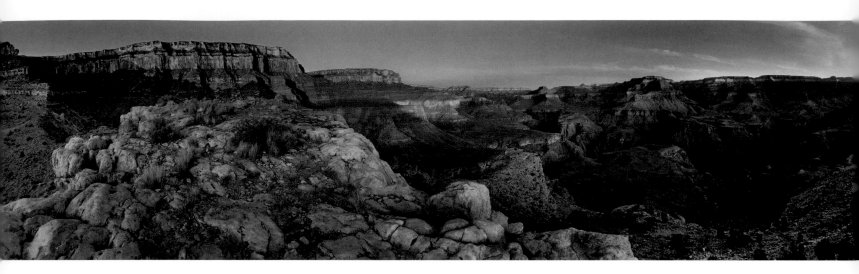

There is always something to photograph, no matter what light there is, or the location you are in—the skill is in finding which features of the landscape are best enhanced by the light you have to work with. Weather and lighting conditions evolve throughout the day and each change in the light offers different possibilities. Like many photographers, I used to put my camera away after the sun got too high in the sky, but not any more—there are opportunities for photographs all day long. Each lighting condition lets you capture a situation in a unique way, and while some subjects are enhanced by the softer light at either end of the day, some are better in sunlight.

Landscapes take on the color tones of whatever light is in the sky, and this is especially true for all forms of water. The midday sun or cloudy conditions will have a cool, blue cast, while early morning and late afternoon light tends to produce warmer tones. Since the light enhances some subjects better than others, I constantly check the shadow tones and the overall tonal quality and contrast of anything that has the potential for being photographed.

When you're scouting for new photography locations look around for hill tops, open ledges, or other vantage points that might offer a fresh perspective to the landscape. Try to visualize not only what the perspective might be from those vantage points, but also how different lighting and weather conditions might affect that view throughout the day. When you are on location it all comes down to two basic choices: to make the best of the light at the time, or to visualize what might happen and wait for the light to improve. This means staying until the light changes, or even returning to the location another day, when those conditions are more likely. Patience is one of the greatest attributes a good landscape photographer can have.

As the sun rises over the Grand Canyon, the upper cliffs glow with magic hour light, while the depths of the canyon retain the bluer hues of twilight. *Grand Canyon National Park, AZ*

From the Camden Hills, the morning sun rises over the many islands and peninsulas of the Maine seacoast. *Camden Hills State Park, overlooking Penobscot Bay, ME*

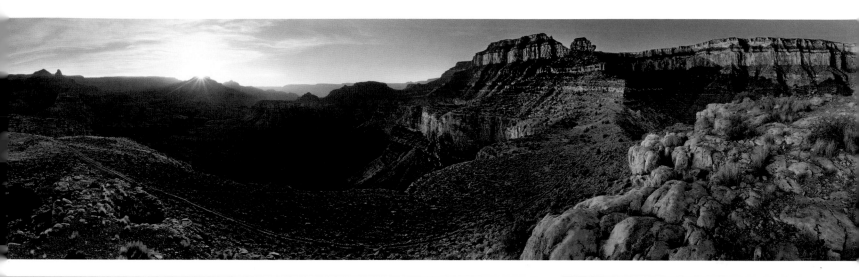

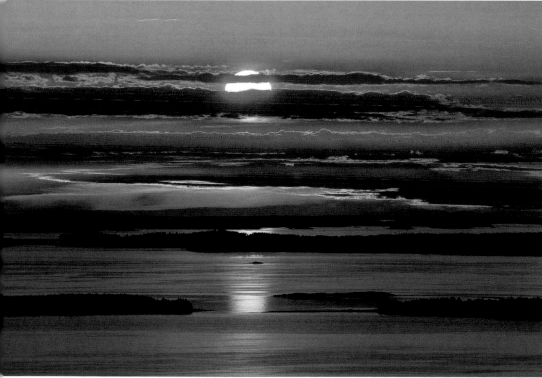

Location and Light Tips and Techniques

• Put yourself in the right location and wait for the best lighting. Alternatively, choose the location based on the light you have to work with at the time.

• Look around for different vantage points. Try to visualize the landscape from those perspectives and under the different lighting that can occur throughout the day.

• Photograph broader landscapes and work in the open in bright, higher contrast light. When the lighting is softer, concentrate on textures and details.

• When the camera is on a tripod during longer exposures, be sure to cover the viewfinder so the camera's lightmeter bases the exposure on light entering the lens, not light coming in through the viewfinder.

SUNRISE & SUNSET

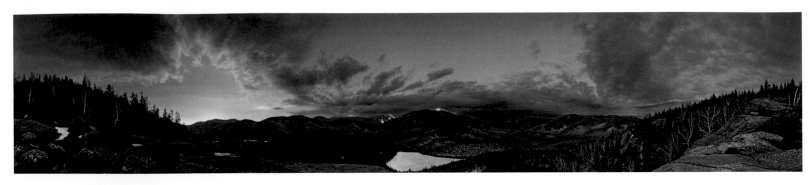

I've watched the sun rise and set over cities, mountains, lakes, and oceans. It's come up over fog, through fog, under the clouds, above the clouds, and in the midst of clouds. I've also been enveloped in the golden essence of the setting sun as it permeated every droplet in the mists of a cloud hovering over a mountain. I've watched it rise with soft color tones that graduated from yellow to red, and have seen it rise and set in an atmosphere so clear the light seemed as bright as if it were midday.

I have always enjoyed watching a sunrise or sunset, and being able to capture the nuances and moods of the spectacle is the icing on the proverbial cake. There are several techniques that can be used for photographing when the sun is near or below the horizon, and creating silhouettes when the contrast levels are high can be just as effective as shooting a sequence for a full tonal range using HDR imaging.

The exposure can be determined in many different ways, but I tend to start with a matrix or evaluative meter reading and adjust the exposure from that. With high amounts of moisture in the air the sunlight will be softer and more diffuse, so the exposure will be close to the metered reading, with less need for bracketing.

This also applies whenever you are trying to record visible color tones in the sun itself. The exposure should be near the metered reading, or very slightly overexposed, but it is still a good idea to bracket slightly to compensate for the tonal variation of the sun compared to any surrounding clouds. When creating silhouettes you can also use an exposure reading that has been measured from a scene containing direct sunlight, but be sure to consider your eyes when looking into bright sunlight, especially when you are viewing it through a lens in the viewfinder.

When the clarity and intensity of the light is stronger, or you are shooting into the sun but want to retain some detail in the landscape, you will need to dial in positive (over) exposure compensation. The closer the sun is to the center of the image, the more overexposure you will require, and if you are shooting an HDR sequence, you will need to record a wider number of bracketed images.

When the sun is below the horizon, the situation is reversed. The soft hues reflecting from the clouds themselves are best captured with very slight underexposure, making sure no highlight detail is lost, while the shadowed landscape should be underexposed by about 1½ to 2 stops

f8 1/8 sec ISO 100 FL 18mm

This 360 degree winter panorama shows both the wonderful light around the sun, as well as the nice glow that can light up the clouds in the west when the conditions are right. *View from Mount Jo, Adirondack Park, NY*

below a metered reading to have the right appearance. The overall evaluative reading needs to be underexposed so the camera doesn't lighten the landscape, as well as the clouds, and make the whole image appear pale and washed-out. To be sure you get the exposure(s) you need, bracket your shots to be certain you get all of the image information you need.

Finally, where there is an even transition line between the sky and foreground, don't forget that you can use a graduated neutral density filter to darken the sky and bring the tonal values of the sky and land closer together. If the horizon isn't level—there are trees or other details protruding into the sky, or the horizon contains an uneven ridge of mountains, for example—consider shooting a bracketed sequence of images and using HDR techniques instead.

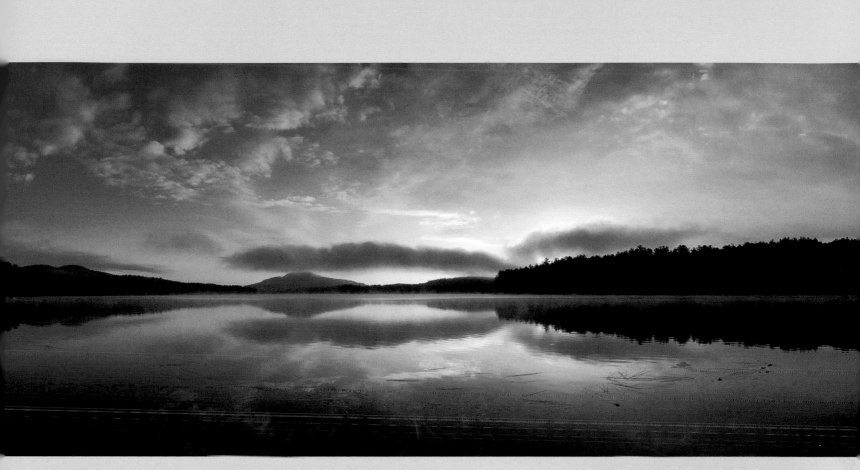

f 11 1/30 sec
iso 100 fl 28mm

Every sunrise and sunset has its own unique character. On this morning a golden glow filled the clouds above the light fog over the lake. _Loon Lake, Adirondack Park, NY_

Every Sunrise and Sunset is Different

While experience and weather-forecasting will give you a sense of the impending conditions at the start and end of the day, you will never know exactly what the weather will be doing until it is happening. Remember to look all around you—and especially behind you—since sometimes the most dramatic sky conditions occur where you least expect them!

THE MAGIC HOUR

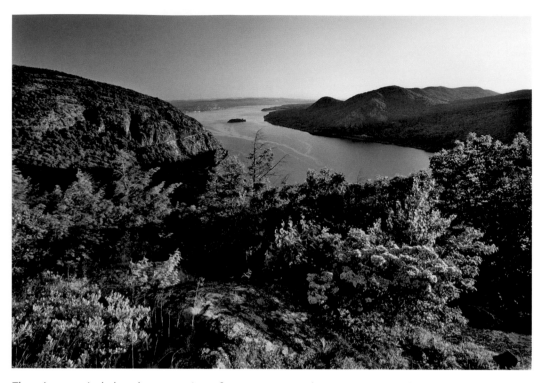

LEFT: In this view there is still some golden glow as the sun is close to an elevation of 10 degrees above the horizon. *Hudson River, Storm King State Park, NY*

RIGHT: Sea stacks billow from the ocean when the temperatures drop well below freezing. The shadows created by the low morning light add detail and interest to the trees and shoreline. *Otter Cliff, Atlantic Ocean, Acadia National Park, ME*

There is a mystical glow that occurs just after sunrise and just before sunset, when the most gentle light of the day spills across the landscape, enhancing a scene with soft, warm light. It creates magical conditions for both the landscape and the sky, and for this very reason is often referred to as "the magic hour." Unless the atmosphere is exceptionally clear, the magic hour light will gently fill in shadow detail, enveloping the landscape in a mystical light unlike any other.

The length of the magic "hour" depends on a number of variables, and it ends when the sun reaches an elevation of 10 degrees, when the light becomes more intense. The time of year, the relative humidity of the air, and your location and latitude can all affect the duration of the

magic hour: In temperate latitudes, for example, the low angle of the winter sun can add up to 15 minutes, while at the equator, it only takes about 45 minutes for the sun to rise above 10 degrees.

In general, little exposure compensation is needed when you are shooting in the magic hour, and bracketing for HDR work usually needs to be no more than 1 stop over and under. However, because of the lower intensity of light, longer exposure times will be needed, so it's important to work with the camera on a tripod, especially when maximizing the depth of field with a small aperture. These longer exposures will also help increase the color saturation and, since the light is less contrasty, there will be a better balance of tonal values throughout the scene. Morning

landscapes are often accompanied by dew or frost, which can add wonderful textures to the landscape, while the low angle of the light creates shadows that can enhance the sense of depth.

There is often a calmness to the air at sunrise and sunset, and this makes it easier to photograph flowers and other subjects that can be affected by a breeze or the wind. Conversely, the lower intensity of light is great for experimenting with longer exposures of anything that is in motion. Although I generally set out to capture the broader landscape at this time of day, the light is perfect for detail photography as well, and the magic hour light reflected from snow-covered mountains or sandstone cliffs is superb for both telephoto and macro photography.

SUN & CLOUDS

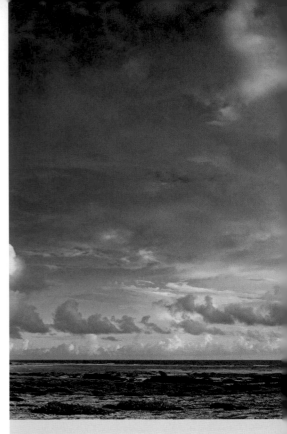

While the glowing light of the magic hour creates a serene, ethereal mood, it doesn't mean it's time to pack up your camera and head home when the sun is higher in the sky—it just means using different techniques for composing and taking pictures. Daytime lighting is more lively and energetic. It's also when most people are out enjoying the landscape, so they can often more easily relate to picture taken at a time they identify with.

Photographing under the sun and clouds is all about choosing the light for the subject, or selecting the subject for the light. When I'm photographing for a project, I have usually scouted specific locations where I plan to be for both of the "magic hours" of the day, and then I'll work on a photo list for the "normal" daylight hours in between. By having a hit list like this, you can choose where you would like to go according to the weather and light. It also gives you the flexibility to work in a variety of locations, shooting whatever you come across that works best for the light at the time. If you come across a perfect subject, but the light isn't right, simply return when it is right.

During the day, the main lighting conditions you'll encounter are direct sunlight, shade, and varying degrees of cloud. While one bright, blue, sunny day can be quite similar to the next, as soon as you add some clouds to the mix the mood becomes more unique. Clouds and sunlight combine in an infinite number of ways and the clouds themselves can make wonderful subjects.

When working with bright clouds in an image, it's important to keep them in balance with the rest of the image. Since bright and dark areas can pull the viewer's eye in a picture, aim to make them harmonize with the rest of the tones in the image. This can often be a waiting game, since clouds keep moving and changing their perspective to the rest of the landscape. Keep checking in the direction the clouds are coming from so you have a sense of how things might change and how that might affect a photograph. Most importantly, if you see something you like, take the photo right away! If you wait, it will definitely change and the moment will be lost.

One of the biggest issues for composition is that with the sun higher in the sky there are fewer shadows, so landscapes tend to appear flatter, or more two dimensional. To work round this, look to tie in a variety of subjects by using wider focal length lenses, with composition angles that add life and depth to the image. Remember to keep checking for composition by closing one eye, and think of how the view can be affected by using different focal lengths. Daytime can be the ideal opportunity to experiment with fisheye lenses, a Lensbaby, and various other creative techniques.

Daytime also means paying special attention to bracketing. Graduated neutral density filters can be used to moderate the contrast between the sky and ground, while polarizers can add some pop and contrast to the sky, clouds, water, and vegetation. Interesting effects include long exposures of moving clouds—as well as other subjects in motion—and these can be obtained by using solid neutral density filters to cut down the amount of light coming through the lens.

ABOVE: With the right lighting, clouds can become the subject of a landscape photograph in their own right. Check the histogram to be sure you've got the right exposure, and consider shooting a sequence for HDR. *Aruba shoreline*

f16 1/125 sec ISO 100 FL 20mm

RIGHT: A mix of sun, clouds, and showers, adds drama to this view of the Adirondack High Peaks from the Plains of Abraham near Lake Placid. This was composited from a 5 stop bracket. *High Peaks near Lake Placid, Adirondack Park, NY*

f22 1/100 sec ISO 320 FL 18mm

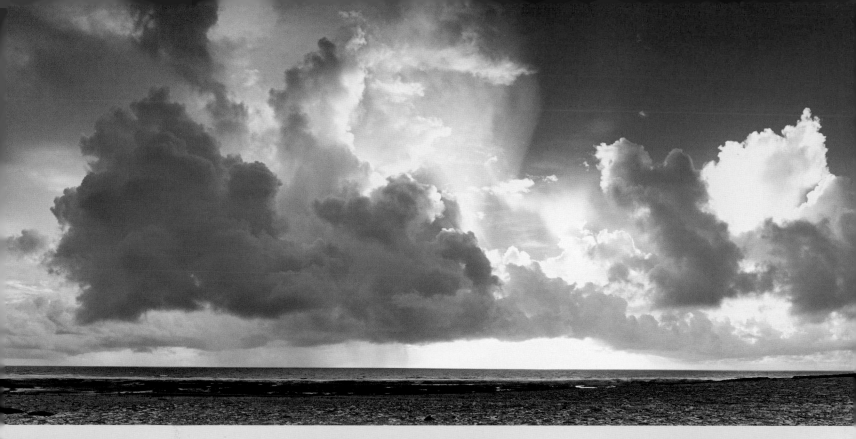

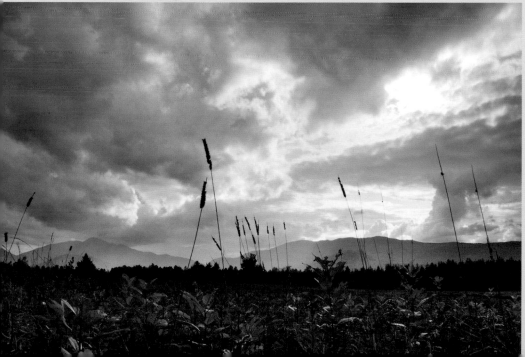

Daylight HDR

When choosing exposure settings, remember that a greater range of bracketed images is needed for HDR work to compensate for the extreme contrast between the highlights and shadows in bright sunlight. The human eye is seeing detail across a range of about 13 stops, while the digital sensor is only recording light in an 8–10 stop range, so bracket at least 2 stops either side of the "correct" exposure to capture both highlight and shadow detail.

DAWN & TWILIGHT: AT THE EDGE OF NIGHT

Twice each day there is a period when the light becomes scattered and diffuse—a time that offers many creative opportunities. Between the wonderful glow of sunlight on the clouds and the total lack of color that comes from the darkness of night, there is a soft, transitional light with varying hues and textures. Stars might be visible overhead, lights are on in villages and cities, and colors will range from the red glow of sunset to an intense blue sky.

Morning mist, frost, and dew can add a wonderful mood to the dawn landscape, while the clearing of an afternoon storm is conducive for layers of fog and mist to form during twilight. During this time of reflected light, tonal variations often shift from one of high contrast, to one where the entire landscape comes into tonal balance. This offers a wonderful opportunity to do some lunar photography, and to capture detail in both the lunar and Earth landscape at the same time.

At the edge of night, the landscape takes on the hues of whatever light is falling on it, and the natural light tends to be bluer at this time of day. This is true whether you are working in cloudy or clear weather conditions.

It's great to play and experiment in this light, when exposure times can be up to several minutes long, but it's important to understand that the intensity of the light can change considerably during an exposure. In the case of a long exposure of a minute or more at dawn, you should underexpose slightly to compensate for the increasing light as the sun rises. In evening twilight you will need to overexpose slightly, to compensate for the decreasing light while the shutter is open.

To help capture the entire range of light and detail, bracketing is especially important, but remember that long exposures made with noise reduction turned on will take the camera as long to process as to actually take the shot. This can limit the number of images that can be taken in quick succession, as well as the variety of photographs that can be composed.

Twilight Shooting Tips

- Bracket widely for potential HDR work.

- Use low ISO settings for the best clarity (least noise) and color saturation.

- Long exposures offer creative possibilities like the blurred movement of clouds, cars, water, or people.

- Look for reflections of lights in rivers and lakes.

- High contrast objects can become nice silhouettes.

ABOVE: Before the sun rises over the Boreas River, its influence is already clear in the sky above, with the clouds in the distance lit from below. *Boreas River, Adirondack Park, NY*

LEFT: The light reflected by the thin mist makes it possible to see the lighthouse's beam. *Cape Hatteras Lighthouse, Cape Hatteras National Seashore, NC*

OPPOSITE: A long exposure emphasizes the city lights, and reveals the motion of cars. *Albany, NY*

SHOOTING THE MOON

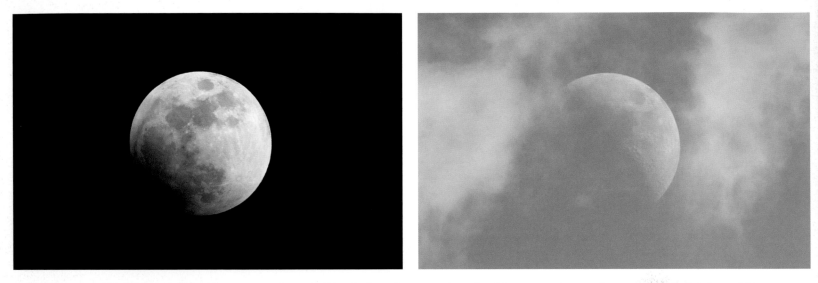

Moonlight is simply reflected sunlight: The intensity of the light being reflected by the moon's surface is the same all day long, with any perceived changes coming as a result of how the light is being filtered through the atmosphere. The only exception to this is during a lunar eclipse, when the moon's orbit takes it through the Earth's shadow.

Setting up an exposure to capture lunar detail when the moon is more than about 10 degrees above the horizon is the same both day and night (assuming the same atmospheric clarity for each), and understanding that helps you realize how difficult it is to include the moon in a landscape photograph at night. After our eyes have adjusted at night to the low light of a quarter moon, for example, we can see detail in both the moonlit landscape around us and the moon itself, but the contrast between the two is actually incredibly high. When an exposure is made for the landscape detail, for example, the moon will appear as nothing more than a white blob in the sky. Consequently, bracketing and post-production

image editing is the only way to show detail in the landscape and the moon in the same photograph. This can be accomplished with just two exposures —one for the landscape, and another for the moon—or you can shoot a whole set of bracketed exposures to be sure you've covered the full range of light.

Personally, I prefer creating photographs that include the moon while there is still some light in the sky. This makes it easier to create an image that retains detail in the moon and the landscape at the same time. The gentle pastels of the last light of day, or deeper blue of twilight in the sky, add a wonderful touch, while the right amount of moisture in the air will diffuse the light and enhance the color tones.

The moon rising before sunset (before a full moon), or setting after sunrise (after a full moon) is a great time for lunar photography—when the moon is near the horizon its tonal values are closer to that of the landscape. But this light lasts for only 10–20

minutes—beyond that, the lighting quickly becomes contrasty as the sky darkens.

Since the moon is an astronomical object, the other factor to consider when determining the exposure time is the rotation of the Earth. Although almost imperceptible to the naked eye, long exposures will start to blur the moon as the Earth rotates. Therefore, the exposure time required is fairly critical. With a 50 mm focal length you can generally set a 1 second exposure and not pick up signs of movement, but with longer exposure times—or lenses—it's best to use astronomical tracking equipment that will follow the moon in a slow panning movement. However, doing this means the landscape will become blurred instead.

Solar/lunar table software programs, as well as some tables online, are helpful for precisely determining solar and lunar locations and timing. GeoClock (http://home.att.net/~geoclock/) is a good shareware program, while online tables are available at www.usno.navy.mil/USNO.

 OPPOSITE: Both of these cropped photos of the moon—one taken in mid afternoon light, and the other shot well after dusk—were shot in a sky with similar clarity at the same exposure settings. The night-time moon was just beginning to enter the earth's shadow during a total lunar eclipse.

 RIGHT: I prefer trying to photograph the moon in the evening, a day or two before it is actually full, or in the morning within a day or two afterward. Shooting landscapes lit by moonlight creates a totally different look to a photograph. *Cascade Mountain, Adirondack Park, NY*

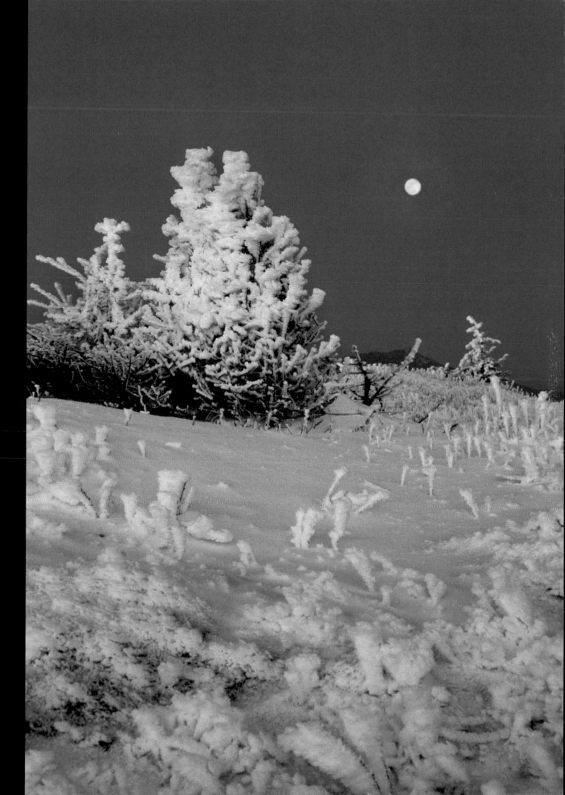

NOCTURNAL IMAGES

Who needs to sleep? Once the sun has set, there's a whole variety of conditions that offer unique conditions for landscape photography. The only issue is that exposure times are a lot longer than those during the daytime, and will often exceed the 30 second maximum exposure time built in to most cameras. Using a tripod and a remote release is essential.

Depending on the available light—and the mood you are trying to create—you can photograph night scenes with ISO settings ranging from about 100 to 800, ideally with noise reduction turned on. I prefer the clean look of the low ISO settings, but sometimes go higher to get the image I want.

Even in the dark of the night there is generally some light to photograph by, or you can always create your own. In urban areas, the abundance of street lights will put most exposures within the range of the camera's automatic exposure, with plenty of opportunities for long exposure tripod shots and panning techniques on people and cars. However, depending on how sensitive the camera's lightmeter is to low light it might not be possible to get an accurate reading, and there is also the risk that it will be misled by any bright lights in the field of view. The easiest way to avoid this is to determine your starting exposure according to the EV charts found in the first chapter, checking the histogram and bracketing your images.

When photographing the stars, there are two options: To record the stars as individual points, or to allow them to streak across the image creating trails of light. An exposure of 30 seconds or less is needed if you want individual points, while an exposure should be at least 30 minutes long to get really nice star trails. Shorter exposure times can be used, but if the trails are too short they can

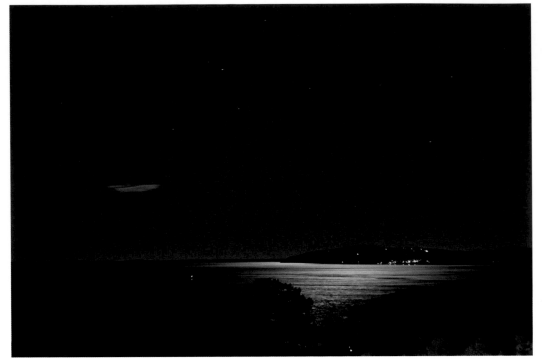

look more like a mistake, so try to photograph the stars at one extreme or the other. A long exposure of about 1½ hours before sunrise on a clear night, that ends when your eyes become aware of some color on the horizon, will produce particularly strong results, with the image containing extended star trails with a rich color to the predawn sky.

ABOVE: The light of the full moon over Penobscot Bay, Maine.
Belfast, Penobscot Bay, ME

OPPOSITE: Depending on your choice of exposure time, star trails can be photographed as point sources of light, or as longer trails. Exposures of less than 30 seconds will create point sources, while exposures of 30 minutes or more are needed to produce strong trails like these.
Lake Winnipesaukee, NH

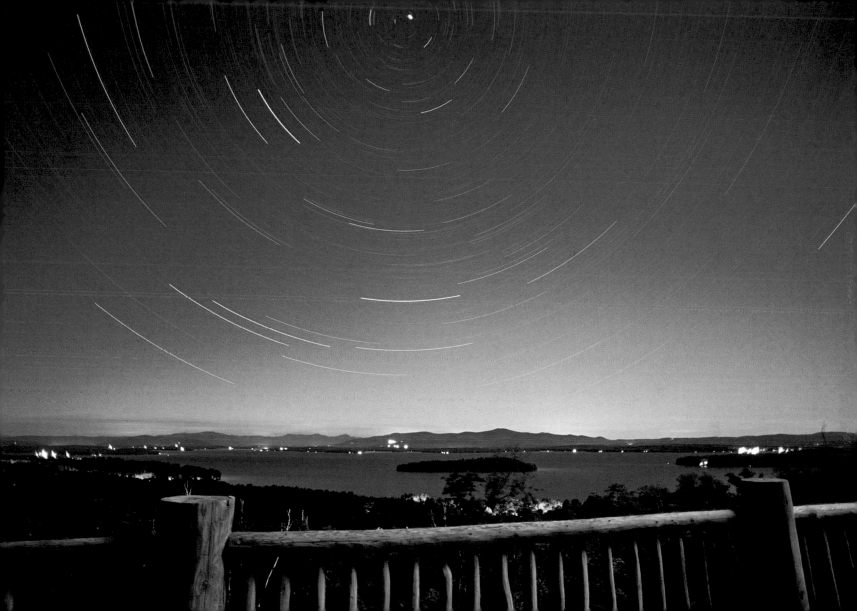

WEATHER DRAMA

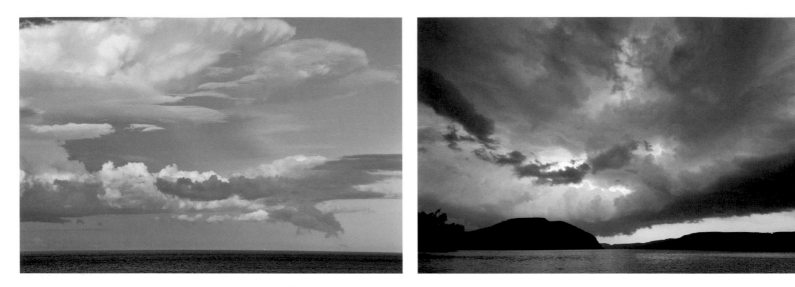

Weather drama is all about the energy of the moment, and working to recreate that in a photograph. It can be about wind, rain, or snow; towering clouds and thunderstorms; light and lightning; different types of clouds and cloud layers, or varying hues of light. The most dramatic conditions for photography generally occur during changes in the weather and weather systems, and skies are often most dramatic when a storm system is moving in, or moving out.

The drama comes not from the weather itself, but from the light, and there is no light more spectacular than when it is passing through some type of precipitation. It could be snow, rain, or just a drizzle, but whenever light passes through visible moisture and precipitation in the air, there will be some kind of unique atmospheric condition that is visible from some location. You might not be able to see it from your vantage point, but it will be there if you are in the right location at the right time, so you need to be prepared.

There have been countless times I've worked to put myself in just the right place at the right time, closely watching weather radar, satellite views of the clouds and water vapor, weather map forecasts, cloud forecasts, and relative humidity forecasts, but no matter how good the forecasting methods are, it's still difficult to predict the exact lighting conditions until you reach your location. Watching the weather will help prepare you, and there will be a number of times you find the conditions you are expecting, but there will also be times when it isn't quite what you hoped for. More importantly, there will also be a few, select, special times where the conditions surpass your expectations, and you find yourself in awe of what is going on in the landscape.

ABOVE LEFT: Late afternoon sunlight highlights the clouds advancing ahead of a storm over Penobscot Bay, Maine. *Penobscot Bay from Pemaquid Point, ME*

f 14 1/320 sec ISO 320 FL 75mm

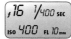

ABOVE RIGHT: The clouds along the leading edge of a large thunderstorm can be quite dramatic. Prepare for these moments by keeping an eye on weather forecasts. *Lake George, Adirondack Park, NY*

f 16 1/10 sec ISO 800 FL 10mm

OPPOSITE: Breaks in the clouds as a weather system begins to clear add considerable drama to this snow-covered mountain landscape. *On Algonquin Peak, Adirondack Park, NY*

f 16 1/400 sec ISO 400 FL 10mm

MIST & FOG

OPPOSITE: When taking photos either in, or of fog and mist, remember that the level of brightness is typically a stop or two above neutral gray. *View from St Regis Mountain, Adirondack Park, NY*

ABOVE: Light values can change quite fast when the fog begins shifting around. Some areas will be sunlit, while others can be shaded in heavier fog. *View of Otter Cliff, Acadia National Park, ME*

RIGHT: Fog can help isolate a subject from the background, adding both impact and mood. *Bog near Brant Lake, Adirondack Park, NY*

Working in light mist or foggy conditions can conjure up all kinds of moods for photography, from a heavy, foreboding look, to a mystical, spiritual feel. Fog and mist are simply clouds that are in contact with the ground, and since they are composed of tiny water droplets they take on the hue of the light in the atmosphere. Knowing why fog occurs can help you understand when to expect it—and where.

Vaporized moisture is held in suspension between the air molecules in the atmosphere. When the air is warmer, these air molecules are farther apart and can hold a higher percentage of suspended water molecules. As air is chilled—as a result of the temperature cooling overnight, or from the cooling that occurs as it is pushed up over a mountain—the temperature can drop to a point where it can no longer hold all of the water vapor. The excess moisture condenses onto minute particles in the air, creating varying intensities of mist and fog.

Fog can occur in many different situations, but it's always because the air is over-saturated by the available moisture. It is quite likely to form on a calm night before a weather system moves in, and on mornings after a relatively calm, warm day is followed by a much cooler night. This is also why mist is found around the base of large waterfalls, over oceans and lakes when the air temperature is well below that of the water, over snow during a warm rain, as well as other situations when relatively warm, moist air is chilled to a

temperature that is below its saturation point. Fog is also more likely to form over bodies of water because of the higher moisture content of the air above the water. In winter there is often valley fog the morning before it is going to rain, but not before a snowfall.

Determining the camera exposure is one of the biggest issues in foggy conditions, but fog is typically about ½–1½ stops brighter than the camera's 18% gray target. As such, the camera's lightmeter will tend to underexpose a foggy scenes and create muddy, dark images. With multisegment (matrix or evaluative) metering, start by setting the exposure compensation to +1 to give one stop of overexposure, then check the histogram and shoot again, or bracket.

The dynamic range in foggy conditions can also be a challenge, as it can range from a very small, compressed tonal range in heavy fog, to a quite extreme dynamic range when the fog is breaking up and sun is highlighting open areas. Bracket your exposures to capture the full dynamic range in the more extreme conditions, and use HDR techniques to create a subtle result that exploits the full tonal range of the sequence. It can be good to experiment with graduated neutral density filters also.

Finally, whenever you are photographing near, or in the fog, keep checking around you in all directions. Look for misty light shafts filtering through tree branches, unique highlights, and possible fogbows that can occur at the edge of a fogbank when the sun is behind you. Moonlit fog offers additional photographic options, but night or day, morning and evening, or after a storm or rain, fog and mist can produce opportunities for unique and moody compositions.

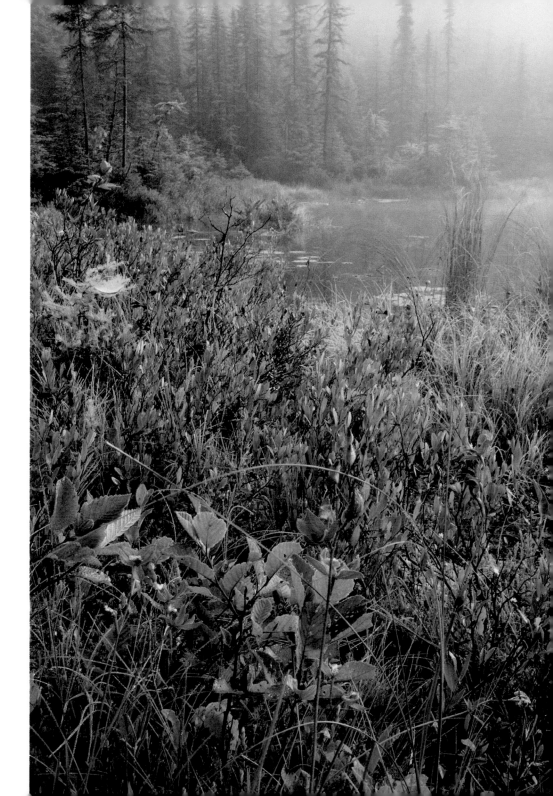

STORMS & LIGHTNING

Working with a digital camera makes it easy to experiment with capturing lightning and other weather phenomena in a photograph. Being able to adjust the ISO setting, along with the aperture and shutter settings, allows you to readily adapt to a wide range of shooting situations. But despite this, including lightning in a landscape photograph can still be quite tricky and there is a certain amount of luck involved when trying to do so.

Before going further into photographing storms, I'd like to add a few words of caution. Lightning is one of the leading causes of storm deaths in the U.S., second only to drowning. The only place that is relatively safe from lightning is in a car or a completely enclosed building, but a car is not a safe place to be during a severe storm that has tornado potential. Try to stay at least several miles away from any storm—lightning can strike up to 10 miles from the leading edge of the storm.

Lightning can be photographed using a number of methods. The first is to use a long exposures, and this has the potential to yield the best results. ISO settings can range from 200 to 800 with an aperture of f/8 to f/22. You want to be able to record the flash of the lightning and any branches of the main bolt with adequate detail, but without the digital bloom that can occur if the light is too bright. If the lightning is quite bright, use a smaller aperture and lower ISO, and use higher ISO's and wider apertures for fainter strikes that are farther away.

Because of the exposure times, it is almost impossible to capture lightning strikes during daylight hours, so shooting around dusk or dawn is a great time to capture lightning and storm images: There will be enough light to record the landscape, but it's dark enough to use longer

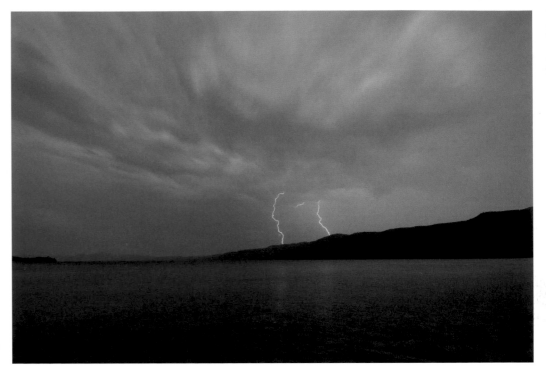

exposures where there is a better chance of recording a lightning strike. If the camera is set to Aperture Priority, and set to underexpose by about one stop, the exposure time can be left up to the camera in conditions when there is enough light to do that—just compose the photo in the direction of the greatest number of strikes, and fire away. If long exposure noise reduction is on, remember that each exposure will take as long to process as it does to shoot.

To catch multiple strikes, switch the camera to Manual and use the Bulb setting to lock the shutter open. Cover and uncover the lens to try and time it with some strikes. There's no rhyme or reason as to when lightning will occur, but in some storms there is a predictable delay between

strikes. At night, simply open the shutter and work with long exposure times to record a series of lightning strikes.

In addition to photos that include lightning, there are also the dramatic conditions that occur before and after a storm, or of the storm itself as part of a broader landscape picture. Thunderheads make wonderful subjects, especially in morning and evening light. Since they can extend as high as 60,000 feet (18,290 m) into the atmosphere there can be a wide variety of light on the clouds, while there is minimal light on the actual landscape.

 OPPOSITE: This set of lightning bolts struck at once. The storm had receded into the distance, and the image became as much about the landscape as it was about the lightning. *Lightning over Lake George, Adirondack Park, NY*

f22 15 SEC ISO 400 FL 10mm

 ABOVE: After a storm there can be some wonderful conditions. Mist in the valleys and hanging around mountaintops, plus the color tones near sunset, create a great mood. *View from Mount Marcy, Adirondack Park, NY*

f16 1/60 SEC ISO 100 FL 18mm

 RIGHT: The aftermath of a good storm can offer some good opportunities. Here, a late summer storm covered the ground with hail, bringing down both fall and summer leaves. The hail chilled the moist air near the ground, creating a soft mist. *Near Brant Lake, Adirondack Park, NY*

f16 1 SEC ISO 200 FL 14mm

RAINBOWS, HALOS & LIGHT SHAFTS

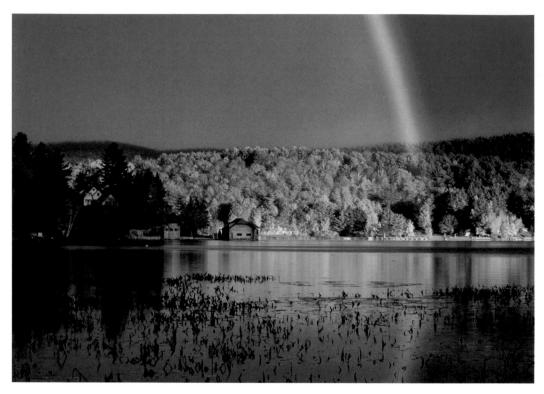

Atmospheric phenomena such as rainbows, fogbows, moonbows, and glories are typically seen in the direction opposite to the sun. While rainbows are common, moon bows are rarely seen, while fogbows appear when the light behind you is bright and clear enough to create the "bow" on the more dense fog in front of you. The one thing that is consistent, though, is the arc of the bow, which occurs at an angle of 42 degrees from the direct line of sight opposite the sun (the antisolar point). Therefore, the sun has to be at a low enough elevation in the sky to be able to see a rainbow. For example, if the sun is 20 degrees above the horizon, the antisolar point will be at 20 degrees below the opposite horizon. Since a rainbow forms at 42 degrees from the antisolar point, part of the arc would be visible, with the highest point being 22 degrees above the horizon.

Crepuscular rays ("God's rays") emanate from the sun itself, and appear when sunlight shining through breaks in the clouds passes through air that contains a high percentage of dust, aerosols, and/or relative humidity. Anticrepuscular rays occur with similar atmospheric conditions, but radiate from the antisolar point. Zooming in on the rays can create wonderful photos of the clouds and rays, while wider angle views really enhance a landscape photograph.

Sun pillars, sun dogs, and rings around the sun or moon occur only when there are ice crystals in the air. Sun pillars can occur vertically above, or below the sun. They are sometimes seen at sunrise or sunset, or shining into a valley from a mountaintop while the sun is still low in the sky. Sun dogs can occur on either side of the sun, at any time during the day, but I've most often encountered them in the late afternoon or near sunset, when the sun is shining through high stratus or cirrus clouds composed of fine ice crystals. Sometimes there is also a partial or full halo around the sun with sun dogs on either side.

Photographing any of these phenomena depends on the average of the tonal values of the subjects in the photograph. When using multisector metering to capture rays coming from the sun, the base exposure will need some overexposure, and I'd also recommend shooting an additional frames at least 2 stops over and under. When shooting away from the sun, the initial exposure can be based on the average reading from the camera, but it's again good to bracket. It's much better to shoot a few bracketed exposures than miss the best exposure by a stop or more.

ABOVE: Showers were moving in as the sun rose over the lake, creating a spectacular combination of fall foliage and an intense rainbow. While the rainbow was almost a full 180 degrees, zooming in on the "pot of gold" at its end offered more impact. *Brant Lake, Adirondack Park, NY*

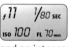

OPPOSITE: With the right atmospheric conditions, crepuscular rays can radiate into the valleys below you. *View from Gothics, Adirondack Park, NY*

THE FOUR SEASONS

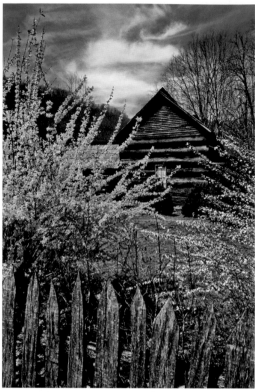

Every change in the seasons presents something new to photograph, and while most tropical and sub-tropical areas tend to have only two seasons—wet and dry—photographers living in temperate regions can enjoy four distinct times of year. When most people think of the seasons, the first thoughts that come to mind are spring flowers, the deep greens and blues of summer, fall colors, and the white stillness of winter. However, in addition to the main characteristics of each season, there are transitional periods between them, where the seasons overlap.

For many photographers, winter is one of the most inspiring times to photograph, especially in mountainous regions where the adventure of the great outdoors is as appealing as recording it with a camera. Fall is also a special time, with the turning trees setting hillsides ablaze with color during magic hour light. Yet spring can be easily overlooked—the ground is muddy after the thaw, flowers initially seem to be few and far between, and despite being the time of "new life," the broad spring landscape just doesn't appear to have as much energy as the other seasons. This is perhaps because spring is the season of subtlety, where you have to look closer to see the delicate colors of the budding leaves and the finer details in the awakening forest, so shoot with that in mind. City parks and the suburbs, with daffodils, lilacs, and

ABOVE LEFT: A profusion of wildflowers in the higher elevations of the Rocky Mountains bloom from about mid June to late July. *View from Bob Marshall Wilderness from Ear Mountain Natural Area, MT*

ABOVE: Forsythia has long adorned spring landscapes. This bush is part of the historic landscape at the *Pioneer Farmstead in the Great Smoky Mountains National Park, NC*

OPPOSITE: It took a clear summer morning to have the clarity to capture both the clear shadow of New York's highest mountain, and the full moon setting above the tip of the shadow. *View from Mount Marcy, Adirondack Park, NY*

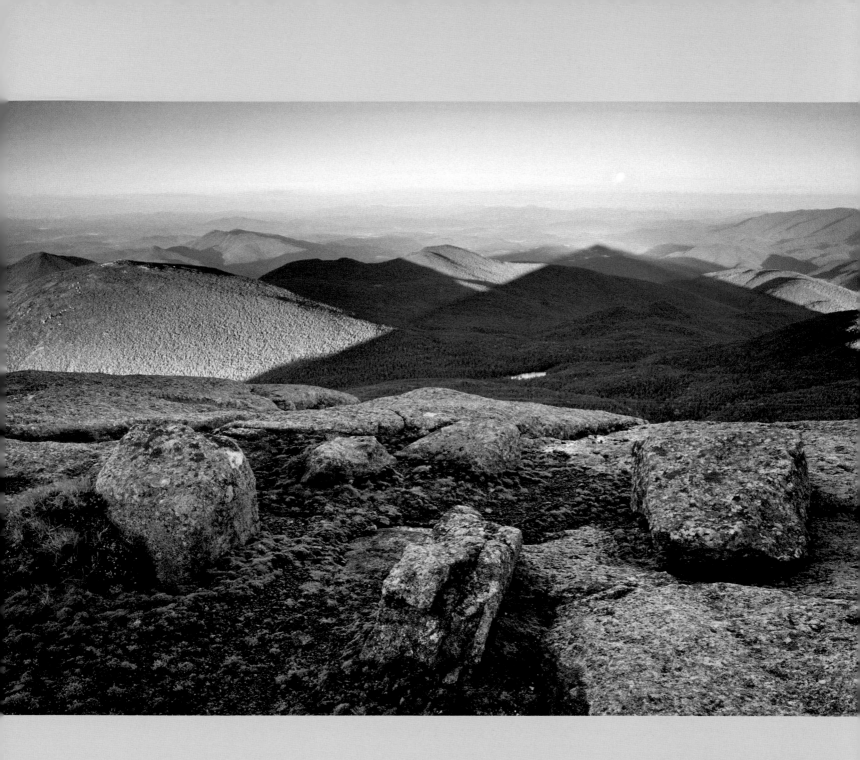

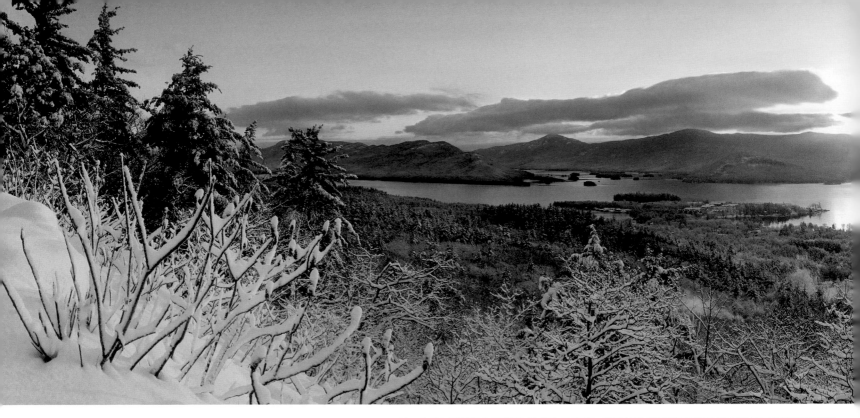

 ABOVE: Lake George is a deep lake that generally doesn't freeze over until January, which gives an opportunity to get some photos with snow on the landscape, along with open water. *Lake George, Adirondack Park, NY*

 RIGHT: Fall is as much about the details as it is about the color. Shooting through the branches helped set off both. *Lake George, Adirondack Park, NY*

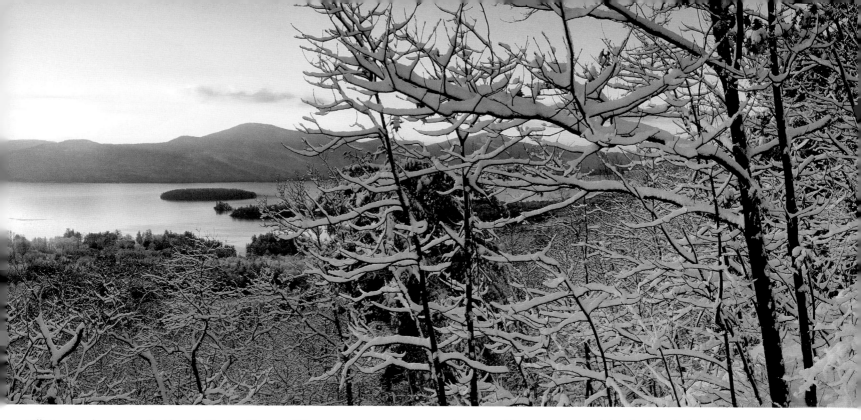

tulips everywhere, can often be a better hunting ground for images than forest, woodlands, or wide spaces. And, of course, there are the transitions—when winter gives way to spring and snow retreats, or when spring rolls into summer, full of lush green foliage and deep blue skies that are perfect for infrared capture.

Even though the tropics and desert areas are mostly based on just two seasons, there are still transitional periods that you can exploit. In the desert, rare winter rains can bring a spectacular bloom of flowers to an otherwise dry and monotone landscape, where the right timing of enough precipitation can mean almost every square inch of the usually arid gravel can be covered with wildflowers. In the tropics, the rainy season brings blooms back to the forests, and in other locations there are the seasonal migrations of wildlife.

Wherever you are, every season has something special to discover, so take time to research, explore, check out the broad views, and study the details. I've found that in the Adirondacks—as with most temperate areas—different flowers bloom from just after the snow is gone, right up until the ground freezes again.

Even without a camera you can explore the intricacies of each season, their interplay with each other, and the unique characteristics each season has. The more you explore and learn, the more you'll find there is to photograph, and the two experiences will help each other: Photography will help you become a better observer of all these details around you, and becoming a keen observer will help you be a better photographer. Remember that photographs are everywhere—in the details as well as the views—so keep looking all around; in front of, behind, above, and below

you, and then look at the landscape from those viewpoints as well. Each perspective brings a fresh way of looking at the landscape, and a new and different angle to help show others your vision.

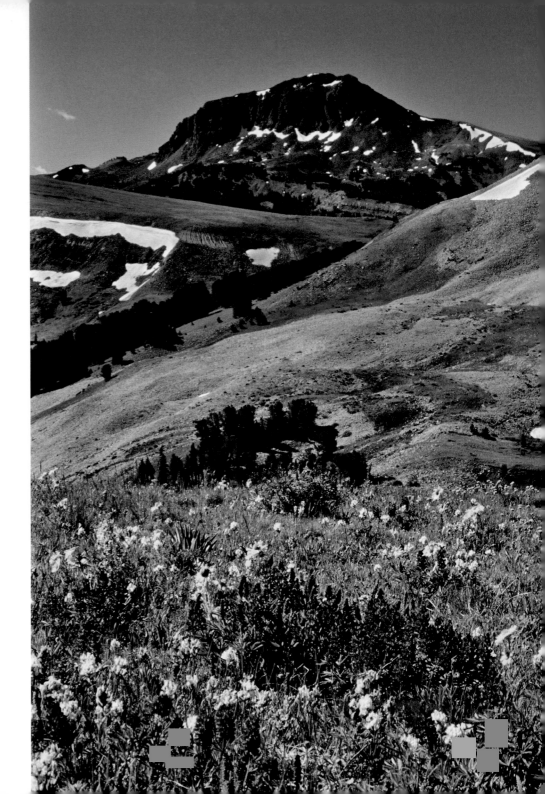

Wild Flowers

Wild flowers bloom in many different locations throughout spring, summer, and fall. While they are oftentimes just a small part of the landscape, there are other times when they can dominate the whole view. Flowers add life, energy, and color to the landscape and come in a great diversity of colors and shapes. As these images show, they can be the whole scene, the detail that draws you into an image, or a touch of color that adds character to the landscape.

Wild flowers grow in all types of environments, and some of the most spectacular blooms can occur in the desert, when optimal conditions allow them to completely cover the desert floor. While woodland flowers in temperate forests are often more isolated, azaleas, laurel, and rhododendrons can really put on a show in May and June, and the blossoming alpine meadows of the western U.S. in late June and July are a truly spectacular sight.

When it comes to photographing wild flowers, timing is critical, so it's good to research blooming cycles before planning a trip. Since there is often a continuous cycle of blooms from early season to late, something will probably be flowering, but if you're interested in a particular plant, there might only be a narrow window of opportunity.

Seasonal Tips

- In winter, when shooting a snow-covered landscape, remember to work with varying amounts of positive exposure compensation (overexposure) as the camera's metering system will be trying to expose the snow at an 18% gray tonal value.

- It's OK to take warm cameras into cold temperatures, but cold cameras need to be protected in a camera bag or sealed plastic bag when you bring them into warm air, to avoid condensation.

- Many annoying and biting insects are attracted to the color blue. Wearing green or another woodsy color helps minimize the number of insects, and also helps make you less noticeable to other wildlife.

- A nylon, waterproof, breathable, wide-brimmed hat that folds up easily can be used for camera protection in rain or snow, and offers great protection for you as well. It also provides protection from the intense sun in the summer.

- Wearing a wide-brimmed hat also helps cut down on insect issues by covering the top of your head and keeping them out of your hair. The shadow from the brim also seems to deter some types of biting bugs.

- Carry a lightweight, waterproof, breathable parka and pants for emergency protection in all seasons. They can be helpful for wind, precipitation, and even bug protection.

f22 1/100 sec ISO 200 FL 14mm

OPPOSITE: Wild flowers can be used to add color and energy to a landscape, or to lead the viewer into a picture. Here, they do both. *Gravelly Range, Black Butte Area, Beaverhead, Deerlodge National Forest, MT*

f16 1/30 sec ISO 100 FL 18mm

TOP RIGHT: The flowers in this shot echo the shapes of the trees behind, while also adding some foreground interest. *Bitterroot Range, Bitterroot National Forest, MT*

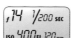

f14 1/200 sec ISO 400 FL 120mm

BOTTOM RIGHT: As well as adding a touch of character and energy to a broader landscape, wild flowers can also be treated as a subject in their own right. *Field near Pembroke, ME*

WATERFALLS, LAKES & OCEANS

Water is one of the most dynamic landscape subjects to photograph. It can be liquid or solid, clear, murky, muddy, limpid, soft, or stormy. Its energy can appear as falling water, crashing waves, swirls, rapids, and gentle ripples, as well as calm, quiet water that reflects the energy and light of other objects, as well as the sky.

Since water tends to be fluid and continually moving, the way you portray it depends on your use of shutter speed. The aperture still plays a part for depth of field (which is critical for tight detail and photos of reflections), but the length of the exposure is what determines how the water's motion is portrayed. As with any other photography, the exposure time required is related to both the focal length being used and the amount of blur you want. This holds true whether you are working with details, or a broader landscape photograph. By working with different exposures it's possible to capture the detail of every drop in a waterfall or crashing wave, or have it appear so soft and silky that it looks like fog.

Overcast days are great for working along streams, cascades, and waterfalls in the woods, since the less intense, diffuse light softens contrasts between shadows and highlights, and allows for longer exposure times. When composing around water, I base the length of the exposure on the energy I'm trying to create in the image, and use Shutter Priority so I can set the shutter speed I want. If I'm photographing a big waterfall I'll often work with a shutter speed of about 1/60 sec with a focal length of 50 mm or shorter, or 1/100 sec with telephoto lenses of 70 mm and longer. These speeds are fast enough to freeze the water at the top of the falls, but are long enough to give a sense of motion as the water starts its chaotic drop. Faster shutter speeds can completely stop the action, but I find that working around these suggested shutter speeds gives a much better feel of the power of bigger waterfalls.

If I want to calm the water's energy, I'll set an exposure of 1/10 sec or longer. Depending on the specific exposure time the moving water can take on a nice silky effect (at 1/10 sec), or can be made to blur so much that any detail softens into a fog (with an exposure of 20 seconds or more). I rarely use shutter speeds between 1/60 sec and 1/10 sec for water because of the odd blur effect, but experiment—these are just guidelines!

 FAR LEFT: I liked this image more with sharper water detail than others I took where I let the detail go soft. *East Branch, Ausable River, Arirondack Park, NY*

 LEFT: This is one of the most special locations along the Big Sur coastline of southern California. *Julia Pfeiffer Burns State Park, CA*

 RIGHT: This view of the water and mists of Niagara Falls was shot with a 1/60 second exposure—fast enough to freeze the water at the top of the falls, but still give a sense of movement as it crashes down. *Niagara Falls State Park, NY*

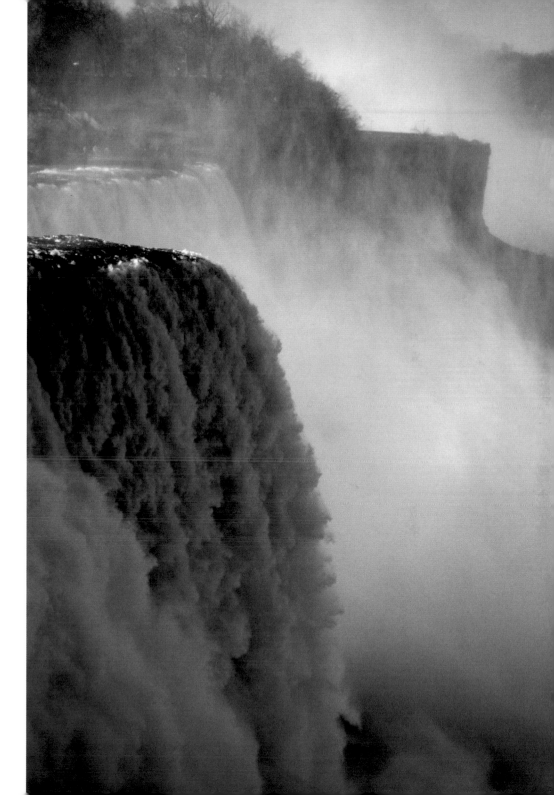

MAJESTIC MOUNTAINS

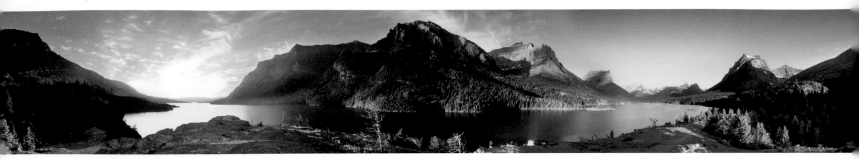

Hiking to so many wonderful views in the wild Adirondack mountains was what inspired me to pick up an SLR and pursue photography, and these mountains have remained one of my favorite places to explore and photograph. But it was some time before I was able to take a photograph in the mountains that really evoked an emotional response for me. I experimented with a manual camera and a couple of basic lenses, working to get just the right combination of lighting and composition, and once I found a style that worked, I started using it for most everything I shot. Since then I've also experimented with other ways to "see" the mountains and create images with impact.

Perhaps one of the most important things to remember is that every mountain range has its own character and mystique, so seek out the unique qualities. With all of the different weather and lighting conditions, changes of the seasons, and different topography to work with in a mountainous region, there are many options for creating a good photograph. Views looking into the mountains are often more dramatic than those taken from the tops of the peaks, and you can use both standard and panoramic formats to portray the beauty, majesty, and wonder, working with focal lengths ranging from 10 mm all the way through to 400 mm.

Photographing mountains from a lower vantage point will isolate the peaks against the sky and clouds, which adds to the feeling of height. Compose shots to include foreground subjects in wide-angle compositions, as this will offer a perspective from near to far, to help give a feeling of size, distance, scale, and three dimensions. Up on the mountaintops, including the valley in front of the nearest mountain will also help add scale and drama. While I mostly use wide-angle lenses for broad views, there are times when telephoto lenses can be used to pick out and emphasize patterns and details. As depth of field is more important than shutter speed, work with the camera set to Aperture Priority.

Side lighting during the magic hour definitely sets off views in the mountains, but that's not the only lighting that works well. I'm always watching cloud movements, and looking for sun shafts and any other kind of weather drama. Since mountainous areas create their own weather, there is usually a good variety of weather to work with, and the popular saying is, "If you don't like the weather, wait five minutes—it's bound to change!" Clearing conditions can be especially appealing as views appear through breaking clouds, while undercasts let you walk up above a sea of clouds to look out over the mountaintops.

Safety First

- When heading into the mountains to photograph, be sure to travel safely. It's best to hike in groups of 3 to 4—if someone has an accident, help could be hours away and you don't want to be on your own.

- Dress comfortably, using layers of synthetics. Always have a windproof, waterproof, breathable parka and pants along with you for full body protection if needed.

- The temperature drops by about 3 to 5 degrees with every 1,000 feet (300 m) of elevation gain, so be sure to carry enough layers to stay comfortable at higher altitudes in windy conditions—don't just dress for the temperature and weather you set off in.

 OPPOSITE: Magic hour lighting sets off this 360 panorama of the spectacular mountains surrounding St. Mary Lake. When shooting a panorama, I try to find a location where the highest mountain tops will balance out to a similar height. *St. Mary Lake, Glacier National Park, MT*

 RIGHT: I used a telephoto lens to zoom in on Mount Colden and the few clouds that were glowing lightly as the sun was setting in the Adirondack High Peaks. *Adirondack Park, NY*

BELOW: The first day of spring in the Adirondacks. The deeply shadowed valley helps give a sense of being up high in the mountains at sunset. *Adirondack Park, NY*

WIDE OPEN SPACES

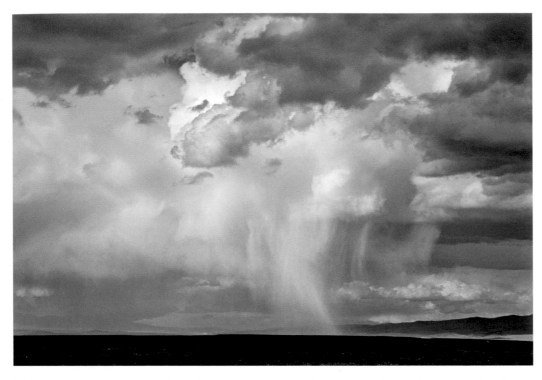

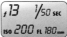

LEFT: The misty rain becomes a focal point in this telephoto view, but the eye gets drawn through the mist to the far-off mountains. The dark foreground line at the bottom, and dark clouds at the top, both become points of reference that lead you into the distance. *Big Hole Valley, MT*

OPPOSITE: The duck provides a point of reference in this shot. The soft detail in the waves gives an expansive feel to the water, with the gentle tones in the sky drawing the viewer into the distance. The tilted horizon gives the impression that you actually are the duck—flying across an infinite ocean. *East Sanctuary at Biddeford Pool, ME*

Wide open spaces occur almost anywhere—on mountaintops, along shorelines, on wide open plains, deserts, and tundra, in and around open fields, as well as on or along large lakes, seas, and oceans. But capturing the spaciousness of a scene is a photographic challenge—evoking a sense of infinite space is more difficult than it sounds.

In general, wide-angle compositions will provide a sense of depth and space that accentuates the infinite feel of wide open spaces, and wide-angle lenses can be used to include more foreground or sky. When using a short focal length to bring in the foreground, maximize the hyperfocal settings to draw the eye to a point in the immediate foreground—this will help lead to the distant background and provide a sense of distance.

By tilting a wide-angle lens toward the sky, clouds can be used to draw the viewer into the distance. The hyperfocal settings aren't as critical as when trying to compose an image with a subject as close to the lens as possible.

Wide-angle lenses are only a partial answer, though. While telephoto lenses tend to compress the foreground into the background (and need a larger space to be effective), picking out and minimizing detail can also work well for scenes where simplifying the composition gives it strength. Use as few elements as possible, working only with those that add a dimension of space. Sometimes, working from the top of a van or using a ladder can help add distance to an image and enhance the feeling of open space.

However, the sense of space not only comes from composition—it can come as much from the mood that an image creates. Of all the images I chose to illustrate this topic, the one I feel offers the greatest sense of "spaciousness" is a panned telephoto view of a duck flying over the Atlantic Ocean at dawn (opposite).

BY THE WOODS

The conventional suggestion for photographing in and around a forested area is to compose an image either from outside the woods looking in, or from the inside looking out. But this really only scratches the surface—there are many options for using different focal lengths and angles to photograph the great diversity of plant life, wildlife, and moods that occur both in and around a forest. A completely wild forest features a mix of young and old trees and flora, fallen and deteriorating trees and plants, and a wide variety of mushrooms, fungi, and warm and cold-blooded creatures. There may be some springs, streams, and small rivers, and perhaps some ponds, bogs, marshes, and other wetland habitats. The ecology will be similar between comparable types of forests within different temperature zones, but can vary considerably between boreal forests, temperate forests, rain forests, and montane forests that rely on fire for tree reproduction and keeping a balance in the understory.

Most landscape photography is about creating order from the chaos, so when a forest is full of saplings, obstructions, and distracting elements it can be a real challenge to create a balance. Working from the edge of a clearing will make it easier to compose views of the woods itself, but it's still difficult to keep the details in the composition simple and to the point. This means it is very important to visualize compositions with one eye closed, as this brings all of the scene down to two dimensions—just as the camera sees it. I've looked at many potential images in and around the woods that look wonderful with both eyes open, in three dimensions, but the same scene can become a jumble of abstractions when translated by the camera. Avoiding bright spots of sky in the image will help avoid an element that can draw the viewer's eye, although looking up

from ground level along a tree trunk to the forest canopy can also be quite effective with the right light and tonal qualities.

Compositions in and around the woods can range from fisheye and wide-angle images, to panoramic views and macro or telephoto detail shots. There are lots of options for compositions along trails and pathways, streams, vernal pools, and ponds, and the views and color tones will change considerably from season to season. Spring brings flowers, fresh leaves, and soft pastel color tones, which shift to the deep green of summer, the rich colors of fall, and winter snows that turn the forest into the perfect black and white landscape, with different textures, shadow lines, and details.

Bright sunlight can create some pretty extreme contrasts, so choose softer light to work with in and around the woods. Overcast conditions, soft light filtering through clouds, misty conditions, or dawn and dusk light all work well for shooting in the woods, but the conditions and subjects are so diverse from one habitat to another that it's still best to research as much as you can before heading into a new area. Selecting some of the different guidebooks for wildlife, birds, wildflowers, and trails can be most helpful for deciding the best season for photography, and what there will be to potentially photograph at that time. Then, head out with both eyes open, look all around, close one eye to visualize the camera's viewpoint, and shoot.

f22 3 SECS **ISO 100 FL 10.5mm** OPPOSITE: Fisheye lenses offer a unique perspective in the forest. Work to visualize images from all kinds of angles. Live View helped in creating this unusual composition. *Adirondack Park, NY*

f8 1/500 SEC **ISO 320 FL 70mm** ABOVE: Deer and other mammals can often be found along the edge of the woods in early morning or late afternoon, or in soft light conditions after precipitation. *Glimmerglass State Park, Otsego Lake, near Cooperstown, NY*

f20 1/80 SEC **ISO 1600 FL 116mm** RIGHT: A telephoto lens was used to compress the tree and snowfall detail in this image. *Adirondack Park, NY*

WILDLIFE

I don't consider myself a wildlife photographer, but enjoy photographing wildlife in the landscape whenever I have the chance. There are locations where it can be easier to see and photograph wildlife—national parks and wildlife refuges, for example—but most of the images I've taken have been more coincidental; I'm not a person who likes to spend time in a wildlife blind.

Including wildlife in a photograph adds life to a landscape, but I don't care as much for "head shots" as I do for using the animal to add a "sense of place." While people appreciate a great landscape photo with dramatic lighting, they really tune in if there is wildlife in it as well. Many animals are "creatures of habit," and tend to frequent similar locations, in similar conditions. Some may have a general route they follow over a period of time, while others will stay closer to their den or burrow. Learning about the typical patterns of regional wildlife is quite helpful for photography, but it's important to remember that

you are in their element. They're not used to anything creeping up on them unless it's considering catching and consuming them, so give them space and watch carefully for any signs of nervousness or alarm—no photo is worth endangering the life of a wild critter.

Photographing from a car is almost as good as being in a blind, as most wildlife isn't bothered by the vehicle, but stay within the realm of what people would normally be doing. I once thought I could get a better perspective of an elk herd in Rocky Mountain National Park by photographing from the top of my van. Everything was fine until the upper part of my body showed up above the roof of the van, which spooked them immediately.

When photographing wildlife you must practice patience, calmness, and persistence—and bracket! Shoot many images to be sure you come back with good expressions and positions, especially when animals are grazing. Try to catch

eye highlights when you are close enough, and be aware of both camera motion and animal motion when you are shooting in lower light conditions. Wildlife is a great excuse to purchase fast, stabilized lenses, as images will often be handheld because of the spontaneous nature of the subject. Digital cameras with a high dynamic range and a wider range of ISO settings will also help in low-light conditions. If you have a chance, experiment with panning techniques and other effects, but most of all, just enjoy the opportunity you have to share an experience in nature with a wild animal.

 OPPOSITE LEFT: I wanted to take this shot from the frog's perspective, rather than just having a photograph of the bullfrog. I was lying down in a lightweight canoe with my camera steadied on a tripod pushed up against the gunwale. By leaning the canoe over I could get the camera closer to the water's edge for a low image angle. *Wild Pond near North Hudson, Adironack Park, NY*

 OPPOSITE RIGHT: I was up well before dawn to photograph the early light on an Everglades National Park pond. Just after I set up near the reeds on the pond, I noticed the alligator slowly gliding across the surface toward my composition. I had the camera set and clicked the shutter when the balance was just right. *Everglades National Park, FL*

ABOVE: Using a telephoto lens and a medium aperture setting allowed me to keep the pair of loons in sharp focus, while softening the mountainous background and creating a sense of place. *Wild Pond near North Hudson, Adirondack Park, NY*

A PEOPLE PERSPECTIVE

As with wildlife, including people in the landscape adds life to a scene, but in a completely different way. While wildlife tends to offer a more mystical feel, a person in the image provides a more direct connection with the viewer. A completely wild scene can often feel "untouchable," but introducing a person—or personal objects—into the view helps create a reality that most people can relate to, even if they might never visit that place, or undertake that activity themselves. People can also help show how dramatic, dangerous, or peaceful a scene is, and add a sense of scale or remoteness to a wilderness shot.

When shooting this type of image, I prefer to photograph a person "in the moment," rather than posing them. When choosing a composition the big question is whether the picture will be about people or the landscape. There is a direct connection between the two, but at the same time the two elements are very different. For example, the same scene—a person in the landscape—could be photographed so the image is of a landscape that happens to include a person, or it could be a portrait, where the person is the subject and the landscape acts as a backdrop. The difference can be subtle, but it's important to decide how you want the viewer to see the picture—a person in the landscape can be the anchor, or simply a prop to draw the viewer in.

Unless I am on a specific photo shoot, I'm usually shooting each image for its own merits, and don't worry whether there is a commercial purpose for the photo until later. If everything comes together for a good photo, I'll compose it, shoot it, and worry about the applications later. That's great if you know the person you are including in the frame, but if you don't, it brings up the issue of model releases. This isn't a problem if a person

can't be fully recognized—there is no need for a signed model release. However, if there is a recognizable person in the shot, and the image has the potential for some kind of commercial use—for a book cover, or any other use where the photo helps sell any kind of product—you must have a signed model release. This isn't a clear-cut requirement, as if a recognizable person is in a public location and the photo will only be used non-commercially, no model release is needed. Perhaps the best rule is if in doubt, ask for—and get—a signed model release.

f 11 1/250 sec ISO 200 FL 24mm

ABOVE: The canoe and canoeists add a vibrant energy to this more serene view. *Looking over Whiteface Mountain, Adirondack Park, NY*

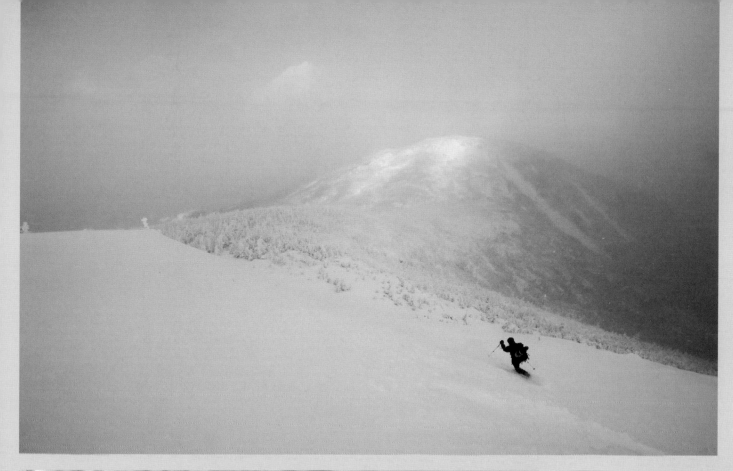

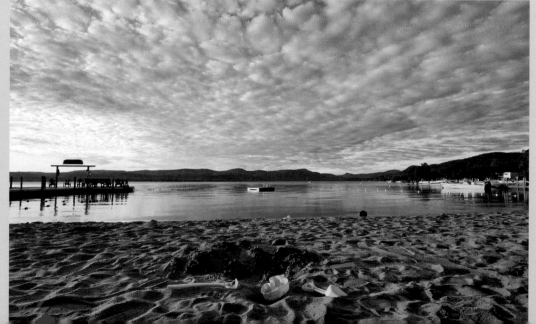

ƒ 16 1/250 SEC
ISO 400 FL 10 mm
ABOVE: Including a person in a shot immediately gives the viewer a reference point that they can identify with. Here, the lone skier not only adds a focal point to this minimalist mountain scene, but gives us an idea of the scale and danger of this vast landscape. *On Algonquin Peak, Adirondack Park, NY*

ƒ 16 1/50 SEC
ISO 200 FL 10 mm
LEFT: The sand in the foreground of this photo echoes the texture of the sky, but it's the toys on the beach that make this image eye-catching, giving a sense of energy, activity, and the presence of people without anyone actually being there. *Hague, on Lake George, Adirondack Park, NY*

CITYSCAPES, BUILDINGS & HISTORIC LOCATIONS

Landscapes cover many different types of locations—urban, suburban, rural, historic, and wild—but while the subject matter changes, the general guidelines for composition and lighting stay the same. No matter where you are, you should look for the same balance of contrasts, tones, lines, and textures, and work to create a flow of energy through your pictures that draws a person into, and around the details in the frame.

When a photo is about many details, a wide-angle lens is a good starting point, but when it is about only a few, consider composing with the camera closer to the subject, or use a telephoto lens to isolate detail. In both cases, it's still about finding the right lighting to highlight the parts that tell the whole story, and capturing the energy of the moment that will draw people in.

Working to capture the details and dynamics of buildings, the energy of cityscapes, and the timelessness of historic locations has the same basic goal as photographing a wild landscape— to evoke the feeling of what it was like to be there when the photograph was created. Although the same lighting and composition guidelines apply, the "magic hour" for buildings and cityscapes is the hour before sunrise and after sunset. The city and any illuminated buildings take on a special glow when their lights are on, and having some twilight in the sky helps set off various shapes and skyline details. The lights also add life, contrast, and energy to the buildings as movement becomes blurred with the longer exposures needed for the darker conditions. In some locations there can be enough light to handhold the camera after dark, but most times it's better to have your camera on a tripod.

All of the glass in modern buildings gives options for photographing window reflections of other buildings and various details. Just remember that when trying to photograph a reflection, you need to set the aperture to cover the depth of field from the near detail of the window to the actual distance the subject in the reflection is from you—not just the distance to the reflection. Different types of reflections can also be fun to work with in rainy weather, when the puddles on the sidewalks and streets reflect nearby buildings and pick up the highlights from any artificial lights.

f 11 1/8 sec ISO 100 FL 14mm

ABOVE: In Times Square, it's all about the lights! Even though the traffic had passed, and the streets are somewhat quiet, the huge lighting panels in this 360 degree panorama evoke the energy of this well-known (and well-photographed) location. *Times Square, New York City*

Most photographs shot from a public access vantage point are fair game for commercial use, but there are situations where permission is required. Some structures are trademarked—the Eiffel Tower, the Empire State Building, and Rockefeller Center, for example—and rights must be negotiated before an image of any part of these properties (and many other well-known properties) can be used for any commercial purpose. Ignorance is not an excuse, so if you have any questions about the usage of any photo, be sure to contact the property's media department to check if you need to get permission and a property release.

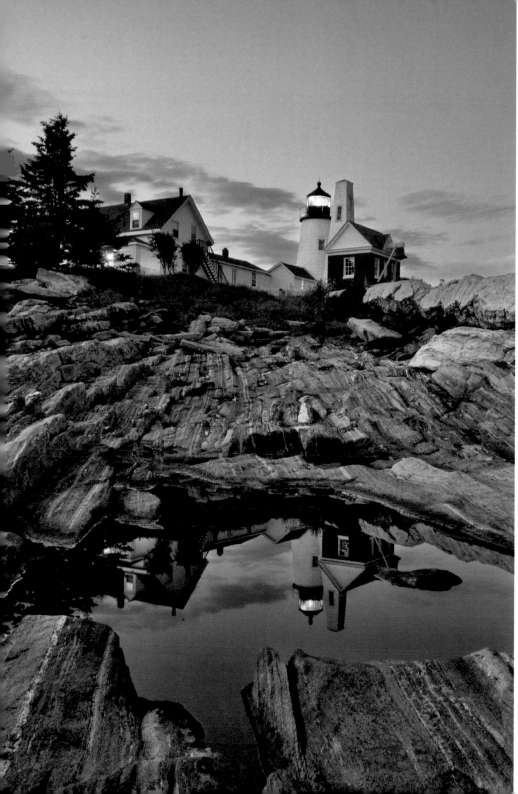

 f 16 6 secs
ISO 400 FL 26mm
LEFT: The tranquil beauty of this historic light-house along the coast of Maine is reflected in a rocky pool in the evening twilight.
Pemaquid Lighthouse, ME

f 11 1/250 sec
ISO 320 FL 100mm
ABOVE: Detail and reflections in the windows of modern office buildings offer all kinds of interesting, abstract compositions. *New York City*

AERIAL PHOTOGRAPHY

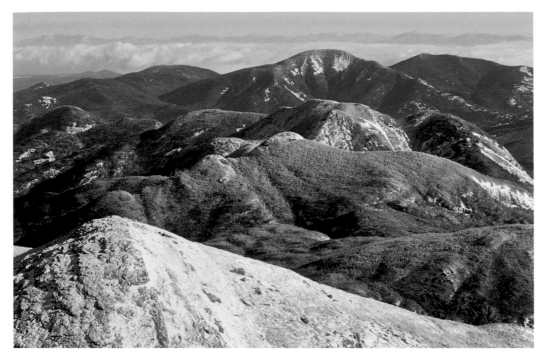

LEFT: This telephoto view of the Adirondack High Peaks really draws you into the snowy peaks. *Adirondack Park, NY*

OPPOSITE: The light and conditions that work best for land based photography also provide the best shooting conditions for aerial photography. *Indian Lake, Adirondack Park, NY*

So far, I've concentrated on photographing the landscape from the ground, but taking pictures from the air offers a completely different perspective of the landscape that can't be experienced any other way.

Whether it's from a fixed-wing aircraft or a helicopter, early morning is definitely the calmest time of day to be flying—once cumulus clouds start forming it's a sure sign that the air is mixing and you'll have a bumpier ride. It's also best to choose a time to fly according to the relative humidity levels, as high amounts of moisture in the air can have a negative impact on the quality of aerial images. Air is often clearest and cleanest when the leading air of a high-pressure system moves in, and the longer the system hangs around, the moister and murkier it gets.

Composition guidelines are similar to that for other landscapes, but there is often no foreground, so the composition becomes a balance of the features in the landscape itself. Because extremely wide-angle lenses have corner elongation distortion issues, stick to focal lengths from about 30 mm, through to various telephoto lengths, and if you can, consider working with at least two camera bodies—one fitted with a wide-angle zoom, and the other with a telephoto zoom. Work with stabilized lenses if possible to avoid camera shake caused by vibration.

Since shutter speed is much more important than depth of field, set the camera to Shutter Priority and let the camera bracket the aperture. Choosing exposures depends on the altitude you are flying at, the haziness of the atmosphere, the number of clouds in the sky, whether there is any fog, and the ratio of land to sky in the image. Working with auto white balance helps balance out the atmospheric blue tones that come from shooting higher up in the air, and shooting Raw will let you fine-tune this when you convert the images.

You should try to bracket at least three shots for every image in case you don't pass by again. However, if you are working different focal lengths and shooting a lot of bracketed exposures, you can easily exceed the limits of the camera's buffer and have to wait for it to catch up. Seconds can seem like hours at a time like that, but it's unavoidable. If you shoot with high capacity memory cards (I use 16GB cards) you at least don't have to worry about running out of space.

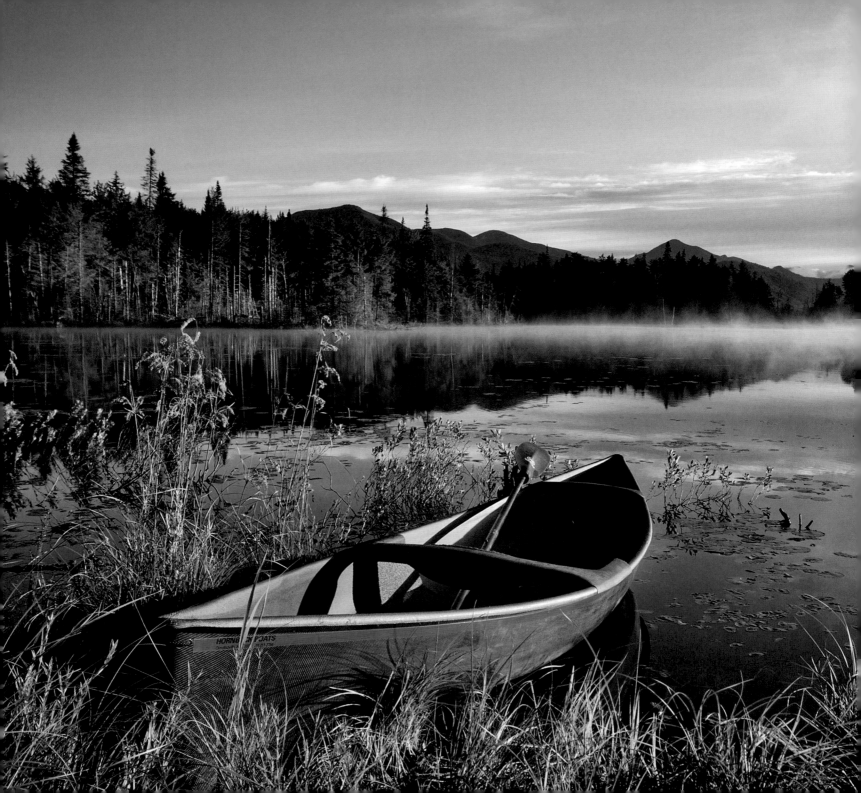

4:
POST-PROCESSING

In many ways, digital technology has brought landscape photography full circle. The 19th century landscape masters packed not only their camera and tripod, but also the chemicals, glass plates, and developing equipment that would let them process their film in the field, so they knew they had the image they were after. Back in their darkroom, fine quality prints would be produced, using techniques such as masking, burning, and dodging, with any retouching or dust removal done by hand.

Digital technology provides photographers a similar level of control over their images, from being certain they have achieved the result they are after in the field, to allowing them to be involved in every step of the process through to mastering the final print.

Yet Photoshop, and other image-editing programs, offer a level of creativity that goes far beyond the choices available in a traditional darkroom, allowing us the potential to produce photographs like never before. As a result, understanding how to work with an image-editing program and knowing what can be done with an image file is as essential a skill for advanced landscape photography as understanding the technical details and principles of a camera.

PROFILING & CALIBRATION

There are an infinite number of variables that can occur throughout the entire digital image creation process, from the moment you click the shutter until the print comes out of the printer. With so many options, it's important to keep the variables down to an minimum, and the starting point is a basic understanding of color management. Although there isn't space to cover this in full detail here (whole books have been devoted to the subject!), the following steps are essential if you want your prints to match the images you see on screen.

Every image file has a color space that defines the range of color tones in the image. When they are recorded by the camera, Raw files don't have an embedded color space, but are assigned one when they are converted to a JPEG or TIFF for use in an image-editing program. Of the color spaces available, Adobe RGB and ProPhoto RGB color spaces have a wider color gamut (range of color tones) than sRGB, but some of the color values will fall beyond the range that can be reproduced by a inkjet printer.

The main aim is to produce a final print that matches the color seen on your computer monitor, and while the process can be a little fussy, it is not that difficult. The first step is to calibrate your monitor, and when you consider the amount of time and frustration saved on color corrections, as well as the cost of media and inks from prints that didn't work out, a good hardware/software calibration package is a reasonable investment. Calibrate your monitor in a dimly-lit room, using the suggested default settings for your equipment. When it's done, the software will create a color profile for your specific monitor that will display color tones very close to industry standards.

LEFT AND BELOW: The ColorMunki from X-Rite (www.colormunki.com) is a dual-purpose calibration device: Not only can it create a profile for your monitor, but it can be used to create a profile for your printer also.

OPPOSITE: With a calibrated monitor and printer, the colors you see on your screen are the colors you will see in your finished prints—essential for images where color fidelity is vital.

With your monitor calibrated, you know that what you are looking at on screen is "correct." However, the color tones you are viewing still need to be translated to the gamut of your printer. All my color work is done in Adobe RGB so I can take advantage of the wider color gamut, but this exceeds the gamut of most printers. So, between the computer and the printer, the settings need to be adjusted, using another color profile, this time for the printer. Our color profiles have been set up through discussion with the printer manufacturer, reference articles, and some experimentation. It's important to note that each printer and paper combination requires its own profile.

Some manufacturers provide profiles with their printers and papers, and these are a good starting point. But, if you are serious about getting color right, you might want to invest in a printer profiling hardware/software solution, or use a color profiling service. In both cases, a test print is produced, and colors—usually from a test chart—are read by a device similar to a monitor calibration tool. By knowing what the colors on the test print are, and what they should be (in relation to the industry standard colors on a correctly calibrated monitor), a profile can be created that instructs the printer to make any necessary color alterations to match the two devices. Once you have a color profile, you will be able to use it for every print you make using the same printer and paper combination, and will be rewarded with printed results that match the image you see on your screen.

LAYERS & MASKING

For landscape photographers, one of the keys to getting the best from Photoshop is to understand adjustment layers and masking. Adjustment layers allow almost unlimited control of exposure, contrast, and color, while the ability to mask sections of an image lets you work on a picture in "pieces," adjusting each image element separately.

In Photoshop there are several windows that you can bring up on the screen, and when the Layers palette is brought up, it automatically shows your background layer. The main goal in Photoshop is to make all of your adjustments as additional layers on top of the background, so that the changes you make can be removed or modified later if needed, leaving the background image as it was originally shot.

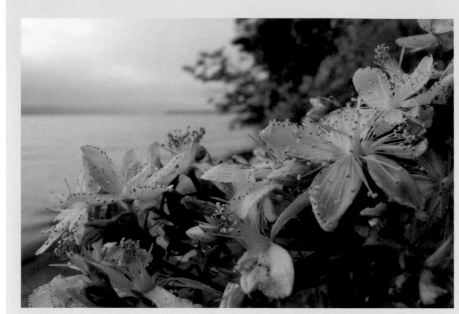

BEFORE

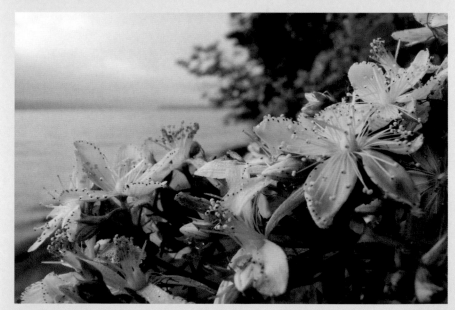

AFTER

Lake George, Adirondack Park, NY

1) Most of the layers you will need are found under *Layer > New Adjustment Layer*. On this image I am starting by using a Curves adjustment layer to brighten the flowers in the foreground. This works well, but causes the sky in the background to be too bright.

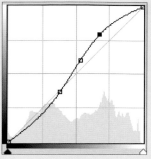

2) Color adjustment layers automatically have blank layer masks, shown by the blank icon to the right of the adjustment icon in the Layers palette. To use this mask, click on it and pick the Eraser tool. Then erase areas of the image to "mask out" the effect of the adjustment layer—in this case, removing the effect of the Curves layer from the sky.

3) After masking out the areas on the image, you can see the mask on screen by pressing the backslash key (shift + forwardslash on a Mac). While this red mask is showing it reverses the action of the eraser tool, so you can now paint the mask back in and fine-tune the area it covers.

Layers and masks have other uses beside color adjustment. In this photo I want to remove the rocks in the foreground of the water. With such a large area to remove, it's hard to clone it out, and the strong contrast between the colors means it would be difficult to use tools such as the Healing Brush or Patch tool.

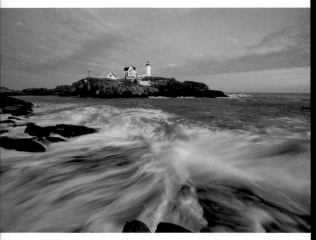

1) Instead, I start by making a selection of water that will make a good "patch" to cover the rocks. Using the Lasso tool to make the selection, right-click on the selection and choose *Layer Via Copy*. This copies the selected area to a new layer. With the Move tool, I can drag and drop the copied water over the rocks.

2) As this is an image layer, rather than an adjustment layer, it doesn't automatically come with a mask, but you can add one by clicking the Add Layer Mask icon at the bottom of the layers palette. This adds a mask box next to the layer, and the edges of the copied layer can be masked out so the copied layer blends into the background. The layer mask is very important here as, without it, you would be erasing parts of the copied area that would not be retrievable if you needed some of the selection back.

3) After masking and blending the layers, I created additional selections to finish covering the rocks and make sure that all of the detail looks appropriate. To make sure there are no obviously duplicated patterns, touch up small areas with the Clone Stamp or Healing Brush tools. These tools often work better after you merge the multiple layers you have created.

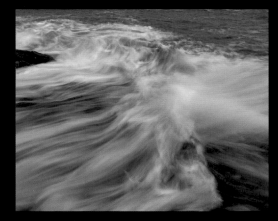

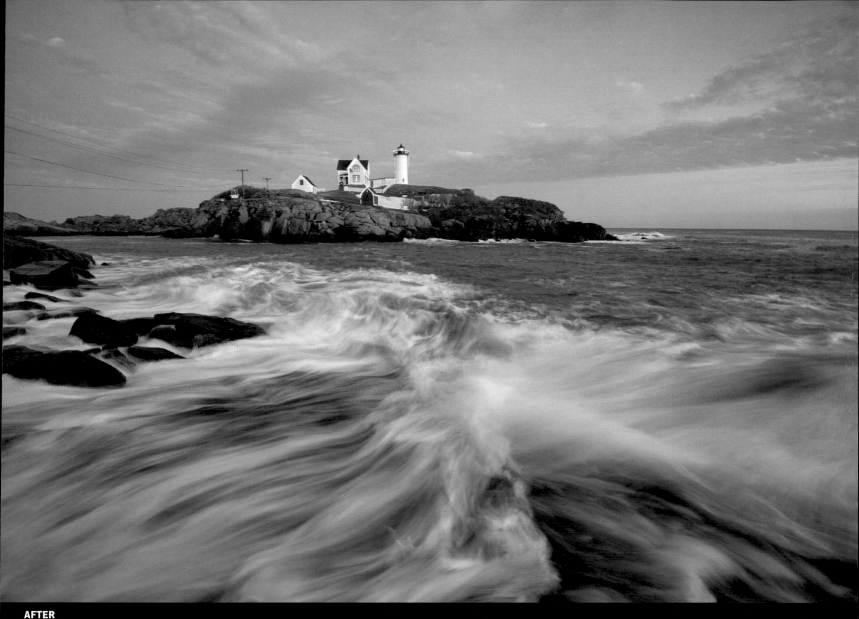

COLOR ADJUSTMENT LAYERS

Sometimes you can get accurate colors in camera, but there are occasions when you will need to adjust the color using your editing software. In Photoshop, the best way of changing the color of an image is to use an adjustment layer that will work alongside Levels and Curves adjustments to optimize the image. In addition to adjustment layers is a remarkable tool called Shadows/Highlights, which can be found under *Image > Adjustments* in the menu.

However, it's important to note that it is not an adjustment layer, so when you activate it, any changes would be made to the background. This means the corrections would be unmodifiable and permanent. The way around this is to right-click the background, and choose *Duplicate Layer* from the pop-up menu. Then, click the Add Layer Mask icon at the bottom of the layers palette and go to *Image > Adjustments > Shadows/Highlights*.

1) With this image there isn't much detail missing from the highlights, so the adjustments are minor. After you are done with your adjustments and click OK, you will see that Shadows/Highlights becomes a part of your background copy. Doing the adjustment this way does not allow you to modify your changes, but you can go back to the layer and mask the changes out.

2) Next, I'm going to use a Curves adjustment layer to adjust the contrast in the image, applying a curve as shown here. Once the detail and contrast have been optimized, you've got the best starting point for any additional color adjustments.

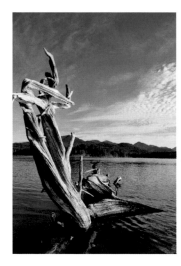

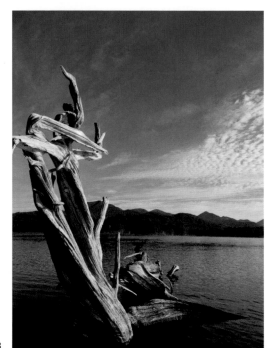

BEFORE

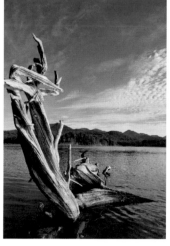

3) I'm again using an adjustment layer to fine-tune the color, this time using Color Balance. Only minor adjustments are needed, as the effect is quite strong. Over time, you will probably find that your camera tends to shoot images with a specific color cast—we almost always have to add blue to images shot using the auto white balance on our Nikon D300, for example.

4) Next, a Hue/Saturation adjustment layer can be added. You can use this to alter the hues of specific colors, but I mainly use it for saturation. Under the drop-down menu you will find that each individual color can be controlled. Here, I'm saturating the yellows, reds, and greens more than the blues and cyans.

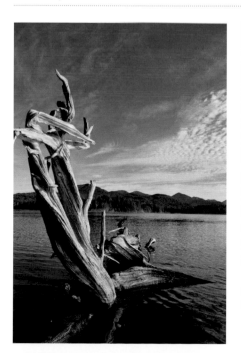

5) The fifth, and final, adjustment layer for this image is Brightness/Contrast. Increasing contrast also increases brightness, while decreasing brightness will lessen the effect of the contrast, so I usually begin with the contrast slider. As with Color Balance, small adjustments can make significant changes.

AFTER
Pond near the High Peaks, Adirondack Park, NY

Final Check

After applying your layers, stop, look, and assess the image. Do the shadows have enough detail? Have you lost any highlights? Use the eye-dropper tool to read the color values of specific parts of the image, checking to be sure you still have all the needed color information. In RGB, 255 is pure white, and 0 is pure black. In most images, try to keep the whites to 252 at most, and the blacks no lower than 3, so you have a full tonal range.

HIGH DYNAMIC RANGE

No matter how good your photography skills, there are some shots where getting detail all the way from the shadows to the highlights is impossible in a single exposure. This isn't because of a lack of skill, but simply because the brightness range of the scene exceeds the contrast range that your camera's sensor can record.

When this happens, you need to consider High Dynamic Range work, otherwise known as HDR, and no landscape photography book would now be complete without mentioning this technique. However, while automatic HDR blending programs have come a long way in recent years, I am rarely satisfied with the results these programs deliver, as they can all too easily look unnatural. This is fine for some subjects, but for natural-looking landscapes I prefer to blend my photographs manually in Photoshop.

This might sound "old fashioned," but with a little practice, hand-blended images that were shot from a tripod are not torturous to produce, and I would argue that they rely more on the skill and craft of the photographer, rather than the software they are using.

1) While it's good to shoot anywhere from 3-7 bracketed images in an HDR sequence to make sure that you have all of the detail covered, you can typically just use two of the exposures for compositing images—one that contains the shadow detail, and another with the highlights. Occasionally, more exposures can be helpful, but two is a good place to start.

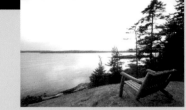

2) I usually start with the lightest image open, and then drag and drop the darker exposure on top as a new layer. Assuming the images have been shot using a tripod they should line up almost exactly. If not, lower the opacity of the top layer to around 50% so you can see the lighter layer underneath. This makes it easier to align the two.

3) It's best to zoom into your image to about 100% so you can really see how well things are lining up, then choose the Move tool and use the arrow keys on your keyboard to nudge the top image into place. Sometimes the pictures cannot be matched by just nudging them, in which case you might need to make more major adjustments using either the Distort or Warp tool (found under *Edit > Transform*).

4) Once the images are aligned, add a layer mask to the top image layer and start masking out the darker image. The aim is to mask off the image so you are concealing the dark, featureless shadows and leaving the areas that improve the highlights.

On some images the masking can be very easy, but on others—especially where there are moving elements such as water or leaves—it can be more difficult. In these situations, I often mask at various opacity levels in order to blend the information. You could also use the Clone Stamp to remove an object from one of the exposures if it is refusing to blend with the other.

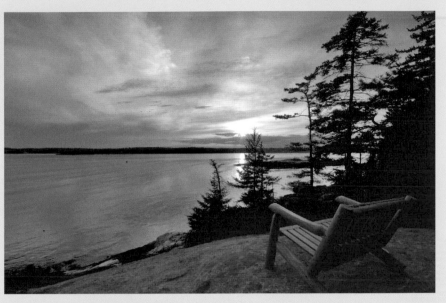

5) Once you've finished blending your exposures, you can apply any adjustment layers that you need to fine-tune the color and contrast. The result will be a continuous tone image that contains full shadow and highlight detail where the camera would have lost one, or both, ends of the tonal range. Unlike automatically generated HDR pictures it will also exhibit a natural appearance, rather than an overtly digital one.

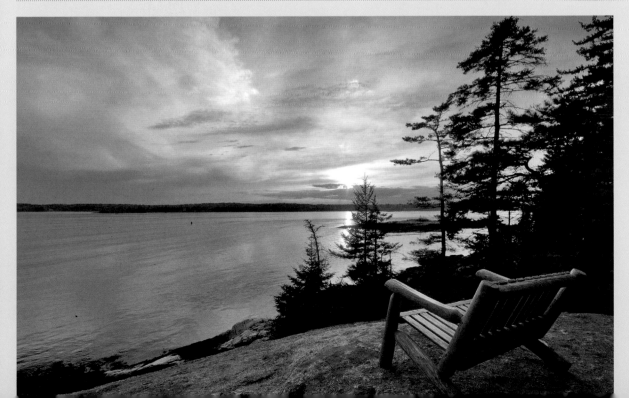

Sheepscot River from the Porter Preserve, Boothbay Region Land Trust, ME

PANORAMIC STITCHING

Panoramic images capture a scene in a radically different way from standard formats. However, for most photographers, the very high price tag of a dedicated panoramic camera is not justifiable, so creating panoramas from multiple "standard" shots is a much more widely adopted approach.

Early panoramic stitching programs had a very hard time lining images up, and they also struggled to deal with any shifts in color between frames. With Photoshop, this changed when Adobe introduced Photoshop CS3, which not only improved the image aligning and color issues, but also created stitched images in separate layers, along with masks, so you could fine-tune the individual frames that make the panorama.

The stitching tool in Photoshop is found under *File > Automate > Photomerge*, and the first step is to choose the photos you would like to merge. A few seconds or minutes later, depending on your file sizes, you are given a layered file to work on (ABOVE AND RIGHT). As you can see, the edges of each image/layer are also masked to create what the software feels is the best join (OPPOSITE TOP).

AFTER
View of Jonesport Harbor, ME

In this image, the edges of each picture have also been warped or rotated, which gives the picture a rather unfinished appearance. This can easily be fixed by cropping down the edges. Before you do, click on *Edit > Select All* and use the Warp Tool to bring the edges back out (RIGHT), so you don't lose as much of your photo when you crop the image.

BLACK & WHITE

Lake George, Adirondack Park, NY

It's exceptionally easy to turn a color image into a black and white photograph with a click or two of your mouse, but it usually requires a few more steps—and a bit more thought—if you want the best result. Photoshop's most recent addition is the Black and White color adjustment layer, my favorite conversion option.

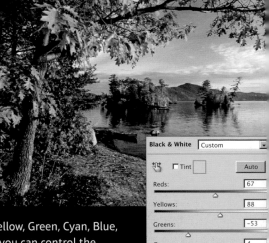

1) When you choose *Layer > New Adjustment Layer > Black and White* you will be given an adjustment layer with several presets for black and white images, as well as letting you make custom adjustments. This layer allows you to independently adjust the lightness and darkness of the Red, Yellow, Green, Cyan, Blue, and Magenta channels. In doing this you can control the contrast in your image, and bring some of the depth back that is often lost by a straight conversion to black and white using the more simplistic Convert to Grayscale or Desaturate commands. With this image, decreasing the Blue deepens the contrast between the sky and the clouds, while lightening the Red and Yellow channels highlights the fall colors in the trees.

2) As well as straight black and white conversions, the Black and White adjustment layer also lets you to add a tint to your monochrome images. Clicking the Tint box at the top of the Black and White adjustments window brings up a color map that lets you choose virtually any hue and intensity that you would like. This is very useful for creating monotone pictures, such as sepia toned images with a vintage feel.

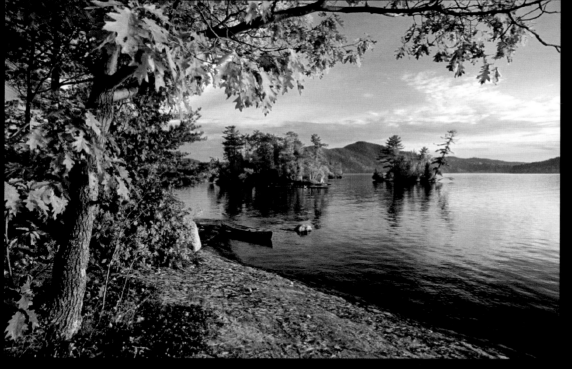

3) Some more interesting effects can be created by masking out parts of the Black and White layer. Here, I brought back the color in the canoe by masking off this area of the adjustment layer and leaving the rest of the image in black and white.

4) Similarly, it can be worth experimenting with the Blending Modes of the adjustment layer. Changing the mode from Normal to Darken Color reveals all the reds and yellows, but leaves the blues and cyans as black and white. Not necessarily something you would want to do with every image, but certainly something to experiment with.

INFRARED

There are lots of infrared conversion techniques that you can read about in magazines, online, and in books. I've tried a wide range of these, as well as playing around with a few different methods of my own—some more complicated than others. My favorite, and the one I use most often, is actually one of the simplest.

BEFORE

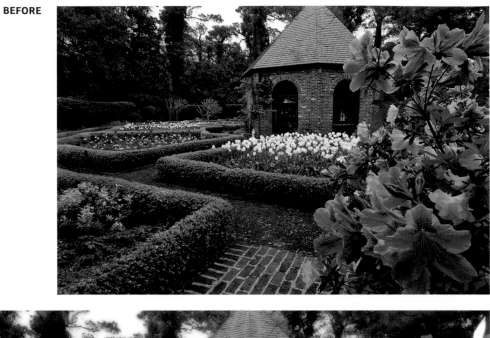

AFTER
Roanoke Island,
Elizabethan Gardens, NC

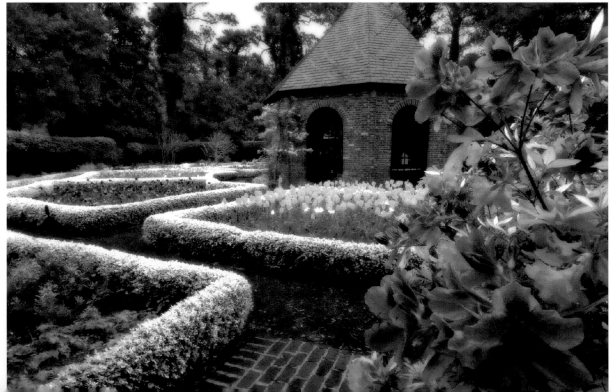

1) First, duplicate the background layer. Add a Gaussian blur to the background copy (*Filter > Blur > Gaussian Blur*), choosing an amount between 4 and 8 pixels.

2) Lowering the opacity of the blurred layer to about 35–50% allows the sharp image beneath to start showing through, so you have a mix of sharp detail with a slightly diffuse glow around it. This is a similar effect to the glow of infrared images shot on film without an antihalation layer.

3) Next, apply a Black and White color adjustment layer. As previously mentioned, there are several presets for this layer, one of which is Infrared. However, this is only a starting point—as with a normal black and white conversion, going a step further can help make better images.

4) Because you are using an adjustment layer, you can still change the default percentages of each color channel, despite picking Infrared from the preset list. This lets you tailor them to exactly the intensities that you are looking for. In this image, for example, I lightened the magentas to soften the appearance of the flowers in the foreground.

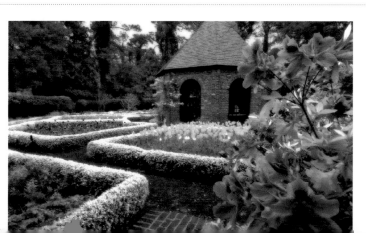

ADVANCED COLOR WORK

While the basic color adjustment layer system that we have looked at brings most photos to a finished state, there will be some that need a few more adjustments. There are a wide variety of different adjustment layers in Photoshop, all giving you different ways to achieve sometimes very similar effects. However, each layer can affect the image in its own unique way.

Color Adjustments with Curves

A Color Balance layer allows you to adjust the tones in your image, but you can also use a Curves layer to get to a similar end point.

By changing from the RGB channel to either the red, green, or blue color channel you can raise the curve to add more of that specific color, or lower the line to take some out. With a layer like this it is helpful to remember the color wheel, so that if you have an image that is too yellow, you can add blue to correct the problem, and so on.

This particular image had a very purple tone overall, so both the red and blue channels were lowered a little to compensate.

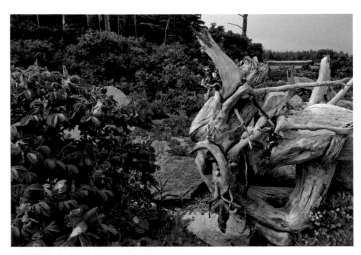

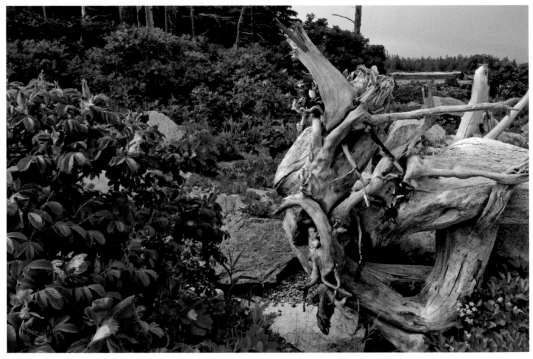

Wonderland Trail, Acadia National Park, ME

BEFORE

AFTER

Selective Color

Another layer with immense color adjusting capabilities is Selective Color. This layer lets you work on nine different color channels, and in each of these individual channels you can change the balance of cyan, magenta, yellow, and black.

Lake George, Adirondack Park, NY

1) In this image, I was unhappy with both the tones of the grass in the foreground, and the blue of the sky. Correcting the grass was achieved by first going into the yellow channel and adding a little cyan (to take out some red). I also took out some yellow. This reduces the brownish tone in the grass, while adding black gives a more realistic shade of green.

2) The sky also looks a little brown, and it is too light. Switching to the blue channel and adding cyan and reducing the yellow accentuate the blues. I also added a touch of magenta to retain a slight warm tone. Adding black gives the blue more intensity.

3) As much as I like the effect on the sky and the grass, the water now looks artificial. To solve this problem, I can go in and mask out the effect of the Selective Color adjustment in that part of the image.

This overall process emphasizes how you can look at an image as a series of individual elements, each of which can be optimized, instead of focusing on how each layer affects the entire image. By individually targeting the three key elements in this image—the sky, the grass, and the water—I now have a much cleaner picture, with purer colors.

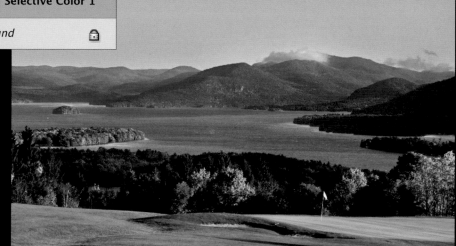

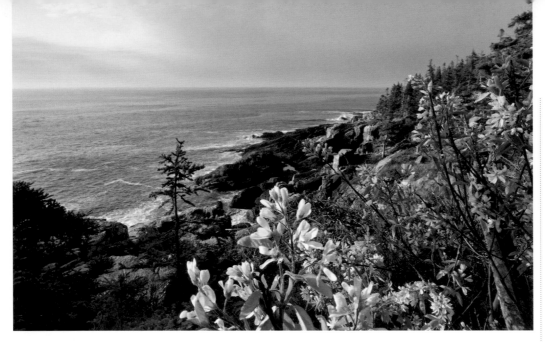

3) The Gradient Editor is brought up by clicking inside the color box, next to where it says Gradient. Double-click on the color stops at either end of the long color box to choose the color of the gradient. The bottom left stop adjusts the color that the line is pointing away from, in this case, affecting the sky.

On most images you will want to pick a completely neutral color, so as not to introduce any new color tones into the image. However, there are instances when using a color fill is desirable.

Gradient Fill

If you refer back to the section on filters in the very first chapter, you'll appreciate that balancing a bright sky with a darker foreground is often very difficult to do without using a graduated neutral density filter or shooting for HDR work. A Gradient Fill layer is similarly useful for dealing with washed out skies, although it is obviously used after capture, and is not the same as getting things right at the time of exposure. This layer is found under New Fill Layer in the Layers menu.

1) When the initial screen pops up, be sure to change the Mode to Soft Light, as this means you will just be adding a soft color fill, with your image still visible underneath.

2) The next screen lets you choose the angle of your gradient. The line points in the direction that will be affected the least by the fill. Here, I point this toward the foreground, so the sky is most affected.

4) With this image, I used pure black as my fill color to give the clouds as much of a boost as possible. As you can see, there is now more detail in the clouds to the top left.

View from Diamond Point, Lake George, Adirondack Park, NY

Reflected Detail

When Gradient Fills aren't enough, you could consider taking information from another part of the image to "fill in" missing detail. For example, I felt this image was lacking detail in the dark water and, as the sky is reflected in the water, I decided to use the sky information instead.

2) Choosing *Edit > Transform > Flip Vertical* from the menu bar inverts the sky selection, which is ready to be moved down and over the water.

4) The final step is to create a layer mask and begin masking out the sky layer at different opacities so that it blends in well. Allowing some of the water ripples to show through in most places makes it look as natural as possible in the finished result.

1) Using the Rectangular Marquee selection tool I selected the whole sky, right down to the treeline, then right-clicked to bring up Photoshop's contextual menu and selected Layer Via Copy so the sky selection was copied to a new layer.

3) Similar to working with manual HDR images, lowering the opacity of the top layer makes it easier to align the two parts of the picture. In this particular image I also used the Rotate tool (*Edit > Transform > Rotate*) to line the detail up. As the detail in the water is not the same as the detail in the sky, it isn't necessary to have things line up exactly, only closely.

CREATIVE EFFECTS

In addition to the various adjustment layers that can be used to correct or optimize an image, there are several different faux filter effects that you can play around with. The first is a "Lensbaby" effect, designed to mimic the flexible lens of the same name by keeping one point in an image in focus while the rest softens out in a radial blur.

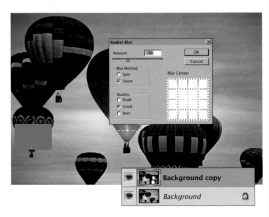

1) To create this effect, start by duplicating the background layer. Right-click on the background copy to bring up the contextual menu and convert it into a Smart Object so you can go back in to the layer and adjust the filter that you will be applying. Next, choose the Radial Blur filter, located under *Filter > Blur*. Here I've set the amount to 30.

2) Create a second background copy layer, and again convert it into a Smart Object. Drag this copy layer to the top of the layer stack in the layer palette, then apply a Gaussian Blur filter (*Filter > Blur > Gaussian Blur*). For this image I set the Gaussian Blur to 24, and then lowered the opacity of the entire layer to about 45%.

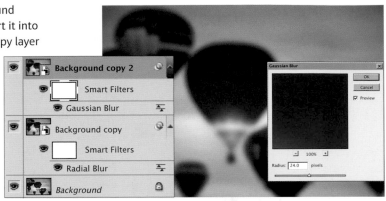

3) To create the Lensbaby look, with it's distinct circle of sharpness—or "sweet spot"—you need to mask the blur effect to bring one point gradually back into focus. Start with the Radial Blur layer, and use a soft-edged eraser at 30% strength. Make sure you are working on the layer's mask, and click once to partially erase a reasonably large portion of the image—this will be your "sweet spot." With this picture I chose the balloon basket in the center as my focal point.

Reduce the size of the eraser and click on the sweet spot again. Repeat this process of reducing the size and clicking on the sweet spot to build up a soft-edged mask that focuses in on the basket. Use the same method on the Gaussian Blur layer to increase the sharpness of the basket.

Because you are working on Smart Object layers, you can go back to the blur filters and adjust them if you need to. Experiment with different strengths and masking to come up with the exact effect that you want.

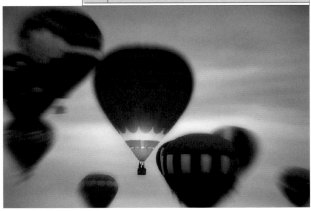

Warren County Adirondack Balloon Festival, Glens Falls, NY

The Orton Effect

Originally created by sandwiching two slides together, the "Orton Effect" (as developed by Michael Orton) is very easy to re-create in Photoshop, giving an image a soft, dreamy effect.

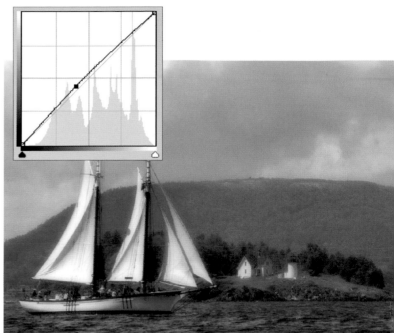

2) To blend the blurred and focused layers, set the blurred layer's opacity to around 40%. In order to give the image an even softer feel, use a Curves adjustment layer to slightly lighten the entire image. And that's it—a very simple Orton effect with only a couple of clicks of the mouse.

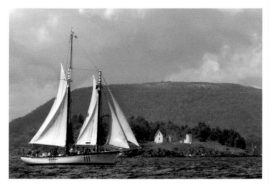

1) As with the Lensbaby technique, the first step is to duplicate the background layer and convert it into a Smart Object. Next, apply the Gaussian Blur filter (*Filter > Blur > Gaussian Blur*). On this image I used a setting of 20.

RIGHT: A softened combination of the Lensbaby and Orton effects adds a soft, dreamy feel to an image, enhancing the emotional appeal of this sunrise picture. *Hudson River view, New York City*

ACKNOWLEDGMENTS

Over the many years I have been learning about photography, I have appreciated the willingness of different photographers to share their knowledge so that others may benefit from their experiences. As I have been presenting photo workshops, I have enjoyed being able to relate my experiences to others. I would like to express my deep appreciation to Ilex Press, and Amphoto, for offering me the opportunity to work on this book, and pass along my own thoughts and suggestions for photography techniques to a much broader audience.

No project comes together without the help of many wonderful individuals. I have thoroughly enjoyed working with my editor, Chris Gatcum, of Ilex Press. He has been helpful with suggestions and planning, flexible but firm in keeping the project on track, and great at maintaining my thoughts and flow while paring down the text and photo choices to fit within the pages of the book. I would also like to thank Adam Juniper, of Ilex, for his help and editing on the original proposal for this book.

There were numerous others who have helped in many different ways. Both Nikon and Canon reps were quite prompt to reply with answers to the various techy equipment questions I asked. I have also appreciated being able to research and fact check some of the more technical aspects of digital photography, and would like to express my appreciation in particular for those behind the scenes at The Luminous Landscape and Cambridge in Colour. I would also like to thank everyone involved with the North American Nature Photography Association for their efforts to promote nature and landscape photography and photographers.

My photography experience has also been enriched by viewing photography through the eyes of the many different participants in my photo workshops. Their questions and ways of observing the world have helped expand my own visions. I have also appreciated the thoughts, perspectives, and writing from some of the top landscape and nature photographers, including: Ansel Adams, Clyde Smith, Galen Rowell, Art Wolfe, Frans Lanting, Dewitt Jones, Freeman Patterson, George Lepp, William Neill, Nancy Rotenberg, Paul Rezendes, Nancie Battalgia, and Nathan Farb. I would also like to express my appreciation to my photographer friends; Eric Seplowitz, and Woody and Elise Widlund for their help on various aspects of the book, and Eric Dresser, John Radigan, and Mark Bowie for sharing their vision through regional workshops.

The greatest support for this project has come from my family. I would especially like to thank my wife, Meg, for all of her support throughout the project. She is one of my best critics, and both she, and my sister, Mary Alice, helped refine some of my writing before it went to the editor. Meg also helped create the time and space for me to work on the book while she picked up on business details and allowed other projects and details to be put on hold.

And this book would not have been able to happen anywhere close to schedule without the help of my daughter, Greta. Greta is the wizard behind my Photoshop work, and got all of the images ready for the book. In addition, she has passed along her own expertise in the post-processing segments in the book. It is a great pleasure to be able to work with her in our office, as well as collaborate with her on a project like this.